THE LANGUAGE OF THE FACE

THE LANGUAGE OF THE FACE

Stories of Its Uniquely Expressive Features

FRANK GONZALEZ-CRUSSI

The MIT Press
Cambridge, Massachusetts
London, England

The MIT Press would like to thank the anonymous peer reviewers who provided comments on drafts of this book. The generous work of academic experts is essential for establishing the authority and quality of our publications. We acknowledge with gratitude the contributions of these otherwise uncredited readers.

This book was set in Adobe Garamond Pro by New Best-set Typesetters Ltd. Printed and bound in the United States of America.

Library of Congress Cataloging-in-Publication Data is available.

ISBN: 978-0-262-04753-1

10 9 8 7 6 5 4 3 2 1

Contents

Introductory Note

At least since the classical era, the idea that human beings are double has enjoyed very wide currency. According to this idea, each of us is divisible into two: an exterior being that all can see, and an interior being that lies hidden. Of the others we see the surface only; we know not what is going on in the realm of consciousness. The psychic agitations of our fellows—whether minor stirrings or severe, convulsive disarray—are generally undetectable to us. Similarly, our own inner commotions are concealed to outsiders. Still, the hidden inside and the visible outside are not wholly divorced from each other; some communication exists between the two. The proof is that some movements of the inside do reach the outside and show through, primarily in the face. Centuries-old observation taught us that we have legible countenances, like open books. We can discern, by examination of the exterior changes, what is happening to the inner being. But this is true in a limited way, and of the fleeting emotions only, which appear one moment and disappear the next.

We are curious; we would like to know more; we would like to find out the whole structure of our neighbors' character. But how are we to achieve this? We are not as fortunate as Peregrinus Tyss, a fictional personage in one of E. T. A. Hoffmann's fantasy stories, "Master Flea," who is given a magnifying lens that can be inserted in front of the left pupil (a sort of contact lens precursor), whereby the wearer can see across the cranial bones into the brain—and actually read the thoughts—of the persons with whom he is talking. Lacking this magical resource, we are forced to try to discern other people's thoughts and emotions by inference. We can see that passing moods,

good or evil, end up stamping their impress upon the face by constant reiteration. Each passion has a distinctive expression. The folds of the skin produced by smiling become imprinted on the face; similarly, the wrinkles of frowning remain fixed. Hence the desire grew to build a whole science that might disclose to us the hidden character of a human being through the study of his or her external features.

This is how "physiognomy" was born. It was originally called "physiognomony" (from the Greek *physis*, φύσις, nature, and *gnomon*, γνώμον, interpretation), which the *Oxford English Dictionary* says is the "etymologically correct term," although it has been "contracted in all the Romanic languages, and still more in English." Initially, physiognomy was considered a twofold science: one part was designed as a way to discriminate character by the face's outward appearance; the other, as a method of divination based on outward form and feature. As late as the eighteenth century, physiognomy's double purpose was generally acknowledged. Samuel Johnson's dictionary defined physiognomy as "The act of discovering the temper and foreknowing the fortune by the features of the face."[1] Relegated to a second place is the acceptation that has survived to our day, which Samuel Johnson formulates laconically: "The face; the cast of the look."

The Messiah of physiognomy in the Enlightenment era was the Swiss writer, mystic, pastor of the Zwinglian Church, illuminist, poet, and would-be scientist Johann Caspar Lavater (1741–1801). An enormously influential figure in this time, he was genuinely convinced that he had founded "the science or knowledge of the correspondence between the external and internal man, the visible superficies and the invisible contents."[2] Moreover, in line with the dual character of his alleged "science," he claimed more than once that he could foretell a man's future from the shape of his head.[3]

Fortune-telling is the most colorful aspect of this discipline, but also the likeliest to lend itself to abuses. English law understood this well: an act of Parliament in 1743 decreed that all persons pretending to have skill in (divinatory) physiognomy should be declared rogues and vagabonds, liable to be whipped, or subject to incarceration "until next sessions." Act 39 under Queen Elizabeth (1597–1598) specified that one claiming to be expert in physiognomy "or like Fantasticall Ymaginaciouns" was liable to

be stripped naked from the middle upward and "openly whipped until his body be bloudye."[4] The British Queen may have tolerated orthographical shilly-shallying from her Parliamentarians, but when it came to implementing rigorous, unpitying laws, everyone knew Gloriana was not in the habit of kidding.

The present book is not intended as a treatise on the history of physiognomy. An enormous bibliography on this theme is already extant. Rather, the material presented here consists of literary and historical narratives, artistic expressions, biomedical notions, and philosophical reflections woven around physiognomy during the eventful history of the face-reading pseudoscience. My idea has been to broaden the reader's appreciation of this subject matter by using a multiplicity of sources. The traditional essay format seemed specially fitting to this endeavor, since it enables an author to move freely across various disciplines, such as artistic, literary, and medical treatises. This approach no doubt has some drawbacks, but also distinct advantages. The multiplicity of viewpoints and the originality of fresh and unaccustomed ideas thus presented is likelier to make a reader question his wonted notions and habitual prejudices than a work built upon a meager documentary support.

In choosing the title of this book, the idea came to me to name it an "anthology." However, anthology signifies, according to most dictionaries, a "collection of choice literary pieces or passages, or selected pieces in any art form"; its etymology (from Greek άνθος flower + λέγειν to gather) implies a deliberate compilation of the best, most representative, or prettiest specimens: truly "a gathering of flowers." In contrast, much of the miscellaneous amassment in the present work is accessory or subsidiary to the history of physiognomy. Some of it may seem but tenuously related to this subject, yet it contributes, I believe, to its embellishment and enhances its interest. Accordingly, an appropriate title for this book might have been "*Parerga* on Physiognomy," since the word "parerga" (plural of "parergon"), as the *OED* further informs us, derives from the Greek παρά beside + έργον work, that is to say, a by-work, something subordinate or secondary to the main topic. Except that "parerga," like "physiognomony," being a Greek term, naturally sounds Greek, and, frankly, is still Greek to most of us.

Thus, the reader will find here, instead of a detailed description of the astrological methods used by early physiognomists to forecast a person's future, a lively biographical semblance of the most colorful forecaster of all; instead of the anatomical minutiae alleged to confer character on a nose, amusing stories centered upon noses of all types; and in lieu of an extensive coverage of the modern scientific explanations of facial attractiveness, old narratives of the calamitous effects of beauty and the ways contrived by previous ages to "fall out of love." Admittedly, the book's plan is idiosyncratic. Colorful anecdotes share space equitably with more serious dissertations. Reports from the specialized sociological or medical literature were not excluded. The only exclusionary criterion applied was boredom. It is my most earnest hope that the reader will not find my selection criteria wholly ill-advised.

1 OF NOSES COMIC, DRAMATIC, LOST, AND RECOVERED

NASAL DRAMA

The Transcendence of Verticality and Obliqueness

A trite metaphor says we are like boats sailing on the tempestuous sea of life, ever at the mercy of the winds of fate. If so, the nose is the bowsprit, the long spar that juts forward from the vessel's prow, for it always precedes us, in whichever direction we chance to navigate. But it may be better to say that the nose is the figurehead, that is, the ornamental carved and painted figure at the ship's bow. For figureheads, like human noses, are much more than merely ornamental: they have character; they proclaim the ship's mission and allow its recognition. By the same token, rightly or wrongly the nose has been said to be a reflection of the qualities of a man's character and psychology. And just as seamen everywhere believed that a boat lacking a figurehead was a most ominous augury,[1] so the loss of the nose has been one of the most baneful occurrences that befall a few unfortunates. Add to this that both a human nose and a boat's figurehead have been known to inspire detestation or amorous passion. To believe the *Dublin Journal* of October 12, 1725 and the *Weekly Journal* or *British Gazetteer* of London of December 11 of the same year, a sea monster, half-fish and half-man, became ardently infatuated with a ship's figurehead sculpted in the guise of a beautiful woman. He held on to the ship's rudder trying to ravish the female-shaped figurehead. Eventually the sailors rid themselves of the lovesick triton. The reports said nothing about his fate. We assume the lovelorn monster returned to his oceanic abyss, there to find consolation in the arms (fins?) of some Nereid,

Eurybia, Amphytrite, or any of the numerous mythical females said to grace the deep seas.

The German-Swiss author Heinrich Zschokke (1771–1848) wrote an enjoyable "Apology of the Nose,"[2] in which he made a curious observation. He said that, if you look attentively at the nose of some people, you will soon perceive that this "citadel of the face" is a little inclined, like the tower of Pisa, "as if it the wind had charged on it always on one side." The bigger and more majestic a nose, he claimed, the more likely it is to be found deviated. Now, this observation might have passed for a triviality, but Zschokke decided to belabor it in order to heighten his moralistic comments. Nasal inclination, he claimed, is emblematic of those men who stubbornly follow the wrong road of life, even when the straight path lies clearly before them. Men do well to follow the direction of their noses; but it is only the wise who know how to correct this pointer that nature has given them and follow the right path even when the pointer is awry.

Alas, it is often the case that people endowed with a nose as straight as a plumb line opt to take the most tortuous life route they can find. Their natural disposition is so thwarted that they cannot do away with chicanery and intrigue. They would walk to heaven only after taking plenty of detours. If you believe, as did Zschokke, that nasal straightness betokens a forthright character, you will be disappointed upon realizing that a whole class of people exists whose nasal straightness is seriously at odds with their moral compass. Alarmed, the Swiss writer proposed that the police mark such people, in order that their deceptiveness be unmasked and cease to be a public danger.

At first blush, these observations strike us as the playful banter of a popular writer. But nasal deviation earned a place of distinction among the most serious and important subjects of philosophical reflection thanks to the great masterpiece of Luigi Pirandello (1867–1936) curiously titled *Uno, nessuno, centomila* (*One, No One, One Hundred Thousand*). Undoubtedly an extraordinary literary work of universal and perennial significance, it was the last of the Sicilian writer's novels and took him more than fifteen years to complete.

The novel opens with a trifling domestic scene: the chief personage, Vitangelo Moscarda, a wealthy bourgeois who lives a life of idleness, is in

front of the mirror examining his nose. His wife asks him what he is doing. "Nothing," he answers, "it is just that I felt a very slight soreness when I pressed my nose." His wife smiles and rejoins: "I thought you were watching on which side it tilts." Somehow this innocent, casual remark by the wife seems to touch a sensitive nerve: it unleashes a veritable cascade of recurrent, disturbing thoughts that end up changing his view of the world and radically unsettling his existence.

So, his nose "tilts" to one side? So, it veers slightly to the right or to the left? But he never knew it! All his life, until that very moment, he firmly believed that he was Mr. Moscarda, a straight-nosed fellow; and suddenly he discovers he is actually Moscarda, he-of-the-tilted-nose. How many times had he spoken critically of Tom, Dick, or Harry's nasal deformity? Alas, not suspecting that others were saying to themselves in tone of mockery: "Look at this guy who so blabbers about the nasal defects of others!" In the normal flow of our lives, we do not think about such things as the verticality of our nose, the color of our eyes, the width or narrowness of our forehead, and so on. These things are parts of ourselves, inseparable from us; things toward which ordinarily we do not direct the stream of our thoughts. We are too absorbed by our occupations and our feelings to ponder such things. But Vitangelo Moscarda *did* think about these things, and his thoughts became progressively more complex, intricate, heavier, and oppressive:

> For the others, who look at me from outside, my ideas and my feelings have a nose, my nose; and a pair of eyes, my eyes, which I do not see and they see. What relation can there be between my ideas and my nose? For me, none: I do not think with the nose, nor do I mind my nose when I think. But what happens inside the others? What happens to those "others" who cannot see my ideas inside me and who see my nose from outside? To them, my ideas and my nose are so closely interrelated that, say, if the former were quite serious and the latter queerly funny, they would burst out laughing.[3]

Moscarda aches from a limitation inherent to the human condition: the inability to represent ourselves as others see us. We cannot escape from our body and see it as others see it; we cannot watch ourselves living as if we were

someone else. Try as we might, we can never do this. Do we stand before a mirror? This is useless: our attitude is immediately changed; we are no longer spontaneous in our gestures; we are "posing"; every move reeks of artificiality and fictitiousness. Pirandello's personage cringes under the burden of this limitation. Walking down the street with a friend, he surprises his own image in a mirror as he passes in front of a shop's window. The perception is barely a flash of lightning; it lasts a fraction of a second, but it is enough to set him wondering:

> Am I really like that, me, seen from outside, when I am living and not thinking of myself? Therefore, to the others I am like that stranger that I surprised in the mirror, and not such as I know myself. I am rather like the one I glimpsed a moment ago and did not recognize with my rapid glance. I am that stranger whom I cannot watch living, except that way, in an instantaneous, unintended way. A stranger that only the others can see and know, but I cannot.[4]

But, he further reflects, the same thing happens to the others. This painful, unbearable realization dawns on him: that we are alone in this world, and that we delude ourselves when we believe that we touch, see, and get to know another human being's reality. All we know is the image that we create. The fact is we are strangers to each other and to ourselves.

This train of thoughts takes him to form a "desperate purpose," namely to obstinately pursue that stranger who was himself and who constantly eluded him; the man who, as soon as he tries to catch him in a mirror, magically transforms into himself. The Pirandellian hero suffers a veritable crisis of identity: he is embarked on a desperate search for his own "self," a foolhardy quest bound to become a perilous odyssey. Who was he, after all? A body for which at times he could feel some antipathy: a head of hair that was white, but could just as well have been black, red, or blond; a nose that was "tilting" to one side, as his wife remarked, but which equally well could have been perfectly straight. Hence, Moscarda is penetrated by the feeling that the body is not only impermanent but fundamentally exchangeable, in the sense that anyone could take it and make of it whatever image he or she pleased.

Therefore, his former conviction that he was someone—some one (*uno*)—is now confounded by the feeling that he is nothing, no one (*nessuno*). But, at the same time, he realizes that the view of "the others" is not uniform: each one sees Moscarda in his own particular way, and no two views are identical. Therefore, there is not one Moscarda, but many: one hundred thousand (*centomila*) or more. We think of ourselves as "individuals," when in reality we are "dividuals": our identity is divided, shattered into countless units, because each one of our fellow human beings gives it a different reality. But the human conundrum is still more confusing. Why, even to ourselves we appear essentially mutable: this moment unlike hours before; today different from yesterday; and this year so dissimilar from years past that presently the stranger inside us would be at pains to recognize his image in a mirror.

Pirandello's novelistic hero conceives the extraordinary plan of discomposing or undermining the ideas that others have formed of his own person. A foolish and dangerous project, insofar as it struggles against the peace, stability, and good order of his society. Nothing can be more disturbing than the upsetting of a preconceived idea. Did people use to call him "usurer" because his late father had been a banker and he lived from the income generated by his investments? He rebels against this "stereotype" and will dynamite it by liquidating his assets and engaging in spectacular, rash acts of incredible generosity and poignant self-renunciation. Did his wife and father-in-law always consider him an innocuous poltroon, easygoing, pliable, and accustomed to a life of comfort? He will sink them into bewilderment and fright when they find that he is giving up all the material elements that sustained the life of ease enjoyed by his family. He asks them with a strange sense of humor (waiting to see their reaction to his question): how would they like to see him go back to the university to become a lawyer, a professor, or a medical doctor? He is sure he can do it, for he knows his own intellectual powers and "the mediocrity of many men who practice those professions successfully." Needless to say, his relatives do not find this funny. With undisguised alarm, they start taking steps to declare him legally insane.

He tries to instill his own doubts into the mind of others, to shake them out of their complacency, but obtains only incomprehension. He would

show them the terrible truth which torments him and which he believes he has painstakingly discovered: that we are all strangers to each other and to ourselves, and therefore condemned to a life of anguishing, irremediable solitude. But this notion is too painful to gain general acceptance. Whether true or false, the idea is too troublesome and disquieting ever to lay down roots in the human heart.

No quick summary can do justice to the keen psychological insights and the precise, lucid descriptions in Pirandello's masterpiece. Suffice it to say that, as one might suspect from the beginning of the narrative, Moscarda's life ends sadly. His odd, astonishing behavior and his extravagant actions, even when morally laudable, are met with reproof from his society. Those who benefit from his largesse are disconcerted. Far from falling on their knees in gratitude, they look at him with a hostility that says: "Madman!" and "What you are doing is sheer lunacy!" His acts are adjudged the product of a sick, unbalanced mind. Indeed, madness, mental disarray, is the only way out of the terrible solitude that he has discovered and in which he feels trapped. His marriage crumbles; his fortune evaporates, and he ends his days forlorn, thought to be a madman and admitted as a resident into an institution for the indigent—a charitable organization that was founded largely with the funds that he relinquished to the Church. There he renounces all identities while waiting—peacefully at last—for his death.

Curiously, Pirandello starts his fascinating clinical-philosophical chronicle of Moscarda's identity crisis with a trivial observation about his nose. This is probably not fortuitous. The nose is *central*—literally as well as figuratively—in the face, which is to say in the configuration of our personal identity. The powerful symbolism of this part of our anatomy must have influenced somehow the novelist's decision to turn the nose of his personage into the starting point of his most disquieting inner journey. Sigmund Freud and his friend Wilhelm Fliess believed that the nose was a nodal point of sexual life, and that it was possible to cure arcane forms of sex-generated mental neuroses by operating on the nose and the paranasal sinuses. Pirandello made the nose into a mechanism that catapulted his personage to the heights of metaphysical doubt, and precipitated him straight down into the depths of mental alienation.

On Nasal Loss

There is much more in the nose than may appear at first sight. A French scholar says that among pre-Islamic Arabs the nose was "the principle of honor" and somewhat like an equivalent of the whole person; the custom of amputating the nose of a rival therefore came to signify the desire to destroy him completely.[5] The complete loss of the nose being one of the most terrible misfortunes that can befall a human being, it is strange that eulogists of a face often glide over this organ without paying much attention to it. The commonplace praises of the beauty of the beloved usually center on eyes like stars, teeth like pearls, lips like rubies, hairs like gold or black-diamond threads, and other gemmological clichés; but the nose is omitted or relegated to a secondary place. Yet what a horrible calamity if it were missing altogether! In this respect, the nose shares the lot of the dear departed, who may be slighted and outright denigrated when alive, but once dead are sorely missed and no hyperbole seems good enough to laud them.

It is indeed fortunate that nowadays the occasions for nose deprivation are rare. Chronic diseases such as tuberculosis, leprosy, syphilis, various forms of cancer, and some rarely encountered mycotic or bacterial infections are known causes of destruction of nasal tissues, but today these pathologic lesions are exceedingly rare. Today there are examples of horrendous nasal mutilation following from accidents, criminal attacks, and other calamitous occurrences. Wars and the infinite species of human malevolence have always been major causes of bodily mutilation. Sometimes, despair has induced self-mutilation. It is recounted that the nuns of the monastery of Saint-Cyr in Marseilles, when the Saracens were about to invade their convent, performed collective self-mutilation of the nose, together with their superior, Abbess Eusebia, hoping to avoid being raped by the invaders. They escaped this fate, yet they were all assassinated.[6] But in the past this mutilation was "institutionalized," so to speak. Amputation of the nose was ordered by the courts of justice in many countries as a form of punishment for various crimes, most notably adultery. The paltriest motives could unleash this horrid punitive measure when the accused were slaves.

This barbaric custom, widespread in antiquity, persisted for a long time. In England, libelous writings against the king were punishable by

"rhinotomy," as it is termed in technical medicalese. Daniel Defoe (1666–1731), the author of *Robinson Crusoe*, narrowly escaped this fate after being accused of writing pamphlets against the reigning monarch.[7] In our own time, amputation of the nose has been used against females in patriarchal societies as a heartless measure of barbaric oppression. A chilling example was flaunted on the August 2010 cover of *Time* magazine with the haunting, close-up photograph of a young Afghan woman whose nose and ears had been cut off by her own male relatives in punishment for having escaped from her home.[8] This atrocity caused a worldwide outcry; the woman received reconstructive surgical treatment and was given asylum in the United States. It has been said that the nose is "the part of the body that has most suffered from hatred, jealousy, honor, chastity, and justice." That jealousy could be a cause of nasal amputation is exemplified by a historical anecdote from ancient China, which I will now tell.

The story is found in the *Hain Fei Zi* (Chinese 韓非子), an ancient Chinese text that contains over 300 fables and anecdotes, attributed to the legalist philosopher Han Fei (c. 280–c. 233 BC).[9] China was then in the historical period appropriately named "the Warring States," for the country was divided into a number of kingdoms often engaged in mutual bloody strife. The ruler of the kingdom of Wei wished to ingratiate himself with the sovereign of the kingdom of Chu, a vainglorious and sensuous man, thereby avoiding a possible conflict. To this end, he sent as a gift a beautiful woman destined to increase the number of concubines who, in accordance to the then prevailing custom, adorned the royal premises while symbolizing the power of the reigning monarch. The problem was, the ruler had a wife, Queen Zhen Xiu, a jealous woman, sagacious enough to realize that her husband, inordinately susceptible to feminine charm, was likely to fall for the newly arrived beauty, with foreseeable untoward consequences for the good order of the kingdom and her own authority. With a finesse that Machiavelli might have envied, she befriended the enchantress, and in a moment of amicable intimacy told her: "The king loves you very much, but I have to tell you, he is a man of strange idiosyncrasy, and he happens to dislike your nose." These words had the desired effect. From that moment on, the belle adopted all kinds of mannerisms to cover her nose in the presence of

the king. The latter, puzzled by this behavior, asked his wife: "I noticed that the new beauty often covers her nose. Why is that?" The queen, a consummate intriguer, said she did not know, but said it in a way that led the king to suspect that she knew more than she declared. He therefore pressed her insistently, until his wife, pretending to yield for the sake of conjugal love, said: "Well . . . I have heard her say that . . . that the king stinks!" The king, proud and vain, felt humiliated. In a fit of rage, he cried: "Damn her! Cut off her nose!" The queen had previously made sure that there should be guards within hearing distance, and these had been instructed to obey the king's orders instantly, without hesitation. Thus, a guard unsheathed his dagger, and with a swift motion denosed the poor, innocent beauty, who thereby ceased to be a serious threat to Queen Zhen Xiu's palatial dominance.

Men in the Western part of the world very rarely displayed this sort of elaborate ruse in their assaults on nasal integrity. To men, sword or rapier combat according to agreed-upon rules was an accepted way to resolve conflicts from the sixteenth to the eighteenth century, despite legislation against it. Among certain social groups, like the military, duels continued well into the nineteenth century and even to the beginning of the twentieth. Many a noteworthy nose went down (flew off?) in this manner. That of Tycho Brahe (1546–1601) is a famed example. Tycho was an illustrious Danish astronomer and mathematician, who joined to his outstanding astronomical work considerable forays into medicine, astrology, and alchemy (figure 1.1). A colorful man he certainly was: an excellent scientist, yet he fell into superstitions unworthy of so elevated a mind. Like many other intellectuals of the Renaissance, he dabbled in the art of astrological vaticination. Having by chance formed some horoscopes that turned out to be correct, he gave himself fully to making predictions. He predicted to an admiral that he would be decapitated, and this was realized . . . ten years later. Based on his observations of the stars, he constructed a table of thirty-two days of the year (January 1, 2, 4, 6; February 11, 17, 18; and so on) which he firmly believed to be ominous or deadly to whoever engaged on those dates in some serious activity, such as traveling, getting married, moving from home, and so on.[10] History says that in 1566, at the age of 20, he had a disputation with Manderup Parsbjerg, a fellow mathematician (who was also his cousin) over

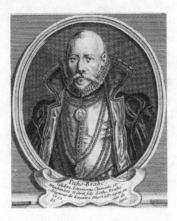

Figure 1.1
Portrait of Tycho Brahe by Jacob de Gheyn (1565–1629). Smithsonian Collection. From the Dibner Library of the History of Science and Technology.

abstruse technical questions of their common field of expertise. They came to dueling, and a sword blow caused Tycho's nose to separate from the rest of his face. Although the combatants were reconciled, Tycho Brahe was left noseless. It is a credit to sixteenth-century reconstructive surgery that a fine metallic prosthesis was constructed that fitted him perfectly and could be attached to the surrounding tissues by means of some glue, a little of which he always carried with him in a small box. Brahe belonged to the highest aristocracy; a rumor said that the prosthesis was made of pure gold, and for the rest of his life he was known as "the man of the golden nose."

He died in Prague, aged 54, of uremia from an unspecified kidney disease. Tourists who visit the temple of Our Lady before Týn ("Týn Church"), in the charming Old Town Square of that venerable city not far from the famous astronomical clock, can see the tombstone and mortuary monument of Tycho Brahe close to the altar. Danish scientists doing historical research obtained permission to exhume his mortal remains in 2010 and collected samples of hair, bone, and clothing for analysis.[11] They were able to rule out definitively the fanciful hypothesis that Tycho Brahe had died of poisoning. A greenish area of discoloration was noted at the site of the nasal bones where the prosthesis attached during life. This indicated that the artificial nose was certainly not made of gold: analysis confirmed it was brass. A little swagger

is unavoidable in the high and mighty, and not a little credulousness its obligatory complement in the admiring lower orders.

NASAL COMEDY

A Nose Lost for Love

Edmond About (1828–1885) was a French novelist and journalist whose work achieved very high popularity in his time. He wrote a satirical story titled *A Notary's Nose*[12] in which nasal amputation is central to the plot, and which I summarize presently.

The main protagonist is Alfred L'Ambert, a young notary. It is common knowledge that in France, as in many other countries of similar juridical system, to be a notary you must be a lawyer, and to head a notary's office is a well-remunerated, enviable post. Accordingly, Monsieur L'Ambert is well off. He is a pretentious, dandyish fellow. He is also profoundly myopic and prone to display his foppish airs in places frequented by men of that kind, such as the Paris Opera Theater. Not that he has a weakness for bel canto; rather, he enjoys watching the ballerinas that perform during the entr'acte. This was actually the only time he watched the world through his gold-rimmed spectacles; the rest of the time he shot his glance above them, while the spectacles rested on the lower part of the nasal bridge—a natural resting place, considering that his nose was vast, powerful, and aquiline. But most of all, he loved to mix with the dancers in what was then called the "foyer of the dance." This was a large, square hall wherein gathered some of the most considerable Parisian men: princes, dukes, legislators, secretary-generals, senators, etc. Perhaps the only important men missing were the papal nuncio and the bishop of Paris. The highest cabinet ministers often came, including "the most thoroughly married of all the ministers." Of course, not just anyone could attend. L'Ambert, by a stroke of luck, was among those admitted.

The illustrious attendees insisted that they did not come to the "foyer" in search of forbidden pleasures: their aim was to promote the noble art of the dance—*honi soit qui mal y pense!* They would converse with the members of the ballet company, eighty young girls mostly of rural extraction; they inquired about their needs and their ideas of artistic expression. These

conversations could not rise to a very high level of sophistication, because the girls were very young, not very well educated, and their questioners utterly ignorant in matters of Terpsichorean art. What went on then? Whispered exchanges in the corners of the hall; offers of economic help; the donation of gifts—artistic "grants," we might say—to outstanding performers. These "grants" could include valuable jewels, the acceptance of which, the donors insisted, "does not oblige to anything."

To the wife of a politician who complained that her husband left her alone too often during the opera performance to attend the "foyer" gatherings, the husband eloquently replied that these reunions were an educational experience for him, given the similarities between ballet and politics: in both you try to please the public; in both you must follow the directions of the conductor; and in both you must learn to quickly change your costume, and nimbly to leap from the right to the left, or from the left to the right, without these sudden displacements seeming in the least awkward.

L'Ambert finds there a graceful nymphet named Victorine who, like most of her congeners, is too naïve and too ignorant to distinguish a simple notary from a multimillionaire potentate. She hears our man's sweet words with undivided attention. He declaims love poems to her, some of which she even seems to understand. Except that she lends an equally attentive ear to the words of a stout Turk, Mr. Ayvas-Bey, first secretary of the Turkish embassy in Paris. The handsome notary figures that, with his respectable emoluments plus an inheritance that he is about to receive from an uncle who just had the good taste to pass away at the most convenient time, he can set up the girl and her mother in a fashionable apartment. He tells his plans to the belle, who does not say no. Therefore, he is off to the province to claim his inheritance.

Meantime, the attendees to the foyer notice that Mademoiselle Victorine is often embraced a little too tightly by the beefy Turk. This one tells her that the surest way to climb to stardom is to accept his proposal of moving, together with her mother, into the fashionable apartment that he is about to acquire for her. She consults with her mother, who agrees that the artistic future of her daughter is best assured under an Ottoman sponsorship. The offer is accepted.

Weeks later, the notary returns from the province, strangely happy for having buried his uncle, and carrying a pricey bejeweled collar that he plans to give to Victorine, for her to wear in celebration of the day she moves into the apartment he will buy for her. Profoundly myopic as he was, he failed to see the sneers in the faces of the foyer habitués when they saw him appear one evening at the exit door of the Opera Theater at the end of a performance. In those days, the performers came out to the street through a series of narrow corridors or "galleries." Crowds formed there composed of dancers, singers, technicians, administrators, chorus girls, and assorted votaries of the thespian art, to which were added the people who came to wait for them. L'Ambert advances through the crowd, and catches sight of Victorine walking arm in arm with a short, squat fellow wearing a "tar-boosh," a red hat of the kind worn by Muslims in Eastern Mediterranean lands.

A tumult develops in the crowd; no one is certain just how. The two men discuss irately. L'Ambert gesticulates dramatically, flailing his arms. Since he does not see very well, he does not calculate the distance correctly, and his right hand collides with Mr. Ayvas-Bey hooked nose, causing it to drip some blood. The receiver of the blow, pale with wrath, swears he will have the offender's nose and demands satisfaction in accordance with the traditional code of honor.

That same evening, L'Ambert is visited by two formal, black-clad, stiff-behaving gentlemen, one a financier, the other a foreign affairs minister: they are Ayvas-Bey's seconds who come to deliver his peremptory demand for satisfaction. A duel to the death must take place. L'Ambert suddenly sees matters in a wholly different light: Victorine, for instance, no longer seems all that important in his life. But his challenger will not accept any excuses. Short of a humiliating show of cowardice, the young notary cannot avoid the confrontation. Therefore, he chooses his own seconds: one a physician, the other a retired member of the judiciary. Both are appropriately conservative and solemn in their outward deportment. They return the visit of the challenger, under instructions to appease the man's wrath. But this one will have no apologies: his tradition, honor, and culture demand an eye for an eye, a tooth for a tooth, and a nose for a nose! With no little trouble, the offender's seconds prevail on him to accept that the combat be "to the first

blood." He agrees, but inwardly he hopes to make it copious enough to be his adversary's last.

L'Ambert keeps a modicum of optimism. After all, he has long cultivated the art of fencing. Once the rapier is in his grasp, he will teach that stodgy Turk to treat with greater respect a member of the race that gave to the world the Three Mousquetaires and D'Artagnan. Alas, the duel code is quite explicit: the right to choose the weapons belongs to the offended party, and the accursed Turk chooses the saber.

The two rivals and the four seconds meet, as is traditional, at dawn, in the countryside, at a clearing in the woods where the police are unlikely to interrupt the fight. No living soul is to be seen. Soon, the sound of the clashing arms interrupts the silence of the scene. L'Ambert does his best to put his fencing lessons into practice, but his enemy shows greater dexterity. At one point, Ayvas-Bey's saber traces a curve swishing in the air, and L'Ambert's nose flies off, cleanly detached from the rest of his face. The combat stops immediately. Confusion reigns. The physician tries to stop the abundant bleeding from the amputation site, while he shouts: "The nose! The nose! Where is his nose?" The medical man has read that a cut-off nose, if properly sewn back immediately taking care to avoid infection, may "take" in the recipient, thereby restituting the victim's original nasal condition. The 1836 learned report by W. Hoffacker, physician of Heidelberg in attendance at dueling matches (an excellent, quick way to acquire abundant experience!) assures that this is so. Whenever an amputated nose fell to the ground during a duel, the officious medico would pick it up, wash it thoroughly and reattach it using sutures or taping. This way he obtained twelve successful replants out of sixteen treated patients.[13] Hence the urgent need to find the notary's nose without delay.

The duelists' seconds scurry around, their heads lowered, looking for the lost nose all over the combat grounds, when lo and behold! A white cat—an animal escaped from a neighboring farm—emerges from the tall grass with L'Ambert's nose in its mouth. They run after the animal, but men are no match for feline nimbleness, much less middle-aged portly men. Imagine the scene: a group of formally dressed serious gentlemen in black suits: here a financier, there a former member of the judiciary, plus an eminent physician,

and a member of the Ministry of Foreign Affairs; all these men, to which some local villagers have now been added, run behind a white cat that bears in its mouth the nose of the notary. They throw stones at the animal when they see it; they rummage through the bushes when they lose sight of it; they throw branches and scream at it. All their efforts are useless. The cat evades the chase, climbs up a tree, and from there looks down amusedly—with a sneer that his Cheshire brother might have envied—at the chasers below, while licking its lips: it has just eaten a notary's nose and found it delicious.

The author of the story, after a number of jocular incidents, takes his protagonist to the consultation cabinet of a world-famous surgeon who squarely lets him know that there are only two known methods to give him back a nose: one is Indian, the other Italian. The Indian surgical technique consists in cutting a piece of skin from his forehead, roughly triangular in shape with its base located superiorly and its vertex placed at the root of what will be the new nose. This piece of skin is detached from the forehead, except at the vertex of the triangle, which is left attached as a pedicle. The detached skin fragment, now hanging by the pedicle, is lowered and twisted so that the epidermis faces to the front. The expert hands of the surgeon will mold this dangling piece of skin into a new nose and will suture it in place. Of course, the wound left by the detached skin of the forehead will leave a scar.

L'Ambert is not very brave: he feels queasy just looking at the stainless steel instruments to be used in this procedure. Furthermore, he is a bigot, and distrusts Indians. A scar on the forehead he deems a serious drawback. How could he appear at the foyer of the Opera Theater disfigured with such a mark? Therefore he refuses this method of nasal reconstruction. Although he distrusts Italians almost as much as Indians, yet he decides for the Italian method when he hears that the degree of pain is lower with this procedure. However, he is informed that this method has a disadvantage. The skin used to shape a new nose must come from an arm of the patient, who is required to keep his arm joined to his nose for the time it takes the transplanted skin to "take" in its new location. This may be as long as one month. Would he be willing to submit to the torture of keeping his arm fixed in the same position for one month? "A month or more!" replies the notary with vehemence. Any

sacrifice he is willing to go through; any discomfort or misery he will gladly endure, provided he can get a new nose.

The end of this farce-comedy requires that we continue to allow great latitude to its verisimilitude and the naturalness of its characters. The surgeon, wishing to spare his wealthy patient much pain and inconvenience, conceives the idea of modifying the Italian method. He suggests using the skin of a donor, not that of the patient, to fashion the new nose. Recall that this story was written in the nineteenth century, when the science of immunology was but a twinkle in the goddess of reconstructive surgery's eyes. The thought that the skin of a stranger would certainly fail to implant when transplanted to another man does not trouble the surgeon's mind. The chief concern was, who would donate the needed skin? Social inequality, worse then than it is now, determined the choice. Among the Parisian dispossessed, there were many whose misery was so extreme that they would willingly give away any part of their bodies in exchange for money. Thus, the designated donor is a ragged, beggarly character called Romagné: uncouth, illiterate, rude, and dirty. He happens to be a "water carrier" who has come to the capital from the province of Auvergne.

In the nineteenth century there was a large influx of migrants from the provinces to Paris; the natives of a given region tended to concentrate in the same neighborhood. Those from Auvergne occupied what is now the 11th arrondissement. Several streets of that neighborhood became a veritable fief held by migrants from that province, the *auvergnats*, who kept the customs, alimentary habits, beliefs, and traditions of their birthplace. They were practically foreigners in their own country; and, like most migrants today, dreamed of accumulating enough money to return to their land of origin as homeowners. There were professional specializations among the various groups of migrants. The *auvergnats* ordinarily were coal vendors or "water carriers," that is, they transported water from public fountains, or directly from the River Seine, to the homes of those who could pay for this service, which was much needed at a time when most houses lacked running water.[14] Needless to say, this work required a great deal of physical strength. A lithograph of the era shows one of these workers transporting two buckets of water, each of which could weigh 20 or 25 kg., aided by a sort of yoke

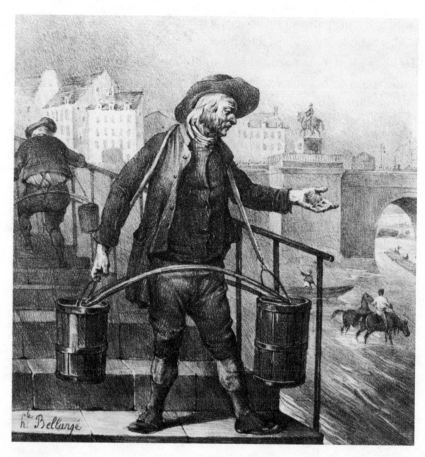

Figure 1.2
Nineteenth-century water carrier from Auvergne in Paris. Engraving by Hippolyte Bellangé (1800–1866). From the Carnavalet Museum of the History of Paris.

thrown over his shoulders (figure 1.2). Thus loaded, he had to make between 35 and 40 trips daily, at a few *sous* (less than a dollar) each.[15]

Given this background, it is no wonder that an impecunious Romagné agrees to donate a big piece of his skin for the high sum the denosed, dandyish notary offers him. Therefore, the skin donor and the patient are duly accoutered to ensure their permanent immobility in tight propinquity to each other, and the famous surgeon performs the transplant operation. This situation is clearly a scheme devised by the writer of the story the better to

criticize the inequities of his society: a miserable, untutored, dirty manual worker, who had not taken a bath for as long as he could remember ("he did not wish to waste water, which was his merchandise"), joined to a pretentious coxcomb. For a whole month the pretentious jackanapes and the foul-smelling water carrier must endure each other's presence, nay, their immediate proximity.

Romagné exasperates the notary. Before long, the outcast fellow learns he must tolerate the humiliations and insults of L'Ambert. The latter frets and fumes over the ridicule poured on him by visitors who see him so firmly bound to that disgusting riffraff. Fashionable, vain women are reluctant to approach him for the same reason. L'Ambert ends up kicking Romagné, and Romagné meekly accepts the kicks out of respect for the illustrious surgeon, whose exquisite workmanship would be ruined if violence took place between the transplant's donor and recipient. But the operation is a complete success. The notary recovers his handsome face, and after this he has no compunction in kicking Romagné out the door amid curses, insults, and revilements.

L'Ambert makes a triumphal return to his old haunts, not excluding the Opera foyer. He is surrounded by an aura of heroism and bravery: he fought like a lion, was gravely wounded, stood at death's door, and is now returned. Women admire him, men envy him. Then, suddenly, in the middle of his apotheosis, misfortune strikes; his new nose begins to swell and to turn red, first gradually, then precipitously and so markedly that it produces a grotesque deformity. It is as if he had grown a violaceous peony smack in the center of his face. Cold compresses, cataplasms, herbal medicines, bleeding from a vein, and even leeches directly applied to the nose: all these are tried to no avail.

The young notary despairs; he is in a dark pit of depression when the illustrious surgeon comes to him with an astounding revelation. His profound researches have led him to conclude that an unknown form of energy, a kind of "sympathy" continues to link Romagné to the skin that was formerly the integument of his arm and is now L'Ambert's nose. The scientist has found out that the water carrier, after squandering the money he was paid for his skin, threw himself into a life of debauchery. He was a drunkard,

ill kept, full of parasites, and the doctor was sure that this was the cause of the notary's new nose's decaying condition. Such was his confidence in his hypothesis that he was preparing a scientific report for the Academy—and he dreamed it would be the foundation of his immortal glory—about the bridge of occult energy that allowed the organism of a skin donor to act at a distance upon tissues no longer materially continuous with his body.

The notary spends a great deal of energy and much of his fortune to reform the water carrier. The doctor's hypothesis proves correct: Romagné begins leading an orderly life, recovers from his ailments, and as the ugly bodily stigmas of his concupiscent days are effaced, L'Ambert's nose regains its lost splendor. The story closes with a series of episodes in which Romagné's organism sways unsteadily between health and disease. L'Ambert, who formerly had nothing but contempt, loathing, and detestation for the *auvergnat*, now looks after him with infinite care and has for him the most delicate, finicky regard, sparing no expense to keep him well. At length, Romagné's condition worsens, his final hour approaches, and L'Ambert's nose, sensible to this development, detaches spontaneously. The notary has no recourse but to settle for a prosthesis. A fine silver nose is fashioned for him, and he passes the rest of his life as an emulator of Tycho Brahe, that is, his equal in nasality, but having not a whit of the Danish astronomer's intellectual vigor.

On Nasal Recovery

To write his farcical piece, Edmond About must have reviewed, however cursorily, some specialized literature concerning the surgical repair of amputated noses, the so-called "rhinoplasty." This is a subject that, after a long period of dormancy, was receiving renewed attention in his time. Tall tales from previous eras were still accepted uncritically by many physicians. Nicolas Andry referred, in his 1743 orthopedic treatise, to the story of a soldier who had his nose cut off, thrown into a dirty kennel and trodden under foot. After this, it was cleaned of the mud and dirt with which it was soiled and successfully sewn back into its former place, where it united again so neatly that one could not suspect it was ever taken off.[16] Such a story is obviously an exaggeration. Surgeons are not known for shyness in extolling their feats. Nonetheless, it is a fact that surgeons devised very ingenious procedures

Figure 1.3
Surgical reconstruction of the nose. On the left, the "Indian" method, lifting a skin flap of the fore-head and bringing it down to the nasal region. On the right, the "Italian" method of Tagliacozzi, in which the skin flap is taken from the arm. Image from the Wellcome Collection.

to correct the terrible deformity caused by amputation of the nose. At the time of Edmond About's writing, the choice of operation was, as mentioned before, between two main procedures, the "Italian" and the "Indian" (figure 1.3).

The so-called "Indian" operation is a testament to the genius of India, as medicine men from the Indian subcontinent developed and implemented an operation over 2,600 years ago which continues to be used, with only some modifications,[17] to our day. An ancient text (ca. 600 BC), the *Sushruta Samhita*, describes in detail the method to reconstruct an amputated nose. Some experts state that although the method consisting in raising a skin flap in the middle of the forehead is usually held to be emblematic of the ancient Indian operation, the most ancient texts describe the making of a skin flap from the cheek; all this is incredibly set forth with such attention to technical details that it remains valid in our time.[18]

The Italian procedure was invented in the sixteenth century by an illustrious Italian surgeon, Gaspare Tagliacozzi (1545–1599), professor of surgery and anatomy at the venerable University of Bologna. He described his technique in a book that made him famous within the realm of European surgery, *De curtorum chirurgia per insitionem*, published in 1597. As mentioned before, it consisted in lifting a skin flap of the patient's arm and suturing it to the nasal region, making sure that both the patient's arm and head remained immobile for the time required for the skin to take root on the nose, which could be at least three weeks. Once the skin had "taken," the flap would be cut off from the arm, molded into the shape of a normal nose, and sutured in place. The molding could be facilitated by nose-shaped accessories made of different materials.

Tagliacozzi's renown was immense. Exalted personages, such as Vincenzo Gonzaga, duke of Mantua, and Ferdinando de' Medici, grand duke of Tuscany, are said to have availed themselves of his services as a surgeon.[19] At his death, the magistrates of Bologna decreed that a statue be raised to honor him and a lofty encomium incised upon his tombstone, declaring him the equal of the great Raffaele Sanzio in his power to reproduce the works of nature. A wooden statue of his likeness may still be seen in one of the niches of Bologna's beautiful Anatomical Theater (Archiginnasio). Curiously, the surgeon is represented holding a nose in one hand, as a way to memorialize his pioneering work on rhinoplasty. (Luckily, he was not a urologist!)

Yet fame, as the sages do well to constantly remind us, is fickle and transitory. Envy spurred his detractors to minimize the value of his contribution. Bigoted theologians accused him of impiety for interfering with the handiwork of the Creator. Excited mobs exhumed his mortal remains from his sepulcher in the church of San Giovanni Battista.[20] Although interest in nasal reconstruction did not die, Tagliacozzi's work was neglected for about one hundred years. It resurfaced in the nineteenth century, about the time when Edmond About was writing "A Notary's Nose." Surgical operations for nasal reconstruction, and in particular the work of Tagliacozzi, gave rise to a wide range of satirical and humoristic writings. Paradoxically, the vicissitudes of the nose—an organ whose destruction or deformity brutally demolishes our identity and ruins our social life—have always been material for jokesters,

lampoonists, caricaturists, and comedy writers. Among the witty writings, a piece by the master essayist Joseph Addison (1672–1719) shines with fine irony and elegant, precise language.

Surgeons had already attempted to take skin from the gluteal area to repair a damaged nose. Indeed, the first efforts to perform free skin grafts can be traced to India.[21] Therefore, Addison begins his satirical essay quoting these lines from *Hudibras* (part 1, canto 1, lines 281–287), a poem of political mockery by Samuel Butler, in which Tagliacozzi's name is Latinized to "Taliacotius":

So learned Taliacotius from
The brawny part of porter's bum
Cut supplemental noses, which
Lasted as long as parent breech;
But when the date of nock[22] was out,
Off dropped the sympathetic snout.

Tagliacozzi never attempted to transfer skin from one individual to another (what today would be called an "allograft"), but this idea was certainly quite vivid in the minds of the public and the members of the medical profession. The Italian surgeon was stopped from doing this by practical considerations, like where to find two people who would consent to be tied together so intimately for so long? How to arrange that the two parties eat, sleep, stand, or perform other necessities while bound to each other? This absurdity was left for later novelists like Edmond About to write about. The formidable barriers with which the immunological system opposes implants of foreign tissues were as yet unsuspected. The very concept of an immunological system still awaited a distinct formulation. Instead, the fanciful doctrine of "sympathies" was pervasive. According to this extravagant notion, if two persons exchanged a piece of flesh, sympathy could establish a correspondence at a distance between the two. For instance, if one of them pricked himself at a designated point, the other would have a sensation on the corresponding part. If one traced a letter on his skin, the other would be able to perceive what letter the other person traced.[23] Such was the presumed, awesome power of sympathy! At a time when the basic biology of graft

rejection was unknown, the notion of a "mystic sympathy" at least offered an explanation of this phenomenon. A graft was rejected because the donor person fared badly or had died.

Addison turns his attention to the disease that used to be, among all chronic ailments, the chief cause of nasal devastation requiring corrective surgery, syphilis. In advanced stages, syphilis destroys the tissues that form the bridge of the nose, resulting in a characteristic sunken appearance, the so-called "saddle nose." Assuredly, the English essayist's mythological account of this pathology is more pleasant than those consigned to medical treatises. He writes:

> Mars, the god of war, having served during the siege of Naples in the shape of a French colonel, received a visit one night from Venus, the goddess of love, who had been always his professed mistress and admirer. . . . She came to him in the disguise of a suttling[24] wench, with a bottle of brandy under her arm. Let that be as it will, he managed matters so well, that she went away big-bellied and was at length brought to bed of a little Cupid. This boy . . . came into the world with a very sickly look and crazy constitution. As soon as he was able to handle his bow, he made discoveries of a most perverse disposition. He dipped all his arrows in a poison that rotted everything they touched; and, what was more particular, aimed all his shafts at the nose, quite contrary to the practice of his elder brothers, who had made the human heart their butt in all countries and ages. To break him of this roguish trick, his parents put him to school to Mercury, who did all he could to hinder him from demolishing the noses of mankind; but in spite of education the boy continued very unlucky; and, though his malice was a little softened by good instructions, he would very frequently let fly an envenomed arrow, and wound his votaries oftener in the nose than in the heart.[25]

The meaning is transparent. The siege of Naples is the military action undertaken by the troops of Charles VIII of France in August 1494, in order to wrest the Kingdom of Naples from King Alfonso II of Aragon. The siege ended in February 1495 with the taking of the city of Naples by the French forces. The triumphant army indulged in abundant celebratory debauchery, after which a terrible syphilis epidemic broke out among the French soldiers, later to spread over the whole of Europe with devastating effects.

Hence syphilis, also called lues or "the great pox," was initially named by Italians "the French disease," and by Frenchmen "the Neapolitan malady." Only a year later (1496), Giorgio Sommariva of Verona introduced mercury as a medicament in the treatment of syphilis.[26] It was given in toxic doses, either topically by rubbing on the skin or internally by mouth or through inhalation of its vaporized form. This produced increased salivation, because mercury injured the salivary glands, which reacted with excessive secretion. This was a clear symptom of toxicity, but at the time it was saluted as beneficent, on the supposition that the disease was being expelled from the body. In reality, mercury had minimal therapeutic efficacy and pronounced, life-threatening toxicity. Yet this was the only available therapeutic agent at the time and its use continued for centuries, even when other, more effective medicines became known. Addison's assertion that the education of Cupid under Mercury did little to reform the recalcitrant boy is well taken: mercury added toxic insult to luetic injury. More patients died from mercury intoxication than from the early lesions of syphilis.

In another part of his essay, Addison says that Doctor Taliacotius's large house became full of "German counts, French marquises, a hundred Spanish cavaliers, besides one solitary English esquire" requiring his services. These were people of various nationalities, all of different skin color. The increased demand for new noses presented some problems. The surgeon resorted to the use of "nose donors," and he had to find appropriate matches for the recipients. To do this, he got together "a great collection of porters," which comprised men of all complexions, "black, fair, brown, dark, pale and ruddy." This way he would avoid the embarrassing blunder of giving, say, to a Spaniard with olive skin, very black eyes, and dark eyebrows a nose of "a white German skin cut out of those parts that are not exposed to the sun." Addison means from the buttocks, since this was a favorite site from which to take free skin grafts.

The English essayist notes that the mighty aristocrats who received skin transplants were, in an important sense, dependent upon the humble donors. According to the concept of "sympathy," the transplant would only be successful as long as the donor was healthy. As Addison puts it, "In this

and several other cases it might be said, that the porters led the gentlemen by the nose."

Note that the nose donors in Butler's *Hudibras*, in Addison's essay, and in Edmond About's *Nose of a Notary* are all "porters." In other words, it was acknowledged, and in a way expected, that the poor, the destitute, the marginalized would be the only people conceivably willing to donate skin for the nose and to submit to the protracted pain and suffering that the transplant operation implied. It is a sad reflection that after the truly astounding technical progress that surgery has achieved, the social situation remains the same. There are in the world, to this day, people ready to sell a kidney, a lung, or one half of a liver to escape from grinding poverty. An Iraqi family considered selling a kidney of their 9-year-old son rather than live on charity.[27] A nose they would sacrifice instantaneously, without hesitation, if ever nasal transplant from live donors became something other than the fantasy of humorists and comedy writers. Organ trafficking continues to target the most vulnerable, impoverished donors, making them victims of harrowing inequity and appalling injustice.[28]

Behind all the humorists' witty, silly, or amusing facetiousness we experience an uneasy, hectic feeling. We sense that there is something disturbing in the transfer of a bodily part from one human being into another. It seems far preferable to pursue the creation of artificial skin and other parts. Organ transplants are profoundly meaningful exchanges which ought to be performed only when the persons concerned are actuated by their highest duties and ideals: love, compassion, altruism, self-abnegation. But to donate organs for money, forced by penury; or under coercion and threat of violence? The outmoded Tagliacozzi procedure, with its forced immobility, may have been created purely as a clever surgical solution to a problem of altered nasal anatomy. But it brought to mind the possibility of using two subjects, donor and recipient joined together; and this was enough for the human fancy to surpass the medical domain. Imaginative writers described the wealthy recipient and the miserable donor tied together: prepotency and weakness, the overbearing and the humble, the insolent and the yielding, all bandaged together in a tight Tagliacozzian tangle. By doing this, a bright light was cast

upon the flagrancy of our unfairness: the brutal, age-old, systematic inflic-
tion of undeserved damage by the privileged upon their defenseless brethren.

Human imagination does not stop here. Addison saw "porters lead-
ing gentlemen by the nose." Starker images could be conjured. Since the
buttocks were favored as a donor site in skin transplants, we can fancy the
Tagliacozzi technique as part of a grotesquerie in which the wealthy receiver
of the skin transplant would be literally tied—by the nose—to the derriere of
an unkempt donor, and forced to remain in that position for a whole month.
He would thus receive, besides the skin, a lot of perceptual inconveniences.
Such is the suggestive power of the nose that from the height of its bridge we
may contemplate the intricacies of personal identity, as did Pirandello; and
from the depths of the nasal cavities, if only we borrow the lens of humorists
and satirical writers, we get a glimpse of human injustice.

2 NASOLOGY: THE LONG AND THE SHORT OF IT

NASAL SEMIOTICS

Bold observers have asserted that to call the eyes "mirrors of the soul" is a prejudice that we would do well to discard, for those who believe the eyes best reflect the state of the soul are woefully mistaken. The worst judgment that we can possibly make of our fellows, they tell us, is one based on the appearance of their eyes, which are excessively mobile organs, too restless and fluctuating to permit a deliberate assessment of a person's character. There is, on the human face, another feature allegedly best apt to serve as a criterion of truth: the nose. Such a surprising claim might seem to shift the error in the opposite direction; for how can an immobile, fixed, and inexpressive organ be an indicator of character? Yet many are of the opinion that the nose is a major criterion of physiognomic truth. Precisely by virtue of its immotile, settled, and fixed state the nose tends to be more in harmony with the average and ordinary character of its bearer.

This much may be said about this part of the face, that it stands naked, like the artists' allegorical figure of truth, before the observer. It "poses" for us, so to speak; it presents itself undisguised and still to our gaze, allowing us all manner of analyses and interpretations. Nor is there ever any hypocrisy or dissembling in a nose, as unfortunately the eyes and the mouth sometimes enact. This is why followers of the now discredited pseudo-science of physiognomy (or to use the original designation, physiognomony) placed so much emphasis on nasal morphology. They honestly believed that a well-trained observer, if properly indoctrinated in physiognomic theory, could accurately

diagnose a person's character instantaneously, upon simple inspection of the nose. It was enough for a person to come into the room, or pass in front of the trained observer, for the latter to pontificate: "There goes a musical genius," or "that man is a pusillanimous individual doomed to mediocrity," or "that woman is astute, scheming, and deceitful: she will rise very high through trickery." Presumably, experts could disclose by simple nasal inspection the profession, the tastes, the vices and virtues of the individual, and so many other revelations of character and temperament as to reduce the whole of neuropsychiatry and investigative psychology to a single new science: nasology.

A foundational work of this discipline is yet to be done. However, in 1848, a British writer (allegedly George Jabet, writing under the pseudonym of Eden Warwick) elaborated a classification of such noses as had cut a relevant figure in the history of the world and hence deserved being memorialized in a treatise.[1] If you can stand a couple hundred pages of Victorian torpid-flowing satire and stock ideas on an outmoded subject matter—the whole enveloped in stilted prose—then *Nasology* by Warwick-Jabet is a book for you. In essence, this treatise affirms that there are six major physical types of noses, long-established and generally acknowledged. Actually, this is at variance with previous classification schemes. Giambattista della Porta (1535–1615) had discerned eighteen nose types, and he was following predecessors such as Pseudo-Aristotle, Polemon of Laodicea (c. 90–144 AD), and Adamantius (fourth century AD) who were equally splendid in their respective nasal typologies. Warwick makes no claim to originality; the treatise is only an attempt to compile the categories accepted in his day, to organize the nomenclature, and to correlate the personality attributes that the treatise writer believes to be the appanage of each type. The six classes of nose are schematized as follows (figure 2.1).

Class I or "aquiline" is also known as Roman. Class II, the straight kind, is of course Greek. Class III, designated as "African," goes by at least two other names: "wide nostrilled" and "cogitative." Since the main feature of this nose is a *gradual* widening from below the bridge, it is the only class that is identified by looking at it from the front, all the others being recognized in profile. Class IV, the "hawk" nose, is unfortunately tainted by having

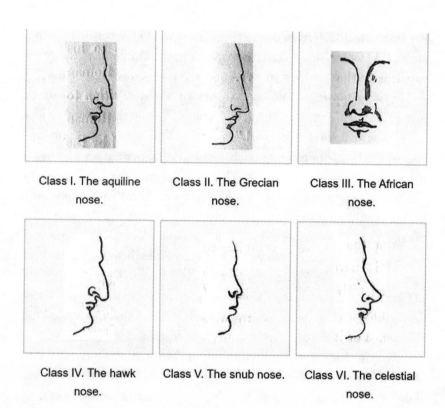

Class I. The aquiline nose.

Class II. The Grecian nose.

Class III. The African nose.

Class IV. The hawk nose.

Class V. The snub nose.

Class VI. The celestial nose.

Figure 2.1

The six classes of physical nose, according to the pseudonymous author Eden Warwick in his book *Nasology: or, Hints towards a Classification of Noses* (1848).

long thrived under the racist moniker of "Jewish nose" (more on this later). Class V, the "snub" nose, needs no description: the name says it all. Class VI, characterized by being slightly concave root-to-tip, may have suggested an aspiration to soar, hence the name of "celestial."

The chief problem for nasologists is to make the public accept that constant character features associate to each of the nasal types. For instance, class I or "aquiline" allegedly denotes a perseverant, unflinching, stern determination. This was said to be the common disposition of the people who built the mighty Roman Empire, among whom this nose type was so frequent that it became "Roman." At the same time, theirs was a rough and unpolished character which disbarred them from fashioning a civilization that could rival the Greek

in refinement. The Romans copied Greek learning and Greek workmanship, but these were copies and stayed as copies; presumably, the copiers' natural coarseness did not permit them to advance one step beyond the originals.

Physiognomists maintained that the psychology of nations might be better understood through the conscientious study of the most prevalent nasal shape among the natives of each country. One argument used in support of this contention is that celebrated historical personages who had a particular nose type displayed the character features which, according to theory, had to accompany that nose. For instance, a Roman nose supposedly predicts marked dynamism, perseverance, and firmness of purpose even to the point of pitiless unconcern for victims. Now a long list of conquerors and warriors is brought before us, from Queen Elizabeth I, Charles V of Spain, Julius Caesar, George Washington, and Hernán Cortés to the Earl of Chatham and the Duke of Wellington—all of whom had "pure, or very nearly pure, Roman noses," and all of whom, it is claimed, possessed the corresponding character traits in the highest degree.

Once the basic tenet has been laid down, physiognomists rise to unapproachable summits of irrefutability. You cannot argue with them; they are always right. The example just described—the alleged character-revealing value of an aquiline nose—may be used to demonstrate how they manage to confute any challenge to the veracity of their premises. Imagine the following dialogue between a questioner (Q) and a physiognomist (P):

Q: Sir, I know someone who has a typical Roman nose. Can you tell me why it is that, instead of being dynamic and determined in his actions, he always engages in a lot of forethought, is easily deterred from his objective, and gets cold feet at the least intimation of danger?

P: You should know that nose types are not always pure, but may exist in various admixtures. Your acquaintance may have a somewhat convex, coarse nose, which is therefore aquiline or class I when seen in profile. But if you saw it in front you might discover that the nose has some features of class III, which gives its owner "strong powers of thought" and a proclivity for meditation.

Q: I see. But how do you explain the craven behavior of this fellow? I tell you, I have witnessed it firsthand. However, in your teaching you insist that such behavior is not a feature of the "cogitative" or class III nose.

P: Well, perhaps you should take a look at the tip of that nose. You might discover a touch of the "celestial" or class VI in it, which, like the "snub" or class V nose, bestows negative qualities on its owner, such as weakness, timorousness, and a disagreeable disposition. Therefore, that nose of your acquaintance would be primarily Roman, secondarily African, with a finishing touch of the celestial at the tip. Complex admixtures are frequent. You can see why physiognomony is a difficult art-*cum*-science.

Q: Excuse me for insisting, but I am not convinced. The man I have been telling you about is cowardly, petty, and has many other un-Roman character flaws. Believe me, I have seen plenty of evidence of that, yet his nose is pure, unalloyed Roman from any angle that it is examined. All the experts who have looked at it concur: it corresponds to the "classical" Roman type: the picture postcard, so to speak, of Class I noses. How do you explain that?

The physiognomist-consultant will appear momentarily pensive, and then exclaim:

P: Behold the power of nurture! Human industry and ingenuity are so potent that they can change the course of nature. Education and the environment may successfully countervail the inborn proclivities of a person. By unvarying pressure, by constant rewards and punishments, a bold child is made to grow into a timid man, and vice versa, the self-effacing will be changed into the insolent and rash. The nose-based diagnosis is correct. You can be sure about that: there is no mistake. Only adventitious influences changed the outward manifestations.

In other words, an expert physiognomist is always right. Like the pope in matters of Catholic dogma, the physiognomist is infallible in matters of noses. Who can argue with absolute inerrancy?

THE NOSE, SEMIOTICS, AND SEMITISM

Clearly, the Class IV nose, absurdly and maliciously called "Jewish," is the nose type that has elicited the heftiest commentary. Graphic representations, scholarly studies, anthropological texts, medical and journalistic articles: the literature about it is so massive that no single person can review it in its

totality. But the most curious fact attending this deluge of texts is that they all revolve around a myth. For the so-called Jewish nose is a myth in the two most common acceptations of this word. In everyday language we use this word to signify that something is an illusion, a fable, something without objective reality. To put it bluntly (and allowing some rhetorical insolence for the sake of emphasis), a myth is a lie. Secondly, the term "myth" is applied to the idealized and exalted image of a person or an event. In both cases we see that the mythical discourse maintains an equivocal relationship with truth and reality. The "Jewish nose" is a myth in the first sense because it does not exist. Assuredly, many Jewish persons have a hooked nose, but so do many non-Jewish persons. Strange as it seems, this matter has been studied by competent, concerned scientists. The 1906 edition of the *Jewish Encyclopedia* tabulates the findings of various investigations done in Jewish communities of different countries, showing that hooked noses were actually a minority among the Jews.[2] In Poland, in the region of Galicia, only 6.5 percent of noses were of hooked morphology; most were straight, i.e., Class II or "Greek" type. In southern Russia, the "Greek" type reached a striking 80 percent. In Lithuania, only 9.7 percent of the people in the Jewish community studied were found endowed with a hooked (also called "Semitic") nose. There is reason to believe that there, as in Armenia and in some countries of the Mediterranean basin, the frequency of "Semitic" nose may be higher among the non-Jewish than in the Jewish ethnic groups. If so, why not speak of, say, a "Lithuanian nose" or an "Armenian nose"? Based on frequency of occurrence, designations other than "Jewish nose" would have been more appropriate.

Clearly, the label did not originate from a dispassionate and impartial observation of anthropological data. It was a biased and prejudiced social construction beginning-to-end, designed to stereotype and to stigmatize a human group. That it was a man-made formulation is also apparent from the fact that it can be dated. From the study of religious iconography, a scholar concludes that before the year 1000 AD, there were no specific facial features attributed to Jews.[3] The "Jewish nose" was invented in the late thirteenth century. Even as late as the sixteenth century, the iconographic representation of Jewishness was not uniform, and not necessarily satirical. Don

Harrán (1936–2016), scholar, musicologist, and writer, noted that Raphael's depiction of Noah, Abraham, Isaac, Joshua, Moses, and numerous other biblical personages in the halls of the Vatican shows not the slightest trace of a hooked nose.[4] In contrast, paintings of Jews contemporaneous with the Renaissance artists are sometimes marked by the features that passed as conventional Jewish physiognomy, and are usually devoid of the veneration shown to their forebears, the biblical patriarchs. The historical time of appearance of an anti-Semitic attitude in religious iconography is still an open question. It is a matter of interest to scholars in various disciplines, and one deserving further investigation.

Further characterization of the stereotypical Jewish nose is described in the aforementioned article of the *Jewish Encyclopedia*. This nose may be rendered by "drawing a figure of six with a long tail." Attention should be paid to the nostrils, which are considered crucial in achieving a proper "Jewish expression." Delete, by way of "experiment," the turn or twist in the line at the base of the figure of six, and "the Jewishness disappears" (figure 2.2). Hence, the authors conclude that the nostrils, more than the nose, concur to form the final expression. "Nostrility," it turns out, is of the essence for Jewishness.

Every conceivable measurement has been applied. The nineteenth-century anthropologist Maurice Fishberg is said to have measured 4,000 Jewish noses in New York ("with calipers!" admiringly exclaims Sharrona Pearl,[5] a brilliant commentator on this work), and found nothing distinctive

Figure 2.2

Left, the "Jewish nose" drawn like an elongated figure of six. *Middle*, the twist representing the nostrils has been removed, and the tip points downward. *Right*, the lower part of the line has been made horizontal, and all traces of "Jewishness" vanish. From the entry "Nose" by J. Jacobs and M. Fishberg in the 1906 edition of the *Jewish Encyclopedia* (New York: Funk & Wagnalls).

of a so-called "Semitic" nasal appendage. The *Jewish Encyclopedia* also gives data of the relation between length and breadth of Jewish noses: the width was less than 75 percent of its height, as commonly seen in most European populations. One wonders today what to do with this piece of information, but it seems that at one time scientists deemed it important.

During the deplorable, tragic rise of German Nazism, rabid anti-Semitic propaganda included the publication of a book for children, titled *Der Giftpilz* (*The Toadstool*, that is, a poisonous mushroom). The book was used in elementary schools in Germany. It contains a story about a mother and her little boy. While walking in the forest, they come across some mushrooms, and the mother tells the child that some are edible and others poisonous, but it is very difficult to tell the two apart. She further points out, for the edification of the little boy, that it is the same with human beings: some are good, some are evil, and it is hard to distinguish between the two. "Do you know about these two kinds of people?" she asks him. "Yes, indeed!" answers the perky boy: the teacher has explained to his class that the Jews are dangerous people, evil beings whose dealings are poisonous to society, and may even be fatal. "And do you know how to distinguish between 'true Germans' and Jews?" The zesty, bright young lad answers that he knows that, too. He has been taught in class that the nose of the Jews is like a figure of six; "which is why we call them sixes," he says. "Now, many Germans have a convex or aquiline nose, but it is one which is not bent downward. The German nose has nothing to do with the Jewish nose, which is pointing downward." The mother must have felt proud of her smart little boy, who already was so well versed in German-made "nasology." It is true that he said nothing about the characteristic "nostrility." I suppose this may have been a subject reserved for higher school levels.

The other way in which the "Jewish" nose is a myth requires us to look a little more closely at the nature of the mythical, a theme that has given rise to an overabundance of philosophical discourse. Without going at great length into the labyrinth of ideas on this matter, it will not be denied that myths serve important social functions. Sometimes they are intended as a mode of knowledge parallel to other forms of knowledge, such as science, philosophy, or theology. In this case, myths attempt to answer absolute quandaries, like

the origin of the universe, or the destiny of the individual, or what it means to be born, to grow, to struggle, to suffer, and to die. Often the function of myths is paradigmatic: they remit us to a system of values that must be accepted and interiorized by all the members of the group. Myths do this by setting forth exemplary personages as models; for instance, Lucretia as a model of unwavering conjugal fidelity; Antigone as the paradigm of a strong, independent conscience and uncommon courage; or Æneas as the embodiment of filial devotion. Still other times, myths subserve an ideological function. Their role then is to propagate certain beliefs, or to acculturate a human group, or to diffuse and circulate the kind of discourse that will increase the internal cohesion of the social group. This multiplicity of functions of myths enabled Roland Barthes to analyze the trivial icons of a consumerist society (wine, toys, plastic products, publicity photographs, etc.) as elements of some species of mythology.[6]

It is in the latter sense that the Jewish nose is *also* a myth. Such a nose is, of course, fictitious. As stated before, plenty of scientific evidence proves that a hooked, downward-pointing nasal contour is not distinctive of Jews. But myths, in the sense we are now considering, are not things that we can subject to argument or to experimental verification. Scholars agree that what matters in myths is not what they say, but *why* they say it. And it so happens that many Jews, although fully aware that the Jewish nose is a myth (in the sense of a lie), heartily embrace it. It makes them proud to be able to claim a particular identity. In the words of Sharrona Pearl:

> There is something deeply comforting about being able to identify someone as Jewish through this quick and highly visible shorthand. The embrace of the Jewish nose is, for many, a way to reclaim a feature that has been caricatured, pilloried, and manipulated in images from the 12th century through Shakespeare's Shylock, Dickens' Fagin, Nazi propaganda, and beyond. Claiming the Jewish nose is a way to reject the use of this feature for oppression, anti-Semitism, and even in the justification of genocide.[7]

We see here the ideological, sociocultural cohesive function of myths superbly exemplified. However, myths are not innocuous fibs; they impact our lives, and the myth of the Jewish nose has had consequences that run

from the risible to the tragic. This became obvious at a time and a place in which nasal shape was made a feature of supreme importance to every individual. I mean in the Third Reich at the peak of its power, when having a class IV nose was tantamount to a death sentence. Two literary narratives make this point with singular strength.

The first story is owed to Jiří Weil (1900–1959), a remarkable Jewish-Czech novelist who managed to survive under the Nazi occupation of Prague. He was summoned for deportation to Theresienstadt, but he faked his own suicide by plunging into the River Vltava, then hiding in a number of places. He lived precariously in concealment amid very harsh circumstances for the duration of the war. The anecdote narrated next is recounted in his book titled *Mendelssohn Is on the Roof*.

General Reinhard Heydrich (1904–1942), the Reich's top security officer, was in charge not only of the military command of the city of Prague, but of the policing of the whole area of Bohemia and Moravia, of which he was appointed *Reichsprotektor*. Heydrich was Himmler's protégé and leader of the SS (*Schutzstaffel*), the major paramilitary organization of the Nazi regime, which included the infamous Gestapo. This man was one of the main architects of the plan for mass extermination of European Jews. A dark figure, indeed; Hitler himself was said to be in awe of the general's inflexible ruthlessness, and called him the "man with the iron heart." Physically, he was a big man of typical Nordic physiognomy (interestingly, some historians continue to believe that he was of Jewish ancestry); his SS subordinates sometimes called him "the blond beast." Had he survived to the end of the war, undoubtedly he would have been indicted for crimes against humanity; but two Czech resistance fighters assassinated him on May 27, 1942. With all that, he was also known as a classical music enthusiast.

One day, the formidable Reinhard Heydrich, executioner and music lover—both by natural inclination—notes that on the rooftop of the famous Carolinum concert hall of Prague there are several ornamental statues representing famous musicians of history. Among these he identifies Felix Mendelssohn's effigy. A Jewish musician thus glorified! To Heydrich this is an intolerable affront. He calls a subordinate, a little cowardly man named Julius Schlesinger, and gives him the order to remove the statue of

Mendelssohn. Schlesinger is a municipal officer who aspires to join the SS, "not even the Élite Guard" (answerable only to Hitler), but just the "ordinary" ranks of the SS, writes Weil.

One does not tarry when executing the orders of the fearsome general. The problem is, Schlesinger is afraid of heights: he does not dare to climb to the rooftop of the concert hall. Therefore, he instructs a group of workers to do the job. The chief worker wants to know which of the statues represents Mendelssohn; from below it is difficult to appreciate the details of the different sculptured likenesses. Schlesinger, whose knowledge of the history of music is rather limited, is himself unsure about which is the statue that must be removed, but he has no intention of accompanying the workers in their difficult climb. He has a ready answer that makes perfect sense in the mouth of an eager aspirant to membership in the "ordinary" SS: "Walk around the statues and look very carefully at their noses. Whichever has the biggest nose, that's the Jew."

The workers are about to pull down the "guilty" statue when Schlesinger realizes that the effigy's head is covered by a big beret. "Sweating with terror," he shouts: "Jesus Christ! Stop! Stop! I'm telling you, stop!"

The reason for his sudden fright? This was the statue of Richard Wagner! Not just *any* musician, but the quintessential Germanic musical genius; Wagner, the man whose stirring strains enrapture the hearts of all patriotic Germans, from the great military leaders to the humblest housewife in the land; he whose incomparable talent is said to have contributed to the creation of the Third Reich. Schlesinger could tell it was Wagner, because portraits and plaster casts of him are seen in every household. His name came up even in the courses that are given to the public on "racial science." Had one of the lecturers in those courses witnessed the gaffe made by the workers in trying to remove the wrong statue, he might have begun to question the reliability of nasal shape as an index of ethnicity. But his doubt would have been transient, because those lectures drew their material from the literature on nasology, and this, as we have seen, is absolutely infallible.

The second story is of a very different, somber tone. It was written by Heinrich Böll (1917–1985) the German writer who became a major postwar literary figure. Not a Jew, he was born and brought up in a Catholic family.

Although a pacifist and an opponent of Nazism (he refused to join the Hitler Youth in the 1930s), as a German citizen he was called into compulsory service, joined the Wehrmacht, and served for six years, during which he fought on the Russian front and elsewhere. His war experiences included being wounded and becoming a deserter. Somewhere in his work he describes his dismay at "the frightful fate of being a soldier and having to wish that the war might be lost." This wish was fulfilled: Germany did lose the war; Böll was captured by the American army on April 1945 and sent to a prisoner-of-war camp, where he was kept for several months. After the war, he went back to his native Cologne, obtained a job that allowed him to devote all his life energies to writing, and produced an impressive collection of novels, short stories, translations, and other texts. In 1972, he was awarded the Nobel Prize in literature. Assuredly his experience as a soldier helped him to couch many of his narratives in the powerful idiom of wartime. This is the case in the story summarized next, which he said he heard from an eyewitness when he was a prisoner of war.

A German soldier, Lieutenant Hegenmüller, returns to his quarters in a civilian dwelling. He is tired, anxious, and wary of the war. To compound his nervous strain, he hears intermittent bursts of machine gun fire coming from a quarry at the edge of the city all day. About every hour, alternating with the machine guns' rhythmic rattling, he perceives something like a rumbling of distant thunder. This noise comes from explosions in the quarry, where executions are taking place. Dynamite has replaced the work of grave diggers. The executed are so numerous that out of concern for hygiene the military thought of making the quarry wall collapse with explosives over the victims, who are thus buried with the desired efficiency.

Lieutenant Hegenmüller finds Marja, his Russian landlady, sobbing uncontrollably: her non-Jewish husband, Piotr Stepanovich, has been taken away by soldiers. Why? Because he "looks Jewish." The couple is Russian; neither of the two is Jewish. But anti-Semitism has reached such a paroxysm that anyone whose physiognomy seems in the least suggestive of Jewish ethnicity (in the Nazi pseudo-scientific concept) is automatically arrested. Piotr Stepanovich is therefore in imminent danger of being executed—murdered would be a more apposite word—by a firing squad on the edge of the quarry.

"Is he Jewish?" asks Hegenmüller. Weeping and sobbing, the wife shouts dolefully to the lieutenant: "No, no Sir, no Jew, no Jew!"

Lieutenant Hegenmüller hurries desperately through deserted streets. There is a strange tension in the air, floating above the eerily quiet city. He imagines that a host of devils hover over the walkways, sneering, grinning and laughing in the silence that envelops the place. After much running, gasping, drenched in sweat, covered with dust, he reaches the site where the condemned to death are driven like animals to the slaughterhouse. He was surprised how clear the faces of the guards appeared to him: "dull and bestial, while those of the guarded stood out of the mass and, in a precious way, reached the height of humanity." He became painfully aware that at that moment he was wearing the same uniform as the murderers. His face red with shame and exceedingly tired, he still has the energy to tell a guard that approaches him: "My landlord is here. He is no Jew." The guard says nothing. Hegenmüller adds: "His name is Grimshenko, Piotr . . ."

An officer comes to them and is informed of the situation. Hegenmüller notes, from the reddening of the soldiers' eyes, from the smell of their breath, that almost all are drunk: clearly, alcoholic inebriation or some other mind-perturbing intoxication helps them to go through the atrocious, bestial cruelty that they are ordered to accomplish. The officer walks to the front of the line of victims and calls out loudly: "Grimshenko, Piotr, come forward!" No one moves. How could anyone come out? The name of Hegenmüller's landlord is not Grimshenko. The lieutenant, tired, dismayed, obfuscated, and on the brink of a mental breakdown has said a name that sounded Russian to him: Grimshenko.

"You can go home!" shouts the officer. Again, no one comes forward. The officer says to Hegenmüller: "He's not here. Perhaps he is already dead, or maybe he's still over there," and he points toward a ridge, next to a precipice, the part of the quarry in which the executions are taking place.

The scenery through which the writer guides his readers is one of profound emotional impact. In the long line of the condemned there are men and women, rich and poor, ragged and elegant. There are some women carrying children in their arms, "How can they bring themselves to kill the infants, some that can barely walk; how is this possible?" thinks the

bewildered and ever more disturbed lieutenant. But he keeps his eyes on the group of victims standing in line until he reaches the highest level, close to the edge of the quarry. Here there are soldiers posted with machine guns at regular intervals; here is where the repetitive, crackling sound of machine gun fire originated: the sound that has pierced through his soul all day long. Here, too, is where he sees the "bloodied black boot" of a drunken soldier kick an infant into the abyss.

Hegenmüller spots Grimshenko / Stepanovich precisely at the time when the man receives a shot from the executioners and is about to go down the seemingly bottomless chasm. Hegenmüller screams "Halt! Halt!" so loudly that the executioners are startled and interrupt the shooting. Hegenmüller lifts the severely wounded Russian by the armpits, and "in front of the line of murderers with their smoking guns and frozen eyes that stare at the next group of victims," he manages to carry the agonized, bleeding victim on his back. They let him pass. He felt a power within him, that with a single glance he could dominate these "human butchers in their brand-new uniforms and with their medals covered with dust." He barely has the strength to ask for a vehicle in which the two are transported to a hospital. At last, overcome by exhaustion, he collapses.

When he recovers his senses, he finds himself lying on a hospital bed. There is a physician by the bedside, and a nurse sitting next to a table with a writing machine on which she types what the physician dictates. He is impressed by the kind, tender solicitude the doctor employs in ministering to his care, as when he takes his pulse and his body temperature. Seeing that he has regained consciousness, the first words that the doctor addresses him, in a comforting, friendly tone are: "It was too much for you, eh?" After all, the patient is a German patriot, a soldier who has been fighting in defense of the fatherland. Would he be so protective and caring toward non-Aryan, non-Germans?

Hegenmüller wants to know what happened to the man he transported. He mumbles: "And Grimshenko?" The doctor says, with an emotionless voice: "So that was his name? Nurse, you can complete the clinical chart now. And under Cause of Death just write—'Hooked Nose.'" These words are

said with laughter "while the hand to which that voice belonged continued its almost loving ministrations."

The pathos of the scene is greatly enhanced by the juxtaposition of the callous mocking in the doctor's remark alluding to the death of the Russian, and his careful, "almost loving" solicitude in caring for the German lieutenant. Hegenmüller hears the words "cause of death, hooked nose" together with the laughter they provoke; he stares idiotically, with eyes wide open at the white, disinfected four walls that surround him, and bursts out in a loud guffaw of irrational, uncontrollable laughter: the laughter of madness. We are told that since then, the only two words that he would utter for the rest of his days were precisely those: "Cause of death: Hooked nose" (*Todesursache: Hakennase*). Heinrich Böll chose these two words as the title of this story.

THE NOSE IN THE TURBID HISTORY OF ANTHROPOLOGY AND AESTHETICS

The nose was a major element in the anthropological typology that classified human populations into physically distinct racial groups. The preceding stories go a long way in revealing the untrustworthiness of such typology. How many innocent people suffered for no other fault than having been born with a particular nose type? Nevertheless, between 1933 and 1944 Germany produced a great mass of pseudo-scientific, distinctly racist works whose major underpinning is the idea that the various human groups are organized in a hierarchical scale. Although in Germany these ideas were carried to a fanatical extreme, with the nefarious consequences that we all know, it must be said in fairness that this hateful phenomenon did not occur in a vacuum. "Biological racism," as it is now called, has deep roots and counts among its champions illustrious names from diverse disciplines and from many nations. In one way or another, in explicit or veiled form, they prepared the seed that bore such dreadful fruits in the land of Germany. A tiny fraction of the great many precursors includes: the aristocratic author Arthur de Gobineau (1816–1882), the naturalist Georges Cuvier (1769–1832), the illustrious scientist Ernst Haeckel (1834–1919), the Dutch scholar and

"craniometrist" Pieter Camper (1722–1789), the American anthropologist Samuel George Morton (1799–1851), and even (though not without controversy) Charles Darwin, of whom it is said that he was a fervent slavery abolitionist but still believed, like many men of his time, that the races could be ranked in a hierarchy, of which whites occupied the highest rung and blacks the lowest. This is but a minute sample of the innumerable thinkers whose work has been used to support racial discrimination and some of its enormously damaging consequences, such as slavery.

Fanatical anti-Semitic racism not only branded the mythical Jewish nose with the absurd imputation of biological "degeneracy," but went on to declare it aesthetically inferior. Allegedly, it violated the hallowed canons of beauty originally developed in classical Greco-Roman antiquity, which established that the nose measures one-third the height of the face. Because the misnamed "Jewish" nose conspicuously exceeded this measurement, and blatantly diverged from the canonic straight angulation and rectilinear course, a spokesman of anti-Semitism pompously declared that "it is not, has not been, and can never be, perfectly beautiful."

The least that can be said about such inane pronouncements is that they are as overbearing as they are valueless. For what can possibly be more otiose than to lay down principles and dogmas about beauty, and more specifically feminine beauty? Blaise Pascal (1623–1662) is the author of an intriguing thought about the nose of Cleopatra: "if it had been shorter, the whole face of the earth would have changed."[8] From the lines that precede that statement, we know that Pascal wanted to bring out the hollowness and vanity of men, whose life course often depends on trifles. On the other hand, it could be that, influenced by the physiognomical ideas of his time, he attributed strength of character and a dominant spirit to the owner of a prominent, aquiline nose. Had Cleopatra's nose been smaller, she might not have been capable of imposing her will on the powerful men she conquered, and history would have changed.

The fact remains that with a large, aquiline nose and a prominent forehead Cleopatra managed to charm Julius Cesar, who made her Queen of Egypt in 48 BC. And seven years after Cesar's death, she cast the same spell upon Mark Antony, for she was "the last and crowning evil" that befell him.

Figure 2.3
Bronze coin purported to be one of the best surviving portraits of Cleopatra. From the University of Glasgow Hunterian Museum. Image taken from the BBC History of the World program. See: http://www.bbc.co.uk/ahistoryoftheworld/objects/1J_GFWtaSsaTgdslRNGBeA.

Roman historians, like Cassius Dio, rhapsodize over her "surpassing beauty." Plutarch, however, says in his *Life of Antony* that as a beauty she was certainly nothing exceptional; those who saw her were not overly impressed. Rather, her appeal resided in her charm, the persuasiveness of her discourse, and something in her behavior that others found stimulating. To this was added the sweetness in the tones of her voice; her tongue, it was said, was "like an instrument of many strings" which she could play in several languages. Plutarch's description of Cleopatra has been considered one of the most critical and objective accounts of her physical features in ancient sources,[9] and some numismatic evidence supports it. Coins minted during her lifetime show a feminine profile that is not exceptionally beautiful, and a nose that stands out more for its intrusive robustness than its finesse (figure 2.3).

The more we look at Cleopatra's likeness in the coins, the more it seems likely that her charm resulted from immaterial, nonphysical gifts and intangible talents. But tastes vary with the time and the place: what the ancient Romans admired in the vast repertory of female physical allurements must have been quite different from the doll-like models extolled as paragons of beauty in our contemporary societies. Received ideas also mold the prevailing tastes. Solid character and steadfast resolution were thought to be

signified by a big, aquiline nose. This probably made people see beauty in nasal prominence. Bigness itself, within certain limits (which could be generous), may have qualified as an attribute of comeliness. Madame Deshoulières (née Antoinette du Ligier de la Garde, 1638–1694), praised by Voltaire as the best of women poets, and the only woman to have been awarded the prize for poetry by the French Academy, wrote a poem in which she describes in flattering terms the physique of one of her contemporaries. She catches his generous nasal endowment in two lines: "Over all the other noses his nose has the advantage, / And never a big nose adorned better a visage" (*Sur tous les autres nez son nez a l'avantage / Et jamais un grand nez n'orna mieux un visage*).[10] A big nose, by virtue of its protuberance, "advances" in the etymological sense of putting forward; hence it enjoys the "advantage" in competition or rivalry, since it is placed beyond all others. In the seventeenth century, Madame Deshoulières could speak of a big nose "adorning"—not spoiling—the face.

Bodily features which may seem ugly in isolation may charm when combined with others in their natural setting. Gaius Valerius Catullus (84–54 BC) pondered this ancient puzzle in his poem about a big-nosed girl. He wrote "I greet you, girl, who have neither a little nose, nor a pretty foot, nor black eyes, nor fine fingers, nor firm lips, nor is your speech elegant [. . .]. And it is you who are beautiful, as the provincials tell us? [. . .] Oh, this ignorant and tasteless age!"[11]

"Different strokes for different folks," says the American vernacular. The relativity of attractiveness could not have failed to attract the attention of the ever-curious, speculative philosophers of ancient Greece. But those men were not always serious; they had their moments of relaxation and enjoyment during which the solemn nature of the discussion could adopt a bantering tone. One of these occasions was a banquet in which the relative nature of beauty was briefly touched upon in a jesting manner. The banquet was given by Callias, a dilettante and "patron of the arts" in the year 380 BC. Xenophon, faithful disciple of Socrates and former adventurer now in exile, narrates the event in his work *Symposium*—certainly not as lofty and poetical as Plato's work of the same name, but more realistic and thoroughly enjoyable.

The banqueters start with playful, informal remarks to each other, interrupted by the performances of a jester, acrobats, and flute girls brought in to provide entertainment. Then follow the more systematic presentations of the guests. Each one makes a short speech about a thing that makes him proud, and which can be of service to the common weal. For instance, Callias says he takes especial pride in teaching men how to build their characters and thereby making them righteous. Antisthenes, founder of the Cynic school of philosophy, says his pride is his poverty, and goes on to discourse on the serene happiness that results from being content with what one has. The turn comes to Critobulus (son of Crito, Socrates' faithful friend), and he makes the striking declaration that his pride comes from being handsome, and further affirms that it is right to be proud of this fact. For the strong must get the things they desire by toil, the brave by adventure, and the wise by eloquence; but the handsome often get what they want without doing anything. And whereas Callias was proud of his ability to make people more righteous, the handsome can inspire amorous sentiment in others, and through love the cowardly become brave; the niggardly, generous; and the lazy, strenuous and diligent. Therefore, the accusation that being handsome does not benefit the rest of the community is groundless. And those who claim that beauty is transitory are equally mistaken; for just as it is possible to see beauty in a child, in a young man or woman, and in a mature individual, so it is possible to see beauty in the old. "Witness the fact that in selecting garland-bearers for Athena, they choose beautiful old men, thus intimating that beauty attends every period of life,"[12] says Critobulus. Moreover, the handsome get what they want without eliciting the ill will of the givers, since these are happy to give to the person who inspires them with amorous feelings.

Perhaps this kind of rodomontade of a good-looking man proved too much for Socrates. For the eximious philosopher asks Critobulus: "So you think that you are more handsome than I am?" Now, it must be recalled that Socrates' ugliness was proverbial: his hair usually unkempt; his eyes slightly protruding from the orbits; a snub nose with the nares open toward the front; and a paunchy frame supported by thin legs: these characteristics were said to liken him to Silenus, the habitually drunk, fat, satyr-like companion of the wine god Dionysus. Predictably, Critobulus is prompt to answer: "Yes, of

course." Socrates then replies by challenging the handsome man to a beauty competition. They would both appear before an impartial jury made of convivials at the banquet, who would judge which of the two, Critobulus or Socrates, was the handsomer. But before the contest takes place, they engage in a brief discussion on the nature of beauty.

Socrates, as usual, leads off the discussion by asking questions. He asks Critobulus whether only human beings can be beautiful. No, says his interlocutor, animals, plants, and even inanimate things can partake of that quality. But how can it be, rejoins his questioner, that things of nature so dissimilar can all be beautiful? "Well," replies a somewhat discountenanced Critobulus, "because they are beautiful and fine. Because they are well made for the things we obtain from them. Because they serve our needs well." This answer makes Critobulus fall into a Socratic trap. Greek scholars tell us that this discussion uses the word *kalos* throughout, which in Greek meant beautiful or handsome, but also excellent, noble, glorious, or fine.[13] This linguistic feature helped Socrates to strengthen his playful arguments. For his next question directs the conversation in this manner:

"Do you know for what purpose we have eyes?"

"To see, of course."

"In that case I say my eyes are more beautiful than yours?"

"Why so?"

"Because your eyes, sunk as they are in the orbits can only see straight ahead, whereas mine are bulging and therefore are better able to see also to the sides."

"That is absurd! By that standard, the most beautiful eyes would be those of the crab."

"Indeed, since they are best equipped to see from all sides."

Critobulus yields, knowing that the debate is only a playful exercise. But he is particularly proud of his "Greek profile," in which the line of the nose appears as a continuation of that of the forehead. He cannot restrain himself from retorting, provocatively alluding to the much-reviled Socratic snub nose: "I suppose you are going to tell me that your nose is more beautiful than mine?"

"As far as I am concerned," says Socrates, "Providence granted us noses so that we could smell. But in such a nose as yours the nares are pointing downward. This means that they are best fit to catch the emanations coming from below. My nose, in contrast, has nostrils that open frontward, therefore enabling me to catch scents from all over the environment."

"And does that prove that your nose is handsomer than mine?"

At this point in the conversation, the above-mentioned polysemy of the word *kalos* probably explains Socrates' rejoinder: "Yes, indeed. My nose, being small and sunken opposes no obstacle to my eyesight; it leaves my eyes free to survey a very wide visual field. This is contrary to your nose, which is very straight and runs down the middle, like a wall or a barrier between your eyes. Mine puts no limits to the visual function; yours does. Therefore my nose is more beautiful than yours."

With this, the jury is summoned to pronounce the verdict. It does not take long and it is unanimous: Critobulus is more handsome than Socrates.

Did anyone expect that a jury composed of Greeks in ancient Attica would have declared the "Greek nose" inferior to any other nose? That said, to my knowledge the entire Western literature contains no more gallant defense of the snub nose with nares open outward than that undertaken by Socrates in the banquet chronicled by Xenophon in 380 BC. In general, this nasal conformation was historically regarded with disdain.

NASALITY EAST AND WEST

The protruding, insolent, and peremptory large "schnozzle" seems to have enjoyed its hour of glory in the Western world. This may be inferred from the lively celebrations that the Middle Ages and the Renaissance created in its honor. In Germany, peasants' festivities included competitions on nasal size, in which the revelers indulged in all kinds of sybaritic pleasures, gorged themselves with dainties and drank immoderately, rioted, fought, and danced the "nose dance" the *Nasentantz*. They could step to the music while singing the catchy doggerel rhymes composed by Hans Sachs (1494–1576), the cobbler-poet famous in Nuremberg in his day, later revived by

Goethe in a 1776 poem, then in the opening scene of Faust, and still later projected to worldwide fame by Richard Wagner in his opera *The Meistersinger of Nuremberg*.

Compare the brilliant career of imposing, haughty nasality in our part of the world with the sorry lot of a hulking nasal appendage on the opposite side of the planet. Over there, the concept of beauty in neb-related matters is distinctly minimalist. No better way to illustrate this disparity than to recount a historical anecdote about an experience of a medieval envoy to the Far East.

The incident concerns William of Rubruck (also written Willem van Ruysbroeck and other spellings, 1220–1293), a Franciscan missionary sent by King Louis IX of France (Saint Louis) in 1253 to visit a Mongol chief suspected, according to some reports, of being a Christian. The French monarch was trying to establish contact with the Tatars, and presumably to convert them to Christianity. The friar, accompanied only by an attendant named Gosset and a translator of Arabic origin, traveled, mostly on horse and on foot, the incredible distance of over 6,000 kilometers (more than 4,000 miles!), in two years, under the grievously harsh conditions of medieval journeying. Nevertheless, animated by a fervent missionary zeal Rubruck reached the land of the Mongol Empire and left us a hallucinating report that stands out among all medieval texts as an extraordinary narrative of adventure, a description of the Mongols' social and religious customs, and a human document that offers a glance at the relations of East and West at a critical moment in history.[14]

On Mongol territory, the missionary goes from camp to camp of the nomadic tribes, until at last, after untold difficulties (local Mongol chiefs were not always welcoming, and at one point his toes were frozen and he had to be carried), he reaches the goal he set out to find: the camp of the great Khan Möngke (from the Mongol word *möngka*, meaning "eternal"). He was the elder son of Tolui, fourth of the sons of no less than the great Genghis Khan, who was therefore Möngke's grandfather. He had combated alongside the fierce tribes that imposed their might and sowed terror in the Russian plains and in Eastern Europe from 1236 to 1241; and when the time came to elect a supreme commander of all the Mongols tribes to succeed

Güyuk in 1251, Möngke made it abundantly clear that he should be the unquestioned sovereign. The two rival families, the Ogödai and the Diagataï, felt the brunt of cruel reprisals for their failed attempts to seize power. Yet, with all that, Möngke has been called by a leading historian "severe but fair, a hard but intelligent politician, and a good warrior who totally reestablished the machine assembled by Genghis Khan."[15]

Given these preliminaries, it is not hard to understand how nervous Rubruck must have been when he obtained the privilege of being admitted to the khan's tent for an interview. It is well known that the Mongol's tents, or "yurts" (a term of Turkish origin; in Mongol the word is *nuntuq*), are circular with a conical roofing. Less generally known is the fact that the inner space of a tent is most rigorously organized for daily life, severely hierarchized for purposes of family, social, and political life, and even "ritualized" in its symbolic-religious aspects. The door opens always on the south. As one enters a tent, the circular space is divided by an imaginary line that runs northward from the entrance: the space to the right of it (that is, the east side) is for the women; the left side (west) is for the men. The dividing line is impassable; one does not move back and forth through it without committing an impropriety. Straight at the far end of the tent, in direct line from the entrance (that is, at the north end), is the place of honor. Here sits the chief of the household, and this order is respected in all tents, not excluding the large, palatial tent of the powerful khan.

Picture the nervous tension of the friar. He has been instructed on how to act when in the presence of the sovereign. There are some precautions to take upon crossing the threshold of the tent, for the door has some ritual significance. Once inside, he is not to advance until he is told that he can come forward: if he is directed to advance on the right side (left of the khan on his throne), that means that he is not considered a very important visitor; if on the left, that indicates that he is held in greater esteem. He is to prostrate himself "sitting on his heels" and with a lowered, humble demeanor. He is thinking of all this, and of the words he is going to address to the great chief, when he enters the tent followed by his translator. He looks ahead, notices that the khan's wife is sitting by his side, on his left according to the prescribed order; and no sooner catches sight of the lady than he exclaims,

addressing his utterance to his translator in a low voice that cannot hide his alarm: "God help us! That woman has no nose!"

In effect, Möngke's wife was endowed with a diminutive nasal appendage of the snub kind, or, to use pedantic "nasological" terminology, a Warwick-Jabet class V type nose, whose nares, to top it all, opened frontward. In the eyes of Rubruck, who came from a land where men proudly competed for prizes awarded to nasal bulkiness and danced the *Nasentantz*, she seemed to have, instead of a nose, two holes in the middle of her face. In Mongols' eyes, however, this was an attribute that conferred great beauty.

In Mongols' eyes, it is certain that Socrates would have been more handsome than Critobolus. The American proverb says it well: Each man to his taste.

3 OF EYES AND THEIR HIDDEN POWERS

THE NEFARIOUS EFFLUENCE

The eyes are not the part of the body that best reflects the inner being. Their reputation as "windows of the soul" is a triumph of astute publicity over the hard data of experience. No one can deny the eyes' uncanny ability to convey the mood of the moment, but such fleeting commotions are an unreliable guide to the fixed, defining features of a personality; and it is ill-advised to take transient agitations as diagnostic of a lasting, immutable character. Nevertheless, the expressivity of the eyes is astounding. To carry it out, these organs dispose of many efficient tools: lids with lashes that can open by degrees the fissure between them; a strikingly colored iris with a pupil that contracts or dilates; brows above them with conspicuous bristles; inconstant or settled wrinkles in the skin around them; moisture or tears that accumulate in front of the cornea; and now and then, like lightning against a dark sky, a strange reflection that seemingly comes from inside the globe, from the bottom of the retina, and produces an eyeshine which is more intimidating than an open invective, more chiding than a spoken reprimand, or more touching than a declaration of love.

All these features are part of the matchless communicative power of the eye. The naturalist-writer Paul Shepard remarked, "The monkey, dog, and parrot watch man's eye and he theirs. More than any other single factor, eye communication transcends the profound barriers of communication between species."[1] This marvelous energy transmission and communicative force gave me a liking for the ancient theory which says that seeing

consists not only of the afferent sensory impulses going from the things seen toward the retina; that in vision there is something, some emanation, going out of the eyes toward the object seen. Nothing in modern science supports this notion. But the ancient belief was quite strong, and some vestiges of it remain in the collective unconscious. The ancients were sure that some kind of effluence streams out of the eyes, and wondered how this hypothetical gushing forth could affect us. The superstition of the "evil eye" falls entirely within this manner of thinking, and it is a matter of no small historical interest.

Plutarch recounts an interesting discussion on this topic. It took place at a banquet given by his friend Mestrius Florus, a Roman consul under Emperor Vespasian and a comrade-in-arms of Plutarch during the battle of Betriacum[2] (or Bedriacum, now Calvatone, near the town of Cremona). Mestrius Florus starts off saying that there exist many reports about people who are believed to have the evil eye, but such accounts tend to be rejected right away as mere superstitions of the silly and uneducated.[3] Yet, he says, it is not right to so treat things that lack a logical explanation, because, if we are honest, we shall have to acknowledge that there are thousands of indisputable facts all around us for which we have no logical explanation. The man who demands an explanation for everything is incapable of experiencing wonder, and this is the antiphilosophical attitude *par excellence*. Recall that Plato established that the sense of wonder is the beginning of philosophy. This is what he meant when he said that the mythological god Thaumas (from the Gr. θαυμα, *thauma*, "wonder") begot Iris ("the rainbow") from his union with Electra.[4] Aristotle expressed the same thing in stating that "it is thanks to their wonder that men first began to philosophize" and that "the lover of myth is in a sense a lover of wisdom, for myth is composed of wonders."[5] When confronted by something that seems to elude every explanation, we are puzzled, we wonder at it, we fervently wish to know more about it in order to find a reason for the unexplained, and thus we begin to be philosophers.

The banqueters go on to examine some of the numerous reports about people purported to cause harm to others through the gaze. Thus, the historian Phylarchus (third century BC) claimed that among the Thibaeans

(members of a tribe that inhabited the shores of the Pontus Sea in Asia Minor), there were individuals who could seriously hurt children by simply looking at them. Children were especially susceptible to gaze-induced harm, but some adults were also injured; and not only the gaze but the breath or speech of the nefarious agents also made the victims waste away and fall ill. (Survivors of the 2020–2021 coronavirus pandemic cannot help but wonder whether the ancient chroniclers witnessed some form of aerosol-transmitted infectious disease.) All this was attested by some human traffickers, in particular the half-Greeks who used to buy slaves from that area. Hence, one had to conclude that, for reasons no one understood, more than one kind of bodily emanation could cause damage in some highly susceptible individuals.

At this point, it is important to note that some contemporary scholars believe that in the times of the Roman Empire, just about anyone could, given the right conditions, cast the evil eye.[6] Anger and envy could channel their nefarious energies through the gaze, so that a person could cast the evil eye without specific intent to do so. In that case, the doer of the vision-mediated misdeed could go unrecognized. But soon a correlation was found between ocular abnormalities and malefic gaze, and it became possible to construct a typology of the evil eye casters.

PATHOLOGIC ANATOMY OF THE EVIL EYE

Not long before the time when Plutarch and his friends discussed the evil eye over viands and drinks, Pliny the Elder (23–79 AD) wrote that among the Illyrians there were people who killed those they stared at for a long time, "especially with a look of anger."[7] The victims were most often adults. Pliny said that there was a way to identify the people possessed of such a terrible power. All one had to do was to look at their eyes, for they had two pupils (*pupula duplex*) in each eye. He quoted reports from Scythia, where there were women who had this ocular abnormality together with the dreadful, murderous eyesight. Pliny added the intriguing comment that some of these women had a double pupil in one eye and "the figure of a horse in the other"[8] (more on this later). The association of abnormal ocular structure and the evil eye must have enjoyed wide currency in the ancient world, because Ovid,

who was born in 43 BC, says in his *Art of Love*, speaking of a certain sorceress named Dipsas, that "her eyes both have double pupils," and that "lightning flies out of the blink of her eyes" (*oculis quoque pupula duplex / fulminat et gemino lumen ab orbe venit*).[9]

What did the ancient authors mean when they spoke of a "double pupil"? The pupil of the eye is simply a hole, a contractile aperture in the center of the iris that allows the passage of light toward the retina. Its name is said to come from the Latin *pupilla*, a diminutive of *pupa*, doll, because of the little image of oneself that one sees reflected when looking into another's eye. The condition of having two (or more) pupils in one eye, named "polycoria" in medical terminology, is extraordinarily rare. The supernumerary pupil is supposed to have its own sphincter, so that it would dilate or constrict following the proper stimulus. But two large, well developed pupillary apertures each lined with its respective muscular sphincter is something so exceedingly rare that some specialists believe "it has never been demonstrated to occur."[10] A photograph published in the internet displaying such features—but giving no information as to its origin—is clearly a "doctored" image, not a true clinical observation. The grossly exaggerated size of the iris is also a clear indication of the spurious nature of this image (figure 3.1).

The presence of extra holes in the iris is not rare, but most are not true supernumerary pupils, because they lack their own pupillary sphincter. The technical name for this abnormality therefore is not "polycoria" but

Figure 3.1

Left: a photograph that is clearly a fake ("doctored") image from the internet shows two isometric, central, round pupils. *Right*: **A**: The hypothetical origin of the medical condition of polycoria by snaring off a portion of the pupillary margin. **B**: Origin of polycoria from the closure of a coloboma. From Niaz Islam et al. (see note 11). Explanation in the text.

"pseudo-polycoria." The latter is easily distinguished because when the true pupil is made to dilate, the accessory hole is passively constricted. In true polycoria, the muscular sphincters of the main pupil and the supernumerary pupil(s) should contract and dilate synchronously under the effect of the appropriate drugs. The supernumerary pupils tend to be much smaller than the main pupil.

Most instances of pseudo-polycoria represent a congenital defect of the iris, called coloboma (plural, colobomata). During embryonic development, the iris expands gradually. Sometimes it fails to close completely, leaving a cleftlike defect, a radial fissure. As a result, the pupil will not look like a perfectly circular aperture, but will be elongated, or have a shape that oph-thalmologists of the past compared to a keyhole. The organism sometimes heals the iris defect but does so incompletely, so that a small hole remains. This is thought to be the origin of most cases of pseudo-polycoria. If the closure is carried out by muscle-forming cells, a sphincter may be formed and true polycoria will exist. It is speculated that the simplest mechanism of formation of true polycoria is by snaring off a portion of the pupillary margin at a late stage in embryonic development, that is, after the sphincter muscle is already formed.[11]

SOME FAMOUS CLINICAL CASES OF EVIL GAZE DISORDER

Besides Ovid's Dipsas, another celebrated double-pupiled woman was Nys-sia,[12] wife of Candaules, king of Lydia. She figures prominently in a famous narrative of Herodotus, which has many of the elements of a folk tale. In the often-told story, Candaules is a vainglorious fool who brags about the beauty of his wife and praises her as the most beautiful living woman on the face of the earth. Sensing that his minister Gyges is a bit skeptical of this hyperbolic praise, he proposes to hide him in his bedroom, so he can watch the queen naked when she disrobes before going to bed. Gyges hesitates, thinking this would be a serious offense to the queen's honor. However, Candaules insists impelled by his egotism: he must convince everyone that he is the possessor of a woman of such surpassing beauty that no more splendiferous bodily forms can be found in any human female alive. Gyges has no recourse but

to obey his king's orders. He hides in a strategic place in the bedroom and gets an eyeful of Nyssia *au naturel*. He then tries to slip out of the bedroom surreptitiously, but the woman detects him and realizes what has happened. One version of the story, told by Photius, ninth-century Patriarch of Constantinople in his work *Bibliotheca* (a sort of early encyclopedia), asserts that the queen is able to detect the concealed watcher because she has a double pupil. Now, in terms of ocular physiology, the presence of polycoria would imply blurred or somehow suboptimal vision, but readers of the story are generally better disposed to heed the voice of the muse of poetry and legend than the dry utterances of an ophthalmologist. Therefore, we gather that one or more extra pupils gave the queen of Lydia an enhanced visual acuity.

The conclusion of the story is well known. The next day, the queen summons Gyges to her apartment, tells him that she knows what went on, and places before him a sharply defined alternative: either he assassinates Candaules and takes over the throne (with herself as an added bonus), or else she will order her personal guards to kill him right there and then. Gyges is scarcely to be blamed for having chosen to ascend to the throne by means other than wide popular acclaim. Poor Candaules was immolated, and his only legacy was that he became the eponym of a form of deviant behavior known as "candaulism," which some dictionaries define as a man's practice or sexual fantasy that consists in exposing his sexual partner, or an image of her, to others for voyeuristic pleasure.

There are a number of variants of this story. In one, as the wedding of Nyssia and Candaules approaches, two huge eagles flying around her house alight on the roof. A seer consulted on the meaning of this remarkable phenomenon pronounces it an omen of the fact that on her wedding night she will have two husbands. Another version of the story, which is not in Herodotus but derives its splendor from the likelihood of being a creation of Plato, is recounted in the second book of Plato's *Republic*. Here, Gyges is a shepherd who through fantastic adventures comes across a magical ring that has the property of making him invisible. When the ring's bezel (the part into which a gem is set) is turned inward, toward his hand, he becomes invisible; and when it is turned outward his visibility is restored. Once in possession of this formidable instrument, Gyges joins the court of Candaules, seduces his

wife, and conspires with her to kill the king and usurp his throne. Plato's aim in telling this story is not to dabble in novelistic narrative, but to illustrate the idea that even a just man, if he were sure of impunity (for instance, by being magically invisible), would be tempted to act immorally.

Regardless of the many versions, the story certainly smacks of an Oriental tale from *The Thousand and One Nights*, and it has been rightly said that Herodotus is at his Sheherezadian best when telling it.

The twelfth-century Byzantine Greek scholar Eustathius, archbishop of Thessalonica (c. 1115–c. 1195), mentioned another double-pupiled individual who became famous and whose name survived in the collective memory across countless generations. This personage, however, belongs exclusively in the world of mythology. His name was Thamyris; he was a Thracian poet and owed his long-lasting fame to Homer, because he is mentioned in the *Iliad* (book 2, 595–602). Thamyris excelled at singing while accompanying himself with the cithara. His musical success made him boastful and arrogant. He bragged that he could outsing the Muses. Alas, the inspirational goddesses did not take kindly to bragging that disparaged them, and in punishment for the poet's fanfaronade blinded him, slashing his eyes and taking away forever his ability to sing. In Eustathius's report, Thamyris is described as having "one of his eyes grey and the other black."[13]

In this context, some scholars have argued that the expression "double pupil" (*pupula duplex*) in ancient texts alluded to a dissimilar color of the irises ("heterochromia"); others insist that the reference was specifically to the pupils. Athanasius I, a Byzantine emperor from 491 to 518, was called "Athanasius Dicorus" because his eyes differed in color between them. His right iris was greenish blue and the left was black, but the outer appearance was otherwise normal, that is, there was no external pathology. Although heterochromia of the irises may be caused by several diseases or injury to the eyes, most cases are genetic in origin, inherited as autosomal dominant trait, and are not associated to any visual impairment. This was probably the case in the Byzantine emperor, who died at 90 years of age and was not known to have had visual difficulties.

A historian has stated that the term *dicorus* at the time of Emperor Athanasius I designated a color difference between the two irises, and not a

double pupil.[14] Now, Dicorus (Greek Δίκορος) means "two-pupiled," from *koré* (κόρη), pupil. The same word, *dicorus* (δίκορος), was employed to describe the eyes of the mythological Thamyris. It should be noted, however, that the pupils, which are simply holes in the iris, could look different when viewed from outside, one black and the other gray, due to the presence of cataracts. An erudite ophthalmologist has given us good reasons to think that the term δίκορος of the ancients was likely to refer to the pupil, and not the iris. In his words, "The pupil is the changing part of the eye, the part that manifests life. Its contraction and dilatation under the influence of light or disease disclosed its nature as an opening, a passage from the outer world of fact and substance into man's mysterious inner world of thought."[15]

The pupils were thus the portals that opened to let the maleficent influence pass out from the evil eye to the victim; and they were also the portal of entrance of gaze-conveyed maleficence. To have more than one pupil magnified the flagitious power of the possessors of the evil eye, for it was like having more than one window whence to shoot the poisonous shafts. A well-known defense against the evil eye was to paint an eye on a conspicuous place: shields, the prow of ships, and many other places bore eye representations. In magical thinking, this would be comparable to our modern antimissile defense systems: the evil sent by one eye would be nullified by a counterforce shot by the painted amulet-eye.

A PATHOLOGIC VARIANT OF THE EVIL EYE

Another question that has puzzled the experts is Pliny's assertion that bearers of the evil eye have been known to display "the figure of a horse" in one eye. Numerous explanations have been put forward to explain this odd statement. One ocular abnormality that could conceivably cause the described appearance is the "persistent pupillary membrane." This is a condition of the eye in which fine strands of tissue are seen crossing the pupil. They represent vestiges of a membrane (*tunica vasculosa lentis*) that exists in the embryo and fetus during the first six months of prenatal life. Its function is to bring blood supply to the lens. This membrane begins to regress in the sixth month and disappears completely by the eight month of gestation. When it fails to

Figure 3.2
Persistent pupillary membrane. From Wikipedia. By Fireinthexdisco—Own work, CC BY-SA 4.0, https://commons.wikimedia.org/w/index.php?curid=42186586.

involute, remnants of it are seen as fine strands of tissue that cross in front of the pupil. Many are fine, translucent, placed not directly on the visual axis, and therefore may go undetected; if thick and opaque, they may require corrective surgery. In either case, the membrane strands may crisscross and join each other in complex, intricate patterns. It is easy to see that fantastic shapes may seem configured by their arrangement, not excluding Pliny's *equi effigiem* or "likeness of a horse" (figure 3.2).

A FANTASTIC PATHOGENESIS FROM THE FAR EAST

To find the "likeness of a horse" in a person's eye brings to mind legends and fables in which fantastic creatures inhabit the interior of the body and

can be peeked at through the pupil. A maleficent spirit or a demon could cut itself an extra pupil as a window to get a wider look at the world, or as machicolation, the better to cast its poisoned arrows upon the unwary. But this interpretation, which suits quite well the mentality of the Middle Ages, steeped in demonology and witchcraft, does not seem to apply to ancient times. Superstition then was of a different character; the writers of classical antiquity were strangers to the figure of the "devil" as conceived by later ages.

Another imaginative way of approaching the ocular disorder discussed comes from the Far East, and is a creation of Pu Songling (1640–1715), an extraordinary author from China now considered a supreme exponent of the fantastic genre of literature. Pu Songling lived practically all his life within the rural district of the province of Shandong in which he was born (except for an 18-month sojourn in the neighboring province of Jiangsu). It is generally known that to occupy government positions in old China one had to submit to the system of examinations; success was a way to climb to higher social status. Pu Songling repeatedly tried and failed in this endeavor. Most of his life he earned a meager living as a private tutor, which may have been a blessing in disguise, for it allowed him to concentrate on his writing. His opus magnum, often translated as *Strange Tales from a Chinese Studio*, comprises over five hundred pieces, tales, anecdotes, and notes of varying lengths. It circulated in the form of hand-copied texts and was not printed until after his death, in 1766. The following pupil-related story comes from this book.

Fang, the main protagonist of the story, was a womanizer and unprincipled libertine, always in search of new conquests. One day, while strolling on a country road, he came across a richly adorned carriage with windows covered by red curtains and exquisitely embroidered blinds. It was followed by servants on horseback, while a young maid on a pony kept pace with it (figure 3.3). Fang approached, as was his wont, attracted by the maid. When he got close enough to look through the window of the vehicle, he descried a young woman inside and was dumbfounded: never had he seen a beauty so radiant. He was speechless, mute with admiration. He could not help

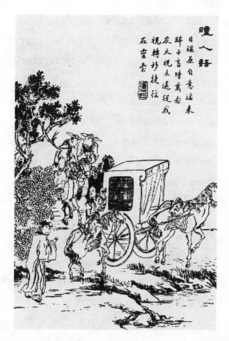

Figure 3.3

Chinese illustration of Pu Songling's story showing Mr. Fang encountering a supernatural beauty with a train of followers. The poem in the upper right corner alludes to the connection between evil thoughts and disturbed vision.

himself and followed the carriage for miles, always trying to get a better look at the divine being in its interior. At length, the beauty, irritated by the incessant ogling, said to her maid: "Let down the blinds, girl. Who does this wild man think he is, to be staring at me so insolently all the time?" The maid obeyed the order, berated Fang for his insolence, and angrily threw at his face a pinch of dust from the road by the carriage's wheel. Fang was momentarily blinded; he rubbed his eyes, and when he finally opened them he found himself alone on the road: the carriage with its precious cargo and its train of followers had disappeared.

All the way home Fang kept feeling some eye irritation. When he arrived, he asked a friend to look at his eyes. The friend said that he could see a film that had formed over each of his eyeballs. The next day he was

not better: he still had much discomfort and shed abundant tears; the film over his eyes was thicker. In the following days the film gradually thickened, until it became as thick as a copper coin. No medicine was effective. Fang became totally blind.

In despair at this terrible calamity, and given that no treatment worked, Fang sought spiritual consolation in the ancestral faith of his land. He obtained a Buddhist scripture known as the *Sutra of Light*, carried it with him all the time, and had someone read it to him many times until he learned it by heart. Every morning he sat cross-legged, repeating the sutra and counting the beads of his rosary. This went on for about a year. His fervent religious practices brought no improvement to his ophthalmic malady, but gave him some serenity and a Buddhist sense of detachment.

One day, while absorbed in his religious practices, he heard a voice that—surprisingly—came distinctly from inside his left eye, and said: "This is terrible! It's pitch black in here. I can't stand it!" The answer came—no less astoundingly—from a voice originating in his right eye, which said: "I feel the same. Let's get out of here and see the light for a while."

These words were followed by a funny sensation in Fang's nose. It was as if some small creatures, like worms, were wriggling inside his nasal passages, trying to get out. This sensation ceased, but after a while, the feeling restarted: the creatures had returned and made their way through his nasal cavity into his eye sockets. Shortly thereafter the voice commented that it had been very nice to leave the gloom in which they lodged, but that it was a pity that the orchids in the garden had withered.

Fang was upset upon hearing this. He was a devoted amateur horticulturist, and the orchids were his favorite flowers, which he tended with great care. Since he became blind he had neglected them, but had hoped that his wife would not allow them to wither away. He complained to her about the shriveled appearance of his favorite flowers. The wife, in turn, asked him how could he have known that, since he was blind; whereupon, suspecting something unusual, she decided to hide in his room and watch him. It was not long before she could see, coming out of Fang's nose, two minute "manikins, not bigger than a bean" that merrily flew out of the house. And shortly thereafter, having enjoyed an outing in the sun, the two tiny creatures flew

back in, and wriggled their way through Fang's nasal cavity to install themselves in their intraocular abode. This they did for two or three days running.

Then, one day, one of the voices complained about the inconvenience of having to work their way through the tortuous passages of the nasal cavity and the paranasal sinuses. The two creatures agreed that they had to create an easier exit route. The voice of the left eye declared: "I will make an opening on my side, and then we can share this door." Presently, Fang heard sounds of cracking and felt a scratching in his left eye, and moments later, suddenly, without warning, he recovered his sight! He could see with absolute clarity through his left eye. He was overjoyed. He ran to his wife, asked her to look at his eyes, and she discovered, much to her amazement and delight, that the film over the left eye had disappeared. But most astounding of all was that his left eye was now provided with two pupils. The right eye was still covered by a prominent, overgrown opaque film. Fang did not seem to mind: he affirmed everywhere that he now saw better with one eye than ever he had seen with two.

Pu Songling, like other Chinese literati, was persuaded that the *belles lettres* must have a moralizing mission. Therefore he concludes the story by telling us that, from that day forth, Fang lived an irreproachable, circumspect life and acquired a fine reputation in his district for his reliably upright, honorable conduct. He leaves it to the reader to decide what happened to the two creatures after they had installed themselves in the renovated left-eye dwelling. The work of Pu Songling has been reprinted innumerable times. This writer is considered a classic in fantastic literature the world over. The least we can say about this story is that it proposes a highly original theory about the etiology of polycoria.

I know no pupil-related tale of comparable extravagance on our side of the world. Yet Western thinkers long marveled at the power of the gaze, which they extended to some animals. They believed that a rooster, by simply looking at a lion, could terrorize the big cat. Lucretius, in *The Nature of Things* (book IV, 714–718), set it forth thus: "Undoubtedly in the body of roosters there are certain seeds that upon entering through the eyes of lions lacerate the pupils here and there, provoking a terror so tremendous that they can hardly bear it, despite their known fierceness."

THE NATURE OF THE EFFLUVIUM AND A NEAPOLITAN INTERPRETATION

Whether a human being can act at a distance upon another being through the power of the gaze or other intangible means is a question as old as the world. Scientific scrutiny may have started during the Enlightenment, but men of discernment have grappled with the problem since remote epochs. The Italian thinker Pietro Pomponazzi (1462–1524) devoted many pages of his book *De incantationibus* (*On Charms*) to this question. People are shocked, he says, when they see a man who performs apparent prodigies. They think that he must have commerce with the devil or other supernatural agencies, but many things in nature have virtues that confer on them astounding qualities. For instance, who would have thought, after receiving a tremendous electrical discharge that left his whole body numb, that this stunning force could come from a little fish? Yet this is so; the electric ray, a sea creature, has this power. Pomponazzi collects a number of traditions, from antiquity and the Middle Ages, in order to emphasize the unusual properties of natural objects: there are stones that have engraved upon them figures of animals; the dittany (*Origanum dictamnus*), a plant so named because it grows abundantly in Mount Dicte, in Crete, heals wounds that no physician can treat. And if plants and stones and animals have properties so numerous and diverse, why would the members of the human species not be able to display powers equally striking? Man, it was generally said in the Renaissance, is a microcosm: he is at the center of the universe; human beings receive their nourishment from the earth and their wisdom from the stars; the sun gives them heat; the moon, freshness. By being placed in the center of the world (so the foremost thinkers believed), human beings partake of the virtues of the two extremes. Pomponazzi concludes that, since in man are concentrated all the powers of the world, nothing is impossible for him. Therefore, it is not impossible that some men use their unfathomable, occult powers to do good, and others to wreak evil upon their fellows. Thus, it may be that some men can restore health to the sick merely by laying hands on them, while others may cause the healthy to fall sick by simply looking at them.

These ideas are completely out of alignment with our modern concept of the world. When we hear about something that strikes us as unbelievable, for the most part we dispense with trying to account for it. We say to ourselves that it would be a "waste of time," since miraculous occurrences generally fall outside the compass of reasonable discussion. Unfortunately, we thus lose the sense of wonder, which, on balance, may be the greater loss. Arthur Schopenhauer said it very well when he set forth this admonition:

> To mock in advance every occult "sympathy" or every magical act, it is necessary to believe that one understands the world, and that one understands it quite well. But this is only possible if we cast upon the world a glance so utterly superficial that it does not allow us to perceive that we are immersed in an ocean of enigmas and incomprehensible things, and that in reality we neither know nor understand things or ourselves.[16]

On the other hand, when confronting the unexplainable it is easy to slide into self-contradiction. This is the situation emblematized by a popular saying familiar to Neapolitans: "It is not true, but I believe it" (*Non è vero, ma ci credo*). The ancient formula of militant Christianity, *Credo quia absurdum*, "I believe because it is absurd"—not in spite of, but *because* of, its absurdity—is alive and well in southern Italy. More precisely, the formula thrives in Naples, which, after all, is reputed the original source of the evil-eye ophthalmologic dyscrasia and the fatherland of a personage who is sum and compendium of dastardliness propelled by eyesight and by bodily emanations: the *jettatore*.

First of all, it should be noted that evil-eye bearer is not the same as *jettatore*, although there may be some imbrication between the two. (*Jettatore* is a word that comes from the Italian verb *jettare*, to throw, to hurl; that is, a *jettatore* throws a spell or a malefic influence upon someone.) The evil eye is exerted actively; the bearer of the nefarious gaze must look, preferably with envy, anger, or some other insidious meanness, upon the victim. In contrast, the *jettatore* is defined by the prestigious Italian dictionary of Nicolò Tommaseo and Bernardo Bellini as "Someone who, especially in Naples, is believed to bring with his presence and his words misfortune or trouble; a kind of passive and innocent sorcerer." In other words, he may be of gentle

and benign disposition; he does not envy, does not covet; nevertheless, maleficence comes out of his body, not exclusively through his pupils. A *jettatore* is not conscious of his state; he is not mean, or peevish, or vengeful, and he bears no grudges against anyone. Pomponazzi proposed that a variety of emanations flow out of all objects. The *jettatore* has the misfortune of emitting those that are notoriously harmful.

Thus, one is born a *jettatore* and one dies a *jettatore*. It is a constitutional disease. Admittedly, it is possible to become one, but once having become a thrower of spells, it is impossible to cease being such. Yet, as a percipient traveler remarked, "by the strangest of contradictions, the more good fortune attends him, the more his evil eye proves fatal to those who approach him."[17] On the other hand, the condition of *jettatore* in itself may be a cause of much suffering for the person so marked out. As soon as someone acquires the reputation of *jettatore*, a social vacuum is created around him; no one will offer him a job; his friends disappear; invitations no longer come to him. "*Jettatura*," wrote Alexandre Dumas père (1802–1870), "was not invented yesterday; it is not a medieval belief; it is not a superstition from the late Empire; it is a scourge that the ancient world bequeathed to the modern world; it is a plague that Christians inherited from pagans; it is a chain that passes through the ages, and to which each century adds one more link."[18]

Indeed, the chain courses unbroken from remote antiquity to the present time. A contemporary author, Sergio Benvenuto, assures us that it is a "Neapolitan obsession" to this very day.[19] Nor is this superstition confined to the lowly and untutored, but it may be found in all social classes and extends to all regions of Italy. It is part of the culture. Thus, Mussolini was more afraid to encounter a *jettatore* than the anti-Fascist militias that wanted his hide. Palmiro Togliatti (1893–1964), founding member and the undisputed leader of the Italian Communist Party from 1927 until his death, lived in fear of *jettatura* (probably with reason: he survived at least one known assassination attempt). He carried in his pocket some iron nails, for in Italy you are supposed to touch iron, not wood as in our latitudes, to ward off arcane, esoteric malefaction. Therefore, neither a Fascist, ultraright ideology nor a radical left Marxist-Leninist persuasion can protect against the deleterious spells of a *jettatore*. Worse yet, a life of religious devotion and

piety is no obstacle to becoming a *jettatore*. Pope Pius IX (1792–1878), a gentle, kind man, was suspected of being one. It was said that a man received his benediction and soon thereafter broke his legs. "Nothing so fatal as his blessing," people said. Devout Catholics used to kneel before him to receive his blessing while, at the same time, cautiously making the hand gesture that protects against the baneful influence (see below); women were known to do the gesture under their skirts. The same undesirable reputation fell upon his successor, Pope Leo XIII (1810–1903), because many cardinals died during his pontificate.[20]

By the same token, a mind painstakingly cultivated in the humanities is no preservative against becoming a *jettatore*. Mario Praz (1896–1982), a man of impressive erudition and a preeminent scholar in English letters, was suspected of being one. He may have earned this reputation by writing a book with the somber title of *La carne, la morte e il diavolo nella letteratura romantica* ("Flesh, death, and the devil in romantic literature"). Presumably, the macabre allusions were enough for popular sentiment to rank the book's author with the birds of ill omen. American editors must have concurred, because they chose a tamer title for the English translation of that book: *Romantic Agony*.

Sergio Benvenuto recounts a striking anecdote that shows the impinging of *jettatura* upon erudition and scholarliness. In 1967, Pierre Klossowski, sophisticated Parisian intellectual, member of a family of prominent artists (both his parents were eminent figures of Paris's cultural scene; his younger brother was the renowned painter known as Balthus), translator, essayist, art critic, and philosopher, was visiting Naples, where he had come to give a lecture. His hosts took him to a fancy restaurant. A young man, desirous to show him that Naples was no backwater of the world of culture, asked him what he thought about the work of Mario Praz. To which Klossowski replied shouting and alarmed: "Don't you even pronounce his name in vain!" and at the same time he placed his hands under the table (possibly to make the gestures that counteract evil spells or to touch iron as a defensive measure). A waiter was bringing him at that moment a tray full of exquisite delicacies; the tray slid off his hand and everything landed on the floor with a loud crash. In this case, the mere invocation of Praz's name brought bad luck! Whether

the illustrious scholar ever knew of the negative reputation created about him is not known. In the halls of academe, many of Praz's colleagues may have deemed it unbecoming to openly steer clear of him; and of the many who shunned him Praz probably thought they were actuated by envy, which is the universal sin of the cognoscenti.

Luckily, the dreadful evil influences of a *jettatore* or *menagramo* (Italian for "jinx") can be counteracted by means of gestures that are easy to do. Best known is the so-called *mano cornuta*, the hand sign of horns: the thumb and the little finger extended, the rest of the fingers clenched; the horns so configured are preferably directed against the source of evil emanations. (Advice to users: Employ both hands for double strength.) It is true that horns have multiple significations in the richly expressive Neapolitan body language, depending on the contextual circumstances and the way the gesture is displayed; but this is not the proper juncture to bring forth fine-drawn distinctions. Suffice it to say that horns are widely known as an anti-*fascino* defense measure.

A Neapolitan scholar and eminent antiquarian, Andrea de Jorio (1769–1851), devoted a whole book to this matter, titled *La mimica degli antichi investigata nel gestire napoletano* (*The Mime of the Ancients Investigated through Neapolitan Gesture*), which has been considered the first ethnographic study of body language. De Jorio remarks that the Neapolitan belief in the protective force of the horns is so strong that it extends to natural horns, to artificial horns, to anything that resembles them, and even to the mere word "horn" (*corno*), all of which are tendered on the right occasions with the same faith as is bestowed upon the *mano cornuta*.[21] It is not without interest that Stendhal, during his visit to Naples, met De Jorio and wrote in his diary that this gentleman, "a man of great merit, had the misfortune of being identified as a *jettatore*." Stendhal also recounts his visit to don Nardo, the most famous lawyer of Naples at the time. In his antechamber he found an enormous ox horn which could have been ten feet tall; it was probably made of four oxen horns. Stendhal called it a veritable lightning rod against *jettatura*: "I acknowledge the ridiculousness of this custom," said don Nardo to Stendhal as he accompanied him to the door at the end of his visit, "but what can I say, a lawyer is bound to create some malcontents, and this horn reassures me."[22]

More than one learned visitor to the city of Naples has remarked that, upon arrival, most foreigners mock the custom and have nothing but disdain for what they consider a "primitive" belief unworthy of a civilized society. But, as time goes by, these same visitors, immersed in the local culture, begin to doubt; they feel a little troubled at first; and in time many end up covered with horn-shaped amulets from head to foot, their hands perpetually clenched in the sign of the *mano cornuta*.

A dark turn of this situation was depicted by Théophile Gautier in his popular novella *Jettatura*. In this story, a young French aristocrat, Paul d'Aspremont, goes to Naples to join his beautiful fiancée, Alicia. His physiognomy is striking, not unpleasant but somewhat inharmonic in a way that Gautier skillfully delineates. Auburn hair that shines with metallic copperlike reflections under the Italian sun (Neapolitans would call it "reddish," a distinctly exotic hue among them); an aquiline nose that, by virtue of its thinness, makes his eyes seem a bit too close together; a pair of pale graygreen eyes which, framed by dark black lashes, impart to his face a Mephistophelian air: these are the features that strongly attract the attention of the Neapolitan populace. Add to this that as soon as he reaches the harbor at Naples a sudden wave rises in an apparently calm sea and overturns the boat in which the luggage is being transported to land, causing some of the porters to fall overboard; not much more is needed for the Neapolitans to begin to suspect that Paul d'Aspremont is a *jettatore*. Yet the writer masterfully develops step by step the idea that there is a pernicious power in his gaze.

At first this sinister identity is barely a suggestion; later, the suspicion grows relentlessly as several disasters take place in the presence of d'Aspremont. There follow the imprecations of the locals, who scream "Jettatore!" when they see him coming. The lively repulsion and genuine fright that he sees reflected in the faces of those who hurl invectives at him strengthen the superstitious notion that begins to lay hold of him; for the poor man is gradually persuaded that he is, in fact, what the ignorant populace believes he is: a carrier of bad luck and misfortune. The latter includes an illness that rapidly turns Alicia from a blooming, fresh young girl into a pale, wasting valetudinarian.

In the climax of the story, d'Aspremont kills a rival in a duel. Distressed by the emotional turmoil this generates, maddened by the obsessive idea that he is the cause of the catastrophes that spread around him, and believing that his eyes are the vehicle of the nefarious influence, he blinds himself with a red-hot iron. After this unspeakable horror, he commits suicide. The emotional tone of this gruesome finale is set at a much higher pitch than present-day taste would find tenable, tolerable, or credible. But we must remember that what we regard today as unseemly exaggeration and romantic gush was the fare most in demand in Gautier's time.

Mark that in northern Europe, witchcraft was clearly associated with the devil. In contrast, the southern Italian *jettatura* was not conceived as a diabolical malfeasance. Consequently, in northern latitudes the evil spirits could be combated with Christian signs: a crucifix, the sign of the cross, holy water, invocation of the saints, etc.; but this arsenal was ineffective against *jettatura*. This is why a German scholar adjudicated the latter a pagan legacy, and the former a Christian legacy.[23] Scholars agree that the very word *jettatura* did not exist in the Italian language before the last quarter of the eighteenth century.[24] People allegedly causing injurious effects by their gaze existed before that time, of course, but they were known by different names. It was only in 1787 that the concept of *jettatura* gained precision with the appearance of a book curiously titled *Cicalata sul fascino volgarmente detto jettatura* (*Prattle on the Fascination Vulgarly Known as Jettatura*). In Italian, the word *cicalata*, which I have translated here as "prattle," comes from *cicala*, meaning "cicada," the insect known for its ability to produce a loud shrill or chirring sound. By extension, Italian words derived from the noun *cicala* generally mean a vain or empty speech with many words (i.e., jabber or prattle) on trivial or whimsical matters. The book's author, Nicola Valletta (1750–1814), was either being overly modest or trying to appear quaintly funny by naming his book a *cicalata*. (He was a lawyer and became an author: two attributes which practically rule out the former possibility.) As a jurisconsult, he wrote treatises on canonic and Roman law, as well as the laws of the Kingdom of Naples; as a man of letters he authored poems, songs, translations, and rendered Horace's poetry into the Neapolitan dialect. But the work that made him popular was his *Cicalata* on *jettatura*. It became an

obligatory reference for all authors who dealt with the folklore and popular beliefs of southern Italy.

Nicola Valletta was convinced that the premature demise of his daughter Rosa was related to the occult forces emitted from an evil eye. He recounts numerous episodes to convince his readers that *jettatura* is not a mere superstition, but a fact of objective reality. However, at the same time he makes fun of the theme of his book: he treats it playfully, and at the beginning of his *Cicalata* says that he is going to write about something he has no knowledge of whatsoever. In other words, he gives the impression that he believes and does not believe in the occult powers he is discussing; he is voicing the Neapolitan formula: "It is not true, but I believe it." The burlesque tone of his book starts with his placing, under an engraving of his own likeness on the first page, a droll stanza describing him thus: "It is not Seneca bled dry / It is not Lazarus resurrected / It is Valletta in his present state / Half alive and half dead." The engraving shows him as a wigged, rawboned, lanky, pale man with a long, thin nose and a pair of eyes encircled by round spectacles of thick, black frame—a feature that makes his little-expressive visage resemble nothing so much as an owl, a bird of ill omen—all of which confer upon him an appearance that could not have failed to suggest to Neapolitans the presence of a *jettatore* (figure 3.4).

It is a safe bet that Valletta's book, were it reprinted today, would not make the best-seller list or earn a recommendation as popular weekend reading. To begin with, no one in Naples would wish to take home a book carrying an image that reeks of the spell-thrower. And then, the reading is anything but amusing. The author, in a show of truly impressive erudition, reviews the history of the evil eye in ancient Greece and Rome—its place in classical literature and in Holy Scripture; its different modalities (mediated through the eyes, the spoken word, or the touch); the different theories that have tried to explain how *jettatura* is produced—and records some personal observations of his own time. The book closes noting areas of obscurity on which further research is needed. Valletta considers matters worthy of future investigation whether a man or a woman is more baneful in the role of *jettatore*; whether the worst are those who wear wigs or those who wear eyeglasses; whether monks are more dangerous than laymen, and if so of what religious

Nicola Valletta·

Figure 3.4
Engraving on the first page of Valletta's book *Cicalata sul fascino volgarmente dette jettatura* (Naples: Stamperia della Società Tipografica, 1814).

order; and so on. Written in a lively and humorous, albeit superannuated style, the *Cicalata* may be of interest to historians, anthropologists, students of folklore, and all those interested in the history of ideas.

Again, perusing Valletta's *Cicalata* during the height of the Covid-19 pandemic, it is impossible to overlook the similarity between *jettatura* and highly contagious infectious diseases. The Neapolitan writer stops to consider such questions as the distance from which a *jettatore* can throw a spell and still produce a manifest noxious effect; what kind of social distancing is best to avoid the injurious effects of *jettatura*; whether the evil eye is equally effective when its nefarious energy is directed at a victim from behind or from the side; and other similar problems. The parallel between the human attitudes and social reactions evoked by contagious diseases and *jettatura* could not be more vivid.

Not every author dealt with this theme in wrinkle-browed, serious style. The great Sicilian writer Luigi Pirandello (1867–1936) succeeded in giving an ironic twist to the southern Italian semi-institutionalization of credence

in *jettatura*. "Credence" is probably the most apposite term, because it does not stress grounds for belief and does not suggest credulity or its absence. The irony and comicality inherent in this credence was genially set into relief by Pirandello's one-act comedy titled *La patente* (*The License*), whose plot is as follows.

Mr. Rosario Chiàrchiaro has the reputation of being a *jettatore* and is therefore ostracized in his community. He has complained to the authorities about this mistreatment, and has sued two of his harassers. The play opens as Chiàrchiaro is expected to appear in a judge's office, where he is to receive some important information concerning his lawsuit. Pirandello gives this colorful description of his personage the moment he enters the scene:

> He has made for himself a *jettatore's* face that is wonderful to see. On his hollow, yellow cheeks he has grown a shaggy, bristling, bushy beard; upon his nose he has installed a pair of thick spectacles with a bone frame that give him the appearance of an owl; then he is wearing a lustrous, slinky suit that inflates all over, and is holding in his hand a rattan walking-stick with a handle made of horn. He comes in the room keeping a funeral-march step, beating the floor with the walking-stick at every step, and stops in front of the judge.

These antics irritate the judge, who is an educated, liberal man and does not believe in *jettatura*. He tells him to stop playing those ridiculous games. He has sent for him to inform him that the court is about to do him justice. Chiàrchiaro has sued no less than the son of the town's mayor and one of his assistants for defamation, because repeatedly, brazenly, and in public they made the gestures purported to send away the evil spirits as soon as they saw him passing in front of them. Only this time, much to the judge's surprise, the plaintiff is not reaffirming his complaint as a victim of defamation. Quite the contrary, he manifests that he has furnished evidence of his real jettatorial powers to the lawyers of his accusers. In other words, he wants to be condemned and declared a true, genuine *jettatore*. The judge is bewildered by the unusual petition, but the plaintiff has reasons for this odd behavior.

Chiàrchiaro has suffered grievously on account of his undeserved reputation. His wife and daughters have been forced to live in seclusion, afraid to come out and suffer the invectives and maledictions of their ignorant

neighbors. No one will marry his young daughters, for who would wish to join the family of a *menagramo*, a spellbinder, a charmer, a jinx? He was fired from his former job and cannot get a new one; the employers are afraid that he will bring misfortune to the workplace. As a result, he and his family suffer the pangs of hunger. But these very torments are the reason why he wants to leave no doubt about his jettatorial powers. "All that remains for me," he says, "is to join the profession of *jettatore*." And he is ready to assume this new role, having confected the appropriate clothes, grown the bushy beard, and worn the imposing eyeglasses. All he needs now is a valid, legal license. He wants to have an official license, duly signed and stamped by the town's authorities, certifying him as an "official *jettatore*."

But how will he make a living? asks the judge. "All I will have to do is to present myself," says our man. The owner of a business, the gentlemen who play card games at the town's casino: they will pay a little money to make him go away. The aspirant-*jettatore* adds: "I will start buzzing like a bluebottle fly around all the factories; I will stand in front of one warehouse, then in front of another. Is there a jewelry store? I plant myself right before the front window and start ogling the people. Like this [and he demonstrates how would he do it]." Who is going to come into that warehouse or into that jewelry store to make a purchase, or even to look at the window? People will want to avoid him and he will feel free to ask them for a modest sum of money to get away from them. Without a license, asking for money in these circumstances may look like extortion. But with a license in his possession he can do it legally: he will be exercising his lawfully recognized profession as *jettatore*.

The comicality of the play is enhanced by its finale. The judge looks at Chiàrchiaro with profound pity, considering the extremity to which he has been reduced by society's widespread superstition. The man stands up and loudly demands, "The license!" No sooner has he said this than a gust of wind opens the window and the birdcage that was hanging on a wall falls to the ground. It contained a much-loved bird left to the judge as a memento of his dead mother. In consequence of this accident the bird dies. At the noise of the falling cage and the involuntary exclamation of the judge, some secretaries and other judges from the neighboring offices come running. As they open the door and see Chiàrchiaro they stop abruptly, some terrified by

his presence. "What happened?" they ask alarmed. "Nothing," answers the judge. "A wind gust opened the window and the cage fell down. The bird has died." But Chiàrchiaro corrects him firmly, in a loud voice: "What wind gust! It was not the wind. It was me! I did it through my malefic powers. I was trying to tell him, but he did not believe me. He is a non-believer. And see what I had to do to convince him." At these words, all those present retreat, trying to distance themselves from him. But Chiàrchiaro, imperious, peremptory, dictatorial, looking at them, threatens: "And thus you will all die, one by one! All of you!"

Frightened, all those present protest, objurgate, vehemently supplicate at the same time: "Please! Don't say that! May God help us! For God's sake, I have a family!"

Chiàrchiaro, menacing and extending a hand, replies: "Then, quickly, pay the tax! Right now!"

"Yes, yes! Right away." The judges and the secretaries put their hands in their pockets searching for the money while Chiàrchiaro, exulting, looks at the judge that summoned him and says: "Did you see? And I don't have the license yet. Dismiss the charges to my accusers and start processing my license! I am rich! I am rich!"

NOTE BY WAY OF EPILOGUE

Before the attention I have devoted here to *jettatura* is condemned as time wasted on a detestable superstition, I would remind the reader that this peculiar southern Italian belief captured the attention of one of the most vigorous minds of the twentieth century. I am referring to Niels Bohr (1885–1962), the Danish physicist and Nobel Prize winner who made foundational contributions to the understanding of atomic nuclear fission, quantum theory, and domains of human knowledge far beyond the field of physics, such as the social consequences of the development of atomic weapons and the new scientific outlook of modern biology.

Bohr was attending a scientific meeting in a mountainous resort area. As is common in some of those gatherings, the participant scientists had been lodged in separate small cottages or cabins constructed to fit the natural

environment and furnished with all the modern amenities. During a recess of the conference, a colleague came to Bohr's cottage looking for him, and was surprised to find him busy nailing a metallic horseshoe to the wooden door of his cabin. Clearly, the horseshoe was an ornament in tune with the décor of his lodging: it had accidentally fallen from its support and Niels Bohr was reattaching it. The visitor asked him: "Sir, what are you doing?"

"As you can see, I am nailing back this object that fell down. It is supposed to be a good-luck charm."

"But, but . . . you . . . you, a prominent scientist! . . . You are not going to tell me that you believe in those things?"

"Of course not! But, you know, I have heard it said that these things work *even for those of us who do not believe in them.*"

Splendid reply, which could have been condensed in the Neapolitan saying: *Non è vero, ma ci credo.* "It is not true, but I believe it."

4 THE THRALLDOM OF DARKNESS AND SOME ESCAPEES

In the humble Mexico City neighborhood where I grew up there were two
blind men. The first one I wish to evoke was an old beggar. Nothing like
that have I ever seen in the countries north of the 32nd parallel in America
or in Europe. Sir Charles Bell (1774–1842), a famous Scottish surgeon and
artist, expressed surprise when he wrote:

> What a contrast is offered to the eye of the painter by the figures seen in the
> churches of the Roman Catholic countries of the south, as compared with
> those in our own! There are seen men . . . abandoned to their feelings with
> unrestrained expression . . . and even the beggars who creep about the porches
> of the churches are like nothing we see nearer home.[1]

Save for minor changes, his observation still held true in my youth. In effect,
the sightless man I remember dressed in rags, and with a face that seemed
carved in stone, was "singularly picturesque"; no doubt he could have been
a model in a Renaissance painting. But, whereas the illustrious Scotsman
focused all his attention upon identifying the personages of the great masters
in the features of the real people he saw, my memory made no concession
to aesthetics. I retained the feeling of the squalor, the misery, and the pain,
not its artistic potential.

 As I recall, a touch of senile dementia compounded his affliction. To
be old, blind, sick, and forced to live on public charity seems a convergence
of circumstances than which none more distressing can be imagined. But
that happened in another time, when the harshness of privation seemed
lessened by its being widely shared; and in another place, where tribulations

were rendered less wearisome under a smiling sun. Early in the evening, the old man was daily conducted by a young girl, perhaps his granddaughter, to the street corner where he sang and begged for alms. His begging was never annoyingly pertinacious; his singing—abominable and always the same song—was meant to satisfy himself that he was no parasite; that he could still perform a useful act that entitled him to the minimal donations compatible with his meager subsistence. Hours later, as the evening progressed and darkness set in, the young girl would come to take him home. Sometimes, however, he would walk back alone, swaying his long, white cane to and fro, in wide arches in cadence with each step. This was my first encounter with the human tragedy of sightlessness, and I was appalled by it. For it seemed to me a horrendous misfortune that a man in poverty and old age should be forced to survive deprived of this most valuable of all sense perceptions; and an incomprehensible injustice that such an atrocious calamity should exist in the world.

One day, as the old man walked home alone, I followed him at a distance. He had to go through a couple of relatively quiet streets and a dark alley. And I did what perhaps many a boy of my age had done, or thought of doing, when first discovering the cruel reality of blindness. I decided I would follow him for a while with my eyes tightly shut, firmly purposing to keep them shut, *just to see* (what a cruel irony lies in this expression!) what it was like to live deprived of the precious sense of sight. What I discovered was unsettling beyond words. To become suddenly sightless, I found out, was like sinking into a frightening, chaotic universe where one is abruptly disconnected from all reassuring perceptions; thrust into a world where every sensation takes on a menacing character. A rustling sound close to me ceased to be a crumpled sheet of newspaper pushed by the wind to become some threatening unknown: an attacker stealthily approaching? a reptile slithering by? A truck passing on the street filled me with anxiety: did the increasing loudness of the motor mean that a distracted driver was precipitating his vehicle toward me? A scream in the distance set me on edge. Vision would have invalidated all these fears, but darkness, by erasing every comforting reference point, only magnified the terrors. The Spanish poet Rosalía Castro de Murguía (1837–1885) gave voice to this amorphous fear in a poem in her

native Galician language, which may be translated as: "What is happening around me? / What happens that I know not? / I fear a thing that lives and cannot be seen / I am afraid of the traitorous affliction / which comes, and no one knows wherefrom."[2]

The sudden loss of sight felt like being hurled into a world of vagueness and ambiguity where every perception suggests a menacing intrusion. We hear, but cannot relate the auditory sensation to anything reassuring; we feel a contact upon our skin, but this touch is not immediately related to anything concrete, and this makes us imagine the worst. We are no longer in control. "Darkness," wrote David Le Breton, "is not the absence of perception, but another form of vision"; the anxiety that it produces is determined by "the impossibility of attaching meanings to one's surroundings."[3] Darkness is the proper milieu of ghosts and apparitions, of monsters and ghoulish beings. Among noisy companions and in a room full of bright lights the phantasms do not come. This is because in darkness all the familiar external impressions are eliminated, and this leaves the brain acting only from within. Thus, the apparitions look for all the world like external phenomena, but their primary cause lies within ourselves. In other words, we are afraid of ourselves.

Much intrigued by the misfortune of the old beggar, I recall having asked several grownups for an explanation of it. What could possibly cause a man's downfall into such degradation and misery? The best I could get from my untutored informants was the statement that the poor man had developed *nubes en los ojos* ("clouds in his eyes"). This much I could have concluded myself; for in my old neighborhood, where the purchase of a decent pair of dark glasses would have been an unimaginable luxury, the beggar went about bare-faced, displaying to the world a pair of eyes whose matte, opalescent front resembled nothing so much as a cloud, and was a poignant spectacle for all to see.

Because of its round form and its luminosity, the eye's most general symbolization has been as the sun. The eye is the orb that receives light but also emits light. The Egyptians' old religion consisted of the worship of the great solar deities: Horus, Atum, Ra, Osiris were different conceptions of the same sun god;[4] the moon, itself round and luminous, was symbolized by male and female deities: Iah, Khonsu, and Thoth. Indeed, for millennia the

refulgent celestial luminaries have been associated with the eyes. Primitive peoples all over the world must have believed, upon looking at the sun, the moon, and the stars, that they were being watched by so many divine beings residing up above. Plato, in the *Republic*, says that the eye is the organ most like the sun.[5] In Christian iconography, Hieronymus Bosch's *Seven Deadly Sins* puts the deity in the center of a big eye: a large circle with 128 radiating lines is the iris, and within it is a smaller circle (the pupil) at whose center stands the All-Seeing divinity surrounded by a banner that says "*Cave, cave, Deus videt*" ("Beware, beware, God sees"). However, I learned that the divine light symbolized in the brilliance of the human eye can be dulled. It seemed absurd, but it was true: the godly sun could be covered over by clouds!

It may be that I discovered the human tragedy of blindness at a uniquely sensitive stage of my life. The dull, milk-white eyes of the blind beggar followed me in dreams. I avidly scrutinized in his lusterless eyes the trace of I knew not what terrible events of the man's life, sublime in their tragedy, repulsive in their vulgarity. As decades went by, I gained a smattering of understanding about the ways the primary quality of the eye, its admirable transparency, is maintained.

The parts concerned with this quality occupy the front of the eye. They are the *cornea*—a transparent, discoid structure about 12 mm (0.5 inch) in diameter and thinner than a United States dime—aptly compared to the crystal that covers the circular dial of a wristwatch—and the *crystalline lens*, or simply the "lens" (figure 4.1). At all times the cornea must be as clear as pure water; therefore it has no blood vessels: oxygen and nutrients reach the cornea by diffusion from the liquids that bathe it. With the aid of the microscope, the perfectly transparent cornea is seen to be multilayered. The most posterior or internal layer consists of a single layer of flattened *endothelial* cells, whose function is crucial for the eye's transparency. The endothelial cells of the cornea have a "draining pump" to extract water from the cornea. They all work synchronously to transport water and solutes from the substance of the cornea day and night (a little less actively at night than during the day) in order to maintain the cornea in the relatively dehydrated state needed for optimal transparency. Let these cells perform their function defectively, and excessive hydration of the cornea will occur; the cornea will

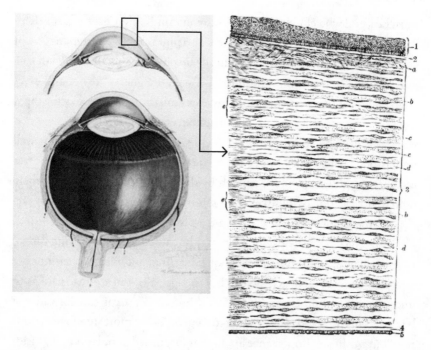

Figure 4.1

Left: Section of the eye globe. Color lithograph after F. Foedisch (ca. 1900). Dresden: C.C. Meinhold & Sohne. From https://wellcomecollection.org/works/yt2cpdg. *Right*: Microscopic anatomy of the cornea. The stroma accounts for most of its thickness. 1: Superficial epithelium. 5: Deep endothelium, the layer bathed by the fluid contained in the anterior chamber. From *Gray's Anatomy*.

turn opalescent, and vision will become blurred. There are about 6,000 endothelial cells per millimeter square at birth, but their number decreases with age: to approximately 3,500 by age five[6] and 2,300 at eighty-five years.[7]

This exquisite organization of form and function leaves us entranced with admiration. Little wonder that philosophers of past eras often chose the body of the human eye as a piece of evidence in the "argument for design" to demonstrate the existence of God. The eye's anatomy is a marvel of ingenuity; the delicacy of its function and the precise coordination of its minute parts suggest a clever machine, like those made by men, but one that surpasses anything man-made in thought, cleverness, intelligence, and wisdom. Hence theist philosophers concluded "by common sense analogy" that there

must be a god who closely resembles human minds, but vastly exceeds them in all intellectual powers. Yet there were also philosopher-contrarians (is not contrariness the soul of their discipline?) who objected that the design of natural objects—and by implication the assumed designer—are not as perfect as claimed; for one may find clumsy design mistakes if one looks for them intently. In the case of the cornea, the human endothelial cells were designed with a peculiar defect: they cannot divide by mitosis, for reasons not well understood.[8] Thus, when one cell dies, the neighboring cells expand, contact each other tightly and fill the gap left by their dead companion. Since there is no multiplication of these cells, their number decreases gradually with age.

Hydration of the corneal stroma is a proximate cause of blurred vision. Unfortunately, corneal opacification may be caused by a bewildering variety of pathologic states. Trauma, infections, scarring, and many other illnesses may produce corneal opacity. None but the specialist can aspire to gain a fair understanding of these conditions. Still, corneal disease is a major cause of blindness in the world; second only to cataract in the more developed countries, but the first in importance among impoverished populations.[9] Considering the appalling living conditions of the blind beggar of my remembrance, the milky-white aspect of his corneas, and the bilateral involvement of his eyes, I suspect he may have been a victim of *trachoma*, a bacterial disease that is among the oldest known to mankind, and is still with us despite the undeniable triumphs that medicine has achieved against bacterial maladies. But it would be idle to engage in retrospective diagnosis at this juncture.

The second blind man of my old neighborhood I met years later, and he was of a very different sort. The neighborhood had changed somewhat. Not that it had become affluent, but it had managed to emerge from its former obtrusive destitution. The sightless new neighbor could afford dark glasses, which he sported constantly. Therefore I could not tell whether clouds or nebulae had descended from the immensity of outer space unto his corneas, or whether darkness had entrapped him in some other wise. He was a teacher in the *Escuela Normal*, the school for teachers. He was middle aged, bald-headed, yet vigorous and with a stentorian baritone voice that must have been an asset in the classroom. Often, he would come home accompanied by a young woman who carried his books. I always thought this a

compassionate gesture of one of his students, until the day I overheard his wife complaining about him. She passed in the neighborhood for a boisterous and brawling person; but who can say if this was but a reactive response to her husband's misconduct? In a voice trembling with wrath, she called him "that blind bastard" among other niceties. The man, as it turned out, had been carrying on a love affair with the young woman. By then, I had grown into adolescence and initiated that inexorable moral involution of human beings which consists in the gradual replacement of innocence by cynicism. Instead of pitying the moral squalor of the whole situation, I rejoiced inwardly: prompted by the heedlessness of my young years and influenced by the local gossip, I thought to myself: "Good for him! Beclouded eyes and all, he still found a way to hoodwink his shrewish wife!"

I do not know what happened to the two sightless men of my childhood memories: both left the neighborhood. They remain in my mind as pure images, which I have evoked before.[10] At the same time, they filled me with respect for the extraordinary resilience and resourcefulness that men can summon to meet adversity. Above all, they gave me a brief inkling of the supreme ability of the human brain to reorganize itself to confront the formidable challenges posed by the deprivation of what has been called the noblest of our senses.

In a masterful essay, Dr. Oliver Sacks described some of the behavioral and cognitive changes that have been recorded in blind persons.[11] He quoted the case of John Hull, a professor of theology who lost his vision in his teens. In the decades that followed he lost all memory of visual imagery, so he came to resemble someone who had been blind from birth. But instead of being imprisoned in the chaos of darkness, whose gloomy pall adumbrated my boyhood the day I playfully closed my eyes to mimic blindness, this man became a "whole body seer." By this, Dr. Sacks meant that he shifted his manner of seizing the world around him from predominantly visual to a new way centered upon the other sense perceptions. His sensorial "center of gravity" moved from vision to the other senses. This was not just a matter of "compensation," i.e., the enhancement of touch or hearing to somehow offset the loss of vision. John Hull actually "reshaped himself to a new center, a new identity." His dreams were different from the dreams he had when

he could see; his hearing acquired a wholly new character; the flow of his thoughts seemed as if detoured to new, unaccustomed channels. In short, he acquired a new personality. Being a highly educated person, John Hull was able to describe his altered condition with clarity and poignancy, and to reflect about it with profundity in more than one book and in a documentary film.[12]

As a neurologist, Oliver Sacks was especially interested in the fact that in people who are deprived of a sense perception for many years or since birth, the part of the brain that normally manages the lost function does not atrophy. In those born blind, or blinded very early in life, the visual cortex of the brain remains active, except that it is "reallocated" in function or "transformed." By virtue of this "reallocation," it gets to process sound and touch. Of course, a consequence of the shift will be a highly increased acuity of the remaining senses. Any observer can verify the extraordinary degrees that this hyperacuity sometimes attains. Touch, for instance, may acquire an exquisite sensibility accompanied by a unique form of spatial perception. Recall, for instance, the celebrated feats of men like Professor Geerat J. Vermeij of the University of California at Davis. This remarkable man, having lost his eyes at age three, became a noted marine biologist-paleontologist able to identify innumerable species of mollusks by recognizing tiny variations in the contours of their shells. His touch and his sense of space must have been very greatly enhanced.[13]

The ability of the human brain to reshape its functional organization in response to external demands is what neuroscience experts today call "neural plasticity." The range of this reorganization is quite amazing. Suppose stimulation of a body part is consistently enhanced: the zone of its representation in the brain's cortex will enlarge. Now suppose that the stimulation of the body part ceases completely; this may cause an invasion of its representational cortical zones by zones adjacent to that which has lost all afferent input. It is as if a "competition for cortical space" was taking place in the brain, with areas that are furnished with important information tending to enlarge, at the expense of others that become narrow.[14]

History has a number of exemplary sightless individuals who excelled in science. Most remarkable is the English mathematician Nicholas Saunderson

(1682–1739). Deprived of his sight at age one by smallpox, he studied mathematics at the University of Cambridge. In 1711 he became the Lucasian Chair of Mathematics at that venerable university, where it was said that "he was a teacher who had not the use of his eyes, but taught others to use theirs."[15] So exquisite was the sensibility of his sense of touch that in a collection of Roman coins he could identify the false ones. From the impression that the air made on his face, he could tell that an object was placed in front of him. Aided by his sense of hearing, he could tell the size of a hall where he was introduced, and could estimate quite well the distance of the walls and other details.

There are also examples in the world of art. One was Louis Navatel, a blind sculptor, known in artistic circles as Vidal (figure 4.2).[16] He was born at Nîmes in 1831 and trained under the renowned sculptor Antoine-Louis Barye. For reasons unknown he became suddenly blind at the age of twenty-one. Like his master Barye, he was an "animalist." His sculptures of goats, horses, bulls, dogs, and other animals were often exhibited at the Parisian Salon. A journalist movingly reported one of his visits to the artist

Figure 4.2
Left: Louis Navatel (Vidal) (1831–1892) by Philippe-Auguste Cattelain. Paris, library of the National Institute of Art History. *Right*: Bronze sculpture with patina by Vidal. From artnet.

during which a greyhound was brought to him. Vidal carefully studied the form of the animal while caressing it and straightaway began working on clay. The journalist expressed his amazement upon observing the faithful figure of the greyhound slowly take form, the outline of muscles, tendons and bones slowly emerging from the dexterous movements of Vidal's hands. There is little question that constant practice had caused a reorganization of Vidal's cerebral motor cortex. It is reported that in blind students who read Braille, the "reading finger" activates a larger area in the brain cortex than its contralateral counterpart, and larger than any finger in non-Braille-reading controls.[17]

Talent and fame did not shield Vidal from the flightiness of fortune. A journalistic note of 27 August 1874 described his accomplishments and finished thus:

> Vidal is poor, abandoned by the government's protection. . . . The administration of the Ministry of Fine Arts has a budget destined to support the artists worthy of encouragement. The blind sculptor does not beg for alms like Belisarius [an allusion to the Byzantine general Belisarius (ca. 500–565), who in spite to his services to Emperor Justinian I was blinded by him and reduced to beggardom]. He wants commissions. He did not lack these under the Empire. The Republic must not be less generous with him.[18]

Vidal's case, although remarkable, is not unique. A seventeenth-century precedent is found in Italy, the country which has been the source of much of what is precious in art and culture in the Western world.

The Italian blind sculptor was Giovanni Gonnelli, born in 1603 in the little walled mountaintop town of Gambassi, in Tuscany. His father was a glassmaker (*bichieraio*), an occupation well remunerated at the time. His early years therefore were spent in relative ease. Giovanni was initially placed as an apprentice to the mannerist sculptor and architect Chiarissimo Fancelli (1588–1632), and later transferred to a better-known sculptor, Pietro Tacca (1577–1640), the chief disciple of Giambologna, in Florence. Under this second tutor, Gonnelli made rapid progress. One day, Carlo Gonzaga (1580–1637), the powerful Duke of Mantua and Nevers, who was visiting Florence, happened to come into Tacca's shop. The duke, a consummate art

connoisseur like so many aristocrats at the time, realized how talented the young apprentice was, and decided to take him to Mantua, the ancestral city of the Gonzaga dynasty. He took also another young apprentice in Tacca's studio named Tommaso Redi. Aristocrats, church dignitaries, and other powerful men were the principal sponsors of artists, who, unless they were famous, had few options for ensuring their livelihood.

In Mantua, the young artists' tranquility was soon brutally disturbed by the war of the Mantuan Succession (1628–1631), which was a peripheral part of a much larger bloody struggle, the murderous Thirty Years War (1618–1648), said to be the most destructive armed conflict in Europe before the twentieth-century world wars. Invading German troops put the city of Mantua under siege in 1630. Giovanni suffered a harrowing ordeal. It was then that he lost the sense of sight. His main biographer, Filippo Baldinucci, says that he suffered no trauma during the war and questions the role of Mantua's unwholesome air; for this city was built on a lake, and "miasmas" or mephitic emanations were then thought to cause disease.[19] An alternative explanation was that blindness was caused by famine and exhaustion; for during the siege Gonnelli was forced to carry provisions and loads of stones for the fortifications day and night, until he could bear it no more. Severe malnutrition can cause of blindness by injuring the optic nerves (nutritional optic neuropathy). As recently as 2019, a group of British physicians reported progressive, irreversible loss of vision in an adolescent who for years sustained himself eating high-energy, nutritionally deficient foodstuffs (so-called "junk food").[20] Note that nutritional optic neuropathy causes blindness *without opacification* of the parts of the eye responsible for its glistening transparency (cornea, lens, and aqueous humor of the anterior chamber). Giovanni Gonnelli was a young man in his twenties when visited by this tragedy. From that day on, he was known as *il cieco da Gambassi*, "the blind man from Gambassi," his hometown. He returned home totally blind, conducted by his friend Tommaso Redi.

He did not produce any artwork for ten years, until a trivial incident persuaded him to resume his sculpting. Years before, he had made a clay bust of Cosimo II de' Medici, grand duke of Tuscany, but bad weather had damaged part of the statue. Whether out of curiosity or because of love

for his former work, Gonnelli asked that some clay be brought to him and applied himself to repairing the damaged bust. According to Baldinucci, "with only the strength of his fantasy and the most sensitive touch of his hands he repaired the statue so well that it seemed it never had any defect." His relatives were impressed and encouraged him to return to his former artistic activity, which he willingly did.

Unfortunately, Gonnelli's handicap restricted him to working chiefly with clay, plaster, and wax. These materials are not as durable as marble or stone; as a result, no authenticated piece of his handiwork remains in our time. Still, his rare ability soon raised him to notoriety. Grand Duke Ferdinando II called him to Florence and had him make his portrait. Wealthy and powerful gentlemen, always prone to imitate those in authority, began giving him commissions. It became fashionable to have their portraits made by the remarkable *cieco da Gambassi*. His fame reached Rome, where he was summoned by Pope Urban VIII, whose portrait he also sculpted.

Cardinal Pallotta was another potentate who had his statue made by Gonnelli. While the sculptor worked, artist and model engaged in conversation. One day, Giovanni was asked by his eminent sitter whether he had ever been in love. Yes, he answered; and he was still very much in love with the same woman. He said the image of his beloved had become deeply imprinted in his mind ever since he had full use of his eyes. Cardinal Pallotta, a curious man, asked him if he thought himself capable, in his present condition, of making a statue of his beloved. When the sculptor answered affirmatively, the cardinal ordered him to go ahead and do her statue. Meanwhile, the prelate sent a painter to the town of Gambassi, there to locate the woman of whom Gonnelli had spoken and paint her portrait. His orders were followed. The cardinal then placed the completed works side by side in his private gallery. Everyone marveled at the resemblance between the portrait, painted from life, and the sculpture, fashioned from memory by a blind man. The hierarch thought the accomplishment so memorable that he ordered a sign placed next to these artworks that said:

Giovan, ch'è cieco, e Lisabetta amò
La scolpì nell'Idea che amor formò

("Giovanni, who is blind and loved Elisabeth / Sculpted her from the Idea that love fashioned").

Recall that at this time intellectual discussions often centered on a comparison of the arts. It was debated (at times childishly, from our modern viewpoint) whether painting or sculpture ought to have the primacy. Thus, the juxtaposition of the sculpture and the painting of Giovanni's love-object may have been more than simply Cardinal Pallotta's whim.

The city of Volterra, which is very close to the little town of Gambassi where Giovanni was born, desirous to "adopt" him as an illustrious son, held a meeting in which the general council declared Gonnelli a regular Volterran citizen. They issued an official certificate dated July 7, 1637, duly signed by the chancellor of the town. But not everyone was content with seeing the blind sculptor's ascending star. Envy or ill will tried to cast doubt over the authenticity of his accomplishments. This got to the point where a wealthy man, who believed that Giovanni could see, at least partially (a belief based on the fact that Gonnelli's eyes were still brilliant and transparent, bearing no trace of opacification of the cornea or the lens), decided to exhibit him as an impostor. He contrived to make him work in a room that had been especially prepared to impede the penetration of the slightest light ray. The sculptor met his model there and labored in complete obscurity. Yet he produced a portrait so greatly resembling the model, and so neatly executed, that it completely erased his employer's doubts over the authenticity of Gonnelli's blindness.

On one occasion, Giovanni was doing the portrait of another cardinal who also doubted the reality of his blindness. When Giovanni had momentarily left his work, the powerful priest got up from his seat very quietly and was replaced by another man, known to resemble him closely and wearing priestly vestments identical to those of the cardinal. Gonnelli returns to his post, touches the model, pauses, and seems to reflect for a moment. Then, he touches the clothing around the model's neck, and suddenly rises, lifts his right arm, closes his fist tightly, and says irately: "By my faith, I swear that if I were sure that you are not another cardinal, as well you might be, I would punch you with this, right on the jaw, so as to teach you how to mock a gentleman next time." Upon these fiery words, the cardinal quickly intervened,

laughing good-humoredly and saying that it had all been a well-intentioned joke; that the prank was meant to put to rest all doubts over his sightlessness. With utterances of this kind Gonnelli's wrath was quieted.

Having gleaned an impressive number of honors and distinctions, Giovanni Gonnelli returned to his hometown and married Lisabetta Sesti, the love of his life. He lived with her in Florence for five years and then in Rome, where some claim Gonnelli died in 1664. (Others say 1656, still others 1642. These contradictions attest to the neglect into which his work had fallen.)[21] There were rumors—but this should come as no surprise in those tempestuous times—that Gonnelli died from poisoning. His biographer makes no comment about those rumors, but from his description of the behavior and habits of the biographee, it is not impossible that he may have elicited strong passions in some rival.

Baldinucci describes his biographee as a tall, handsome man of youthful appearance. He walked in the city always guided by one of his servants and flaunting his best finery with a proud air. He never put a price on the works he produced; he made them to please those who requested them. But most of his clients were rich and powerful, and reciprocated his courtesy with considerable largesse. "However, his weakness consisted in being excessively inclined to amorous pursuits," wrote the biographer, "so that before his marriage, it was enough for him to hear a young girl's talk to fall in love with her," and this proclivity caused him to become involved in many love affairs. It was on account of this temperament that he was often seen attending parties and revelries in the company of young people, where he played the guitar and sang. And, blind as he was, not uncommonly he would dance with the belle he was wooing. At this point in his description of Gonnelli's life, Baldinucci waxed philosophical and felt compelled to reflect soberly: "Feeble is our nature," he wrote, "and it is most difficult to abandon those passions which we allowed to take possession of us since our tender age. So that, when the accustomed delights disappear, those passions grow stronger, and, in less time that it takes for me to say so, they become insuperable."[22] Clearly, he was trying to tell us that the blind artist of Gambassi was no paragon of virtue.

Giovanni Gonnelli received plenty of accolades in his lifetime, only to be cast into complete oblivion shortly after his death. His works, done in perishable materials, were destroyed by time: no unanimously authenticated work of his has come down to us. Consequently, except by art historians, his life and work are seldom discussed. No one is sure of how he looked. There used to be a painted portrait of his likeness in his home; his wife gave it away and no more was heard about it. There is, however, a terracotta bust that bears the inscription *GIOVANNI GAMBASSI CIECHO* [sic] *FECE* ("Giovanni Gambassi blind made [this])." To believe the sign, this is a self-portrait, but no readily available documentation exists to confirm its authenticity.

It is not without interest to note that, contemporaneous with the ascendancy of the blind sculptor, a magnificent Spanish painter, Jusepe de Ribera (1591–1652), nicknamed "*lo Spagnoletto*" ("the little Spaniard") was producing his mature works in Italy. After being neglected for centuries, Ribera is currently acknowledged as one of the outstanding painters of his era, which is no small praise, given the huge constellation of superb artists that flourished at the time. Since both Gonnelli and Ribera frequented the same art circles, and were both sponsored by men of wealth and power, it is not farfetched to suggest that their paths might have crossed, although there is no proof that they were friends or even that they were acquainted with each other.

At least for some time, it was believed that Giovanni Gonnelli was represented in one of Ribera's paintings, kept for many years in the Royal Collection of the Monastery of El Escorial, where its custodians named it "The Blind Man of Gambazo" (Spanish transcription of Gambassi). It is now exhibited in Madrid's Prado Museum, labeled *The Blind Sculptor. Allegory of the Sense of Touch* (figure 4.3). The picture shows an old, blind man who holds in his hands the head of a classical statue, which he appears to be meticulously palpating. The man's eyes are semiclosed, recessed in darkly shadowed orbits; his posture suggests immobility and deep concentration; everything in this painting tells us that this man is absorbed in that amazing neurophysiological process that allows the blind to "see with their hands."

Figure 4.3
Jusepe de Ribera, *The Blind Sculptor: Allegory of the Sense of Touch* (1632). Madrid, Museo del Prado. From Wikimedia Commons (Public domain) at https://commons.wikimedia.org/wiki /File:Ribera-escultor_ciego.jpg.

In the 1950s, the distinguished scholar Delphine Fitz Darby disputed the identification of the blind man of Ribera's painting with Giovanni Gonnelli.[23] For one thing, the man in this painting is old. The painting is dated 1632, when Gonnelli was only twenty-nine. Assuming that he had just come out of the terrible experience in Mantua by which he lost his eyesight, he might have appeared fifteen or twenty years older than his age. Still, he would not have been the bent, lean, bald man of wrinkled face portrayed in Ribera's *The Sense of Touch*. Additionally, Gonnelli was somewhat of a show-off, a dandyesque fellow, always dapper, who used to swank it along the Roman and Florentine streets. But the old man of the painting is poorly dressed: his coat is threadbare, a seam has been torn at the shoulder, and he seems garbed in little more than tatters. No proud artist of rising popularity in those days would have agreed to pose dressed in such bedraggled raiment. In short, Fitz Darby's reasons are quite convincing: the man in Ribera's *The Sense of Touch* is a pitiful, frail, ill-dressed and decrepit oldster—a far cry from the jovial, jocular, womanizing, guitar-playing, singing, and dancing blind man that Gonnelli's biographer described.

Two painted portraits, allegedly of Gonnelli's likeness, were done by artists who were his contemporaries. One is owed to Jusepe de Ribera and is the second work of this artist bearing the title *The Sense of Touch*. It is a masterpiece. A blind man is holding the head of a statue, to all appearances a classical Greco-Roman art work (figure 4.4). The striking, dramatic use of light and shadow inevitably reminds us of Caravaggio, with whom Ribera is often compared. The light strikes preferentially the three objects that constitute the conceptual linchpin of the painting: the face of the artist, the head of the statue, and the hands that seem to be "reading" its surface irregularities. The face of the blind man is turned away from us: we catch its left profile a bit less than fully. But such is the strength of Ribera's art that we are made to feel the intense, reverent, almost worshipful concentration of the blind artist in the act of canvassing the statue with his hypersensitive touch. "He needs no eyes," Ribera seems to be telling us, "as long as he is in possession of those preternatural 'reading fingers,'" and he underscores this message with the solemn, imposing interplay of light and shadow with which he has so elegantly mantled the scene.

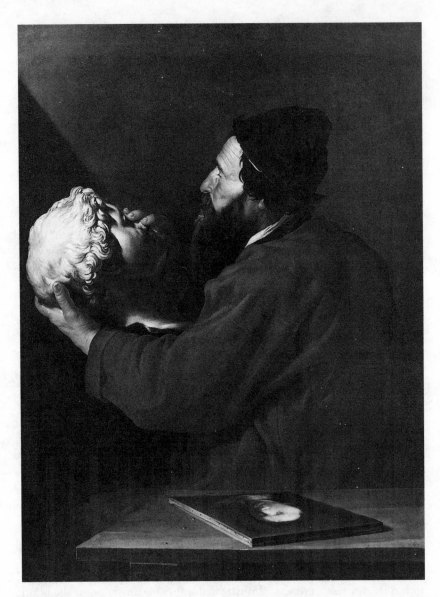

Figure 4.4
Jusepe de Ribera: *The Sense of Touch* (ca. 1630), oil on canvas, belonging to a series of five paintings representing the five senses. The Norton Simon Foundation. From Wikimedia Commons: https://wikivisually.com/wiki/File:Jos%C3%A9_de_Ribera_018.jpg.

The other painting said to be Gonnelli's portrait is the work of Lieven Mehus (1630–1691), a Flemish painter and engraver who lived for most of his creative life in Italy. Livio Mehus is justly recognized as a splendid painter of landscapes, battles, and allegories. His *Blind Man of Gambassi* is a fine piece of work in the baroque manner, although, from an aesthetic viewpoint, it does not attain the same height as Ribera's treatment of the same theme. Concerning the likeness of the Italian blind sculptor of Gambassi, the painting by Mehus has nothing to contribute. Despite the title, it is doubtful whether Mehus actually knew the blind man of Gambassi. Furthermore, Mehus's work is dated circa 1655 and Gonnelli probably died in the 1640s. The Flemish painter represented a "generic" blind sculptor in peasant clothes donning a wide-brimmed hat and with his torso half-naked. Needless to say, the dandyesque Gonnelli never would have consented to pose in such humble raiment.

The true appearance of Giovanni Gonnelli's visage may elude us forever. But his uncanny ability "to see with his hands" is a mystery that we may reasonably hope to unveil one day. The suspicion has long existed that the senses are not as trenchantly divided and compartmentalized as widespread belief would have it. Tactility and sight are much more closely intertwined than commonly assumed. It is known, for instance, that e-books and paper books have a different effect upon us. Studies suggest that what we read in a book than can be carried, leafed, fingered, stroked, and perhaps written on, is remembered better than what we read on a luminous screen that can only be seen.[24] The masterful paintings representing the blind sculptor impress us all the more because they appeal to our sense of touch, not just to our vision. They give prominence to the texture of things as much as to the look of things: hence they evoke a synesthetic response. Ribera's two renderings of *The Sense of Touch* and Lieven Mehus's *Blind Man of Gambassi* cater to our visual enjoyment, and at the same time stir our tactile nerve endings: we almost feel the smooth, cool, marmoreal surface that the fingers of the painted subjects are ranging over. This pictorial realism and its synesthetic response bring to mind the following ancient anecdote owed to Pliny the Elder.[25]

The ancient Greeks were having a competition on a stage building over who was the best painter. A favorite in the competition was Zeuxis of Heraclea, a genial limner who had already acquired great wealth and fame at the time of the 95th Olympiad (400–397 BC). By then he was so full of a sense of self-importance that he no longer sold his paintings: he gave them away as presents, saying that it was impossible to sell them at any price, for no amount would match their value. The other competitors were his contemporaries and bright luminaries of the art of painting: Timanthes, Androcydes, Eupompus, and Parrhasius. As the competition drew to a close, the two finalists were Parrhasius and Zeuxis. The latter produced a painting of grapes so realistically done that birds came flying from the neighboring trees to peck at them. With this proof of the great realism of his painting, a vainglorious Zeuxis declared himself the victor. Nevertheless, he said the work of his rival should be shown, and for this he requested that the curtains covering his painting should be drawn. He then realized his mistake: what he took to be the curtains was in reality a trompe-l'oeil painting of curtains done by Parrhasius. To his credit, he conceded that Parrhasius was the winner. For he, Zeuxis, had been able to deceive animals' eyes, but Parrhasius's realism succeeded in deceiving human eyes. Further testimony of his equanimity was in evidence later. He painted a boy carrying a bunch of grapes, and the birds flew to it as before. Only this time Zeuxis was angered by their intrusion, saying that his painting of the boy was inferior; because, he pointed out, had his rendering of the boy been as good as he had intended, the birds would have been afraid, and would not have approached the painting.

Oliver Sacks wondered in his above-mentioned essay what happens to the brain's visual cortex when it is excluded from any visual input. Isolated from stimuli coming from outside, the brain becomes hypersensitive to internal stimuli of all kinds and to its own autonomous activity. This would explain why as sight deteriorates, the unsighted individuals may have hallucinations, or see geometrical patterns, or figures that appear and disappear without rhyme or reason, or as Dr. Sacks put it, "without any relation to the contents of consciousness, or intention, or context." But, as a good clinician, he realized that different individuals react differently, and noted that some patients are strongly synesthetic from birth, that is, they have a marked

(perhaps inheritable) "over-connectedness" by which their visual cortex can "cross talk" with other parts of the brain, primarily those concerned with language, sound, or music. These are people who have a strong visual memory, and in whom sounds, words, or musical tones elicit or evoke colors and shapes, or vice versa.

These technical considerations of the late Dr. Sacks make us wonder whether one day neuroscientists will clearly define the neurophysiological basis of the blind sculptors' prodigious feats. Were they strongly synesthetic persons endowed with superior visual memory and "over-connectedness" between the visual cortex (no longer employed in seeing) and sensory receptors in the skin and deep in the muscles of the hands? Is there a neural circuitry that accounts for their exceptional ability to "see with their hands"? Of particular interest would be to determine whether *sighted* individuals can develop this "reallocation" of the visual cortex, or whether some persons are born with a capacity to merge the functions of different parts of the brain. For it is a fact that certain persons whose vision is normal are able to execute complex and delicate manual work without the benefit of visual control. The following example from the Far East illustrates this fact.[26]

In the coastal city of Tianjin, in northeastern China, during the reign of the Empress Dowager Ci Xi (1835–1908), there lived a skilled artisan named Zhang Mingshan. Even today, Tianjin is noted for its handicraft products, among which terracotta figurines have earned a place of distinction. This branch of craftsmanship has a centuries-long tradition; generations have cultivated it with diligence and assiduity. Still, the manual dexterity of Zhang Mingshan surpassed all others. A cause of even greater admiration was seeing his statuettes come out of his hands without defect or blemish when he seemed to be looking elsewhere, not focused on the material he was manually shaping.

The skillful craftsman could be seen in the evenings at a local restaurant, enjoying some of the many delicacies pivoting upon seafood which are characteristic of Tianjin cuisine, or leisurely drinking his tea while musing on the difficulties of making a living; for—as artists and artisans everywhere know—the excellence of their creations has little to do with the monetary value that society accords them. One evening, he sat quietly in the restaurant,

by a corner table, carefully observing the faces, demeanor, and clothes of the customers, which he would copy later in his statuettes, when three customers came into the restaurant. One walked in the center: he was a paunchy, ruddy, middle-aged vainglorious man, named Hai Zhang; the two flanking him were his servants. From all the fuss provoked by the man's entrance, the way the commensals dropped their chopsticks in surprise and turned to see him, plus the obsequiousness with which the restaurant's host came to receive him, calling him "Lord Hai Zhang," it was apparent that the rich man wielded considerable power in the community. He had amassed a fortune trading in salt. His success in business was promoted by his social connections. At one time he had been in the service of a highly placed general of the Imperial Army, Hai Ren. This one took a liking to him, and, following a custom of those parts, decided to adopt him. Hai Zhang became, in effect, the general's fifth son. This is why many people, while talking to the wealthy man, respectfully addressed him as "Lord Hai Zhang"; but, in consideration of his "lordly," arrogant, and overbearing attitude toward others, behind his back they called him Hai Zhang-"wu" (*wu* meaning "five"), to emphasize the fact that he was the general's *fifth* son: not exactly a title of great distinction in a society where the first-born was topmost in the family hierarchy.

Hai Zhang-"five" and his cronies sat at a table and soon began talking loudly about Zhang Mingshan, whom they could see across the room. The enmity between those who enrich themselves handling someone else's money and those who depend on their own labor for survival is probably irreconcilable. Tianjin was and is a business city: here, the rich have always wielded great clout. Hai Zhang therefore suffered from "the rich man's syndrome," a condition that makes the sufferers believe that their ability to make money is proof of their superiority in all human endeavors, including those that require prolonged, painstaking preparation, and of which they know nothing. In consequence, Hai Zhang talked disdainfully about the artisan who sat across the room, and loudly disparaged the value of his work and the estimation in which it was held in Tianjin. The restaurant's atmosphere was tense: people could hear the derogatory remarks against Zhang Mingshan, and feared a scene. But this one acted as if nothing happened: he continued eating his soup, handling his chopsticks with his right hand, while with his

left he was kneading under the table a ball of clay that he had brought with him, as was his custom, and which presently he held on his lap.

The spectacle of the artisan eating with his right hand while his left seemed occupied in short repetitive movements under the table could not have failed to intrigue the rich man, who even tried to bend down to see what the craftsman was doing. But Chinese jackets often came with long, wide sleeves that covered the hands completely. Hai Zhang, frustrated and irritated, told his companions: "What is this guy doing down there? What is he mixing, kneading, handling and pinching? I bet he is pinching his own crotch!" and upon this gross joke, the three burst out laughing. Zhang Mingshan said nothing; he continued eating, finished his bowl, got up from his chair to pay his check; but, as he was on his way out, he dropped a ball of clay—"the size of a ladle used to serve soup from a big cauldron," according to a commentator—on top of the rich man's table, where it fell with a loud thud. This mass of clay was shaped in the likeness of Hai Zhang's head, but had been done with such consummate artistry, and such sapient emphasis of the most prominent physiognomic details, that people said that "it looked more like Hai Zhang than Hai Zhang himself." By this colorful expression they meant that the craftsman had sculpted not just a likeness of his model, but had captured the essential features of his character: his small, shifty eyes bespoke his unprincipled villainy; his inflated jowls revealed his love of pleasure. One of his companions said that when the sculpture fell on the table, for a moment he thought Mr. Hai Zhang had been decapitated!

Hai Zhang himself was impressed, but, since he was gravely afflicted with "the rich man's syndrome," he immediately recovered his normal, obnoxious disposition, and found the strength to make a galling remark to the artisan as he was leaving. He said: "What a lousy piece of craftsmanship! It is worthless. Who could possibly want to buy this piece of cheap dirt?" Zhang Mingshan said nothing. He paid his bill, opened his umbrella, and left the restaurant into the rain.

The following day, the people of Tianjin found a stand outside the north city gate in which numerous clay heads of Hai Zhang were being sold. Apparently, the artisan had made a mold of his statuette and reproduced hundreds of heads of Hai Zhang, which now lined up in rows under a sign

that said: "Hai Zhang-wu is for Sale—Dirt Cheap!" The likeness of the wealthy man was so faithfully rendered, and his character so well brought out, that the public celebrated the sale of the statuettes amidst much merriment. Not the least cause for admiration was the fact that Zhang Mingshan had fashioned the striking figure with one hand, hidden under the table, while appearing occupied with eating his soup. A maid of Hai Zhang's household ran to inform her master of what was happening, and the rich man, afraid of becoming the laughing stock of the entire city, sent his people to buy for him the entire stock of the statuettes on sale. It was rumored that he paid a very high price to obtain the mold used to give shape to the many likenesses of his head.

The reputation of the craftsman grew enormously. As happened with artists in the Italian Renaissance, Zhang Mingshan lived for some time in the mansion of a powerful potentate who was proud to see him in his household. The handicraftsman elevated his work to a level of excellence worthy of one of the fine arts, sculpture. The most famous painter of the succeeding generation, Xu Beihong (1895–1953), praised his productions saying that his figures had "faces of perfect proportions, well defined bone structure, and lively expression." It is a tradition that some actors of the theater stage were afraid of him, because he could sculpt their portrait without their permission, working with the clay or other suitable material while his hands were hidden under his sleeves and he appeared to be watching the show.

In 1904, the Empress Dowager Ci Xi was celebrating her 70th birthday. In the course of the celebration, numerous gifts were presented to Her Imperial Majesty. Among these, the Mining Institute was pleased to offer the empress precious statuettes, in pure, solid gold, of the "eight immortals," the powerful personages of Chinese mythology often associated with prosperity and longevity. A court officer, Qing Kuan, displayed them all on a long table, at the end of which he decided to place one of Zhang Mingshan's clay figurines. When the empress came by to inspect the magnificent gifts, she spent very little time with the golden statuettes but was fascinated with Zhang's handiwork, which she could hardly put down. This detail endeared the court officer to the empress. A six-generations descendant of Qing Kuan declared that this incident was true and believable; that he had heard if often

Figure 4.5

Realistic clay figurine executed according to Zhang Mingshan's technique by one of his descendants. It represents a blower of viscid sugar paste in the process of fabricating candy toys, which children play with or eat. From Baidu (Chinese search engine).

from his grandfather as an event that had long endured in the memory of his family.

The skill of Zhang Mingshan's craft has been transmitted from father to son across multiple generations. Statuettes produced by his descendants are striking for their realism (figure 4.5).

It is not known whether the Tianjin craftsman's blood relatives are the possessors of a superior visual imagery, or of exceptional visual memory. Does any of them have a synesthetic ability comparable to that of their renowned ancestor, with the power to "see with the hands" and to sculpt highly detailed statuettes in total darkness, without any intervention of vision? It seems unlikely that these questions have been systematically investigated. Such research, however, may not be pointless.

5 THE LIPS

The lips, according to Samuel Johnson's *Dictionary of the English Language* (1755), are "the outer part of the mouth, the muscles that shoot beyond the teeth, which are of so much use in speaking, that they are used for all the organs of speech."[1] The French dictionary of Trévoux, which was approximately contemporary with its Johnsonian homologue (since it appeared in several editions from 1704 to 1771), gets considerably more technical and tells us that "lip" is a

> part of the face that is double; the border, the exterior part of the mouth; the muscular and fleshy extremity that closes and covers the mouth, above as well as below. [. . .] The lips are two, one superior, the other inferior; they are composed of an ardent flesh [*une chair fougueuse*] and covered by a fine tunic which is continuous with that of the mouth. (Dionis).[2] There are thirteen muscles of the lips: eight are proper [i.e., intrinsic] and five common. The proper are: incisive, triangular, montanus, canine, zygomatic, buccinator & orbicular [but we count seven, not eight!]; of the common type there are two at each lip [which makes four, not five!][3]

After this unpromising introduction, the Trévoux dictionary lists a series of cultural references to the lips that eighteenth-century readers may have found of some interest. We are informed, for instance, of the following:

> Matins, the night liturgical office, begins with the invocation that says "Lord, open my lips." God, through Isaiah, complained that his people worshiped him only as "lip service," but not with the whole heart. The gesture of Harpocrates, god of Silence, consisted in placing a finger on the lips. There are

ventriloquists who can talk without any movements of the lips. Early travelers said that Brazilians pierce the lower lip in their early years, and place there a big ring. Strabo in book XV of his *Geography* says that the same thing is done by Ethiopian women. The punishment for certain crimes used to be the cutting of the lips.[4]

In defining the lips, lexicographers and dictionary writers of the past coincided in emphasizing certain facts. Firstly, the lips' stance as door, portal, or gate to the oral cavity: the lips lie at the entrance of that astounding bodily gadgetry that allows us to incorporate the materials of the outer world into our own substance. The lips are the doorway to the fantastic system of transmutations whereby food, which is alien matter, is transformed into our own flesh. But the first phase involves the mouth as a whole: the tongue, the cheeks, and that formidable set of fine cutlery and trituration machinery that we call teeth. As to the lips, they "shoot beyond the teeth," as Johnson put it; in other words, their place is upstream in the crush-bray-smash-grind process that begins to subdue foodstuffs into flesh-metamorphosis. And as "receptionists" or gatekeepers, the lips are entrusted with a benevolent role of welcome. Many and varied are the functions discharged by the lips. But, in consideration of the space constraints proper to a book chapter, the following discussion will be confined to the two traditionally associated with sympathy and tenderheartedness: the smile and the kiss. Close scrutiny of these two shows that instead of uniform fondness and affection, streaks of injurious trouble may be discovered in them. But this must not be attributed to the writer's moroseness. It is simply an instance of the disaccord between our wishes and the indifferent, doggedly unchangeable nature of things.

THE SMILE, WITH EMPHASIS ON ITS PATHOLOGY

Smiling is a natural manifestation of the pleasure experienced in joy and happiness. Darwin noted that many purposeless actions accompany these states. Clapping the hands, stamping, or dancing about, as well as laughing are frequent, especially in children. Grown-up persons generally are not induced to laugh for causes that suffice in children. But this remark, notes Darwin, "hardly applies to smiling."[5] Newly born infants smile randomly, as

a reflex: the earliest smiles, in premature infants, occur during sleep, in the absence of any known stimuli. Proud parents believe that babies do this in reaction to their presence; actually, it is not until six to eight weeks of age that babies begin to smile as a social act,[6] for by then vision and facial recognition have improved significantly. Some research indicates that the time of onset of social smiling is not set in stone: it may start later in premature babies and somewhat earlier in those of certain ethnic backgrounds, regardless of their gestational age.[7]

None of this negates that smiling is one of the most fundamental acts that human beings do. Nor is it a simple act: physiologically, it is an intricate phenomenon in which seventeen pairs of muscles controlling facial expression must be set into finely coordinated motion. "It is not only the mouth that smiles," wrote a twentieth-century physiologist, "but also the cheeks, the nose, the eyelids, the ears, and the forehead."[8] When the forehead smiles, a phenomenon that occurs through a contraction of the frontal muscle, it enlarges, smooths out, effacing its wrinkles, and even seems to "clear up." Hence the physiologist can quote Iphigenia, in Racine's play of the same name, telling Agamemnon, her father, whom she sees overwhelmed by the approaching tragedy: "Will you not clear up this brow burdened with worries?" (Act II, scene ii).

Sir Charles Bell, eminent Scottish anatomist, surgeon, and neurophysiologist (physicians all over the world recognize one of his many contributions in the eponymous designation of "Bell's palsy"), described and illustrated—for he was also a consummate artist—the muscles of the face and their role in producing a smile and other visible expressions of sentiment (figure 5.1). The Scottish savant was aware that expression does not result solely from the contraction of the facial muscles, but from the contraction of some and the relaxation of others.[9] In laughter and broad smiling there is relaxation of the orbicular muscle of the lips, a muscle that forms a ring around the mouth and is responsible for the fleshy appearance of the lips. As a result, the elevating muscles preponderate and the corners of the lips are elevated in the characteristic manner of the human smile. Of course, this can only happen when the orbicular and straight muscles of the lips are well developed. Animals are incapable of this facial expression in its fully developed

Figure 5.1

Top left: Frontispiece to the book *Essays on the Anatomy and Philosophy of Expression* by Sir Charles Bell, with a general, frontal view of the facial muscles. *Top right*: Muscles of the lips and cheeks according to Bell. Shown are the orbicularis (A), which is a muscle intrinsic to the lips, and the muscles that originate elsewhere and converge on the lips. For example, (B) levator of the upper lip and nasal wing; (C) levator of the upper lip proper, which arises from the upper jaw, near the orbit; (E) zygomatic, which arises from a process of the cheekbone; (G) some fibers of the buccinator, a flat muscle from the inside of the cheek. From Charles Bell, *The Anatomy and Philosophy of Expression as Connected with the Fine Arts*. *Bottom*: Muscles of the head of a dog, to show the relative paucity of muscles contributing to facial expression and strong muscles of the angle of the mouth which raise the upper lip so as to expose the canine teeth in carnivorous animals and even in man. From Charles Bell, *Essays on the Anatomy and Philosophy of Expression*.

form. According to Bell, dogs achieve a slight eversion of the lips and grin in a way that resembles, but does not completely achieve, a full imitation of the human expression.

Smiling, then, is a fundamental human expression which in its pure form, unaltered by deception, announces a gentleness of disposition. It betrays a state of animus that has its source in benevolence and the willingness to participate in the enjoyment of others. What, then, if a person cannot smile? Such a one would go through life "wearing a mask," which is nonetheless his own face: his face transformed into a mask. The consequences of such an odd circumstance are difficult to put into words, but the disaster in social interactions should be immediately apparent. When others cannot read our facial expression, a major condition for social acceptance is missing. If this happens during childhood or adolescence, when social bonds are being formed that may provide lifelong emotional support, there is no telling the seriousness of the psychological consequences. Yet this is precisely what happens in a rare congenital disease, usually referred to as Möbius syndrome or Möbius disease, after the German neurologist Paul Julius Möbius (1835–1907) who described it (although not for the first time) in the nineteenth century.[10]

This malady is characterized by paralysis of both sides of the face. Typically, there is maldevelopment of two cranial nerves, the facial nerve and the *abducens* nerve.[11] The former serves the muscles of facial expression; the latter is in charge of activating the muscle that rotates the eyeball laterally, away from the midline (abduction). Patients with Möbius disease therefore are "cross-eyed": they have one or both eyes rotated toward the nose and cannot deviate them away from it. Involvement of the facial nerve makes the sufferers unable to frown, to wink, to smile, and generally to accomplish many of the nuanced gestural modulations of facial expressivity. Although Möbius disease is nonprogressive, it may be accompanied by other congenital abnormalities involving the face, the upper and lower limbs, and the thorax.[12] An extensive discussion of this complex disease would be out of place here, but its mention is important because it is often held as a prototype of pathologic conditions that make smiling impossible. At the same time, it illustrates the central role of the smile in configuring the personality of a growing child.

Socialization is impaired; hence, in addition to the physical limitations, the social maladjustment in this disease becomes a major problem.

Adults discover the extraordinary social significance of the smile when they lose the capacity to express it. A man whose facial nerve was surgically removed, during an operation to treat a malignant salivary gland tumor, narrated for a British newspaper his experience with smile-powerlessness after the operation. On a visit to the pharmacist, he wrote, "I passed someone [on the line] and did that whole 'after you' pantomime, giving her a little smile. Except it wasn't a real smile—it was a sort of one-sided grimace. She gave me a confused and slightly mistrusting look."[13]

Let us imagine a similar scene with ourselves as participants. A man with a strangely inexpressive, "wooden" face approaches us. He is a sufferer of Möbius syndrome and therefore he is also cross-eyed and has some cranio-facial deformity. This man comes close, utters some words which we cannot understand, because his phonation is impaired by his difficulty in moving the lips. At the same time, he slightly inclines his head and body before us, while his deformed face contorts in what impresses us as a grimace bordering on the grotesque. In reality, this man is an honest, friendly neighbor. His inclination is meant as a gesture of good-humored courtesy; his words, as a magnanimous invitation to take his place on the line; and his facial expression as a comforting reassurance of his good will. But none of this comes across as it was meant. His friendly approach incites in us an alert reaction; the misshapen, contorted face enhances our wariness; and his effort at producing a smile becomes the sudden irruption of the astonishingly impressive: the utterly unaccustomed, the wholly abnormal and therefore menacing.

Möbius syndrome is not the sole cause of a physical impossibility of smiling. Paralysis of both sides of the face, an extremely uncommon occurrence, may develop at any age (although rare in children), in both men and women, from a strikingly wide variety of causes.[14] Thus, human pathology manages to produce a number of subjects afflicted with a distressing ailment which, among many other griefs, makes the sufferer unable to smile. Condemned to wear a fixed, inalterable mask in place of a supple, normal, expressive face, they constitute a set of unfortunates who *wish to smile but cannot do it*. Yet pathology keeps in store against our species a cruel tort

of contrary sign, namely the creation of individuals who *have no wish to smile, but cannot avoid doing it.* They are the unfortunates who smile against their will.

Indeed, smiling may be a symptom of certain diseases. Clinicians of the past distinguished two kinds of "pathologic smile": in one, there was a spasmodic contraction of the muscles of the face; in the other, the smile occurred automatically, almost unbeknownst to the patient, without any spasm of the facial muscles.[15] The latter is the species of smile that accompanies a derangement of the mental faculties. A maniacal joy may be viewed in the same light as other disordered or extravagant manifestations of mental illness. The smile in such cases is a fleeting movement, a transitory contraction of the same muscles activated in the smile of a healthy person. Here the smile manifested by the sufferer is not faked. It is the genuine expression of a feeling, except that this feeling is subordinate to a new, disturbed state of the mind. Now, a person whose affective faculties are in a deranged state experiences a variety of emotions, and these may be reflected in a variety of smiles. For life soon teaches us that the smile is not always an expression of unalloyed joy or candid bonhomie. Smile and laughter may issue out of admiration, rapture, ecstasy, disdain, pride, arrogance, and other feelings. Ascertainment of the "moral state" subjacent to the pathologic smile of mental patients was rightly deemed by physicians of past centuries a "curious" study, but one which does not deepen our understanding of the corresponding mental disorders, or the best way to treat them. There is, however, an abnormal smile that historically elicited great interest in medicine. It is produced by a convulsive state of the muscles of the mouth, and medical authors long designated it as the "sardonic smile." The rest of this discussion will be confined to this pathologic smile

The Sardonic Smile

"Sardonic" is a term that comes from Sardinia, the Mediterranean island second only to Sicily in territorial extent. Pausanias says that the Greeks used to call this island Ichnussa, because its shape resembles that of a man's footprint (*ichnos*). Today it is famous for its majestic beaches and the limpidity of its coastal waters. An ancient tradition says that on this island grows a plant

that contains a powerful toxin which, when ingested, causes an involuntary contraction of the muscles of the face. This produces the facial expression that came to be known as a "sardonic smile"; if accompanied by a chortling sound, the term "sardonic laughter" is applied. The ancients were well aware of this, for many allusions to the sardonic smile and sardonic laughter may be found in ancient authors.[16]

A fuller account of the origin of this term requires a brief reference to some facts about ancient Sardinia. By the year 512 BC, the Carthaginians had already conquered the greatest part of the island, and transported thereto their fierce customs, in particular a religion that required human sacrifice. They had a large bronze statue of their god Baal (Ba'al, meaning "owner" or "lord" in the Semitic languages spoken in antiquity, such as Phoenician, Amorite, Hebrew, and Aramaic); a similar effigy existed in Tyre and in Carthage. It could be put under fire and made red-hot. Baal was represented in human form, holding a knife of Oriental design in the left hand, but with the head of a bull to symbolize power and strength. The statue was hollow and its arms were extended in front, so as to receive the bodies of the sacrificial victims, which could be made to roll into its interior, where they would be roasted alive.[17] Holy Scripture contains several mentions of these practices. We read that Manasseh rebuilt in favor of the worshippers of Baal the altars that his father Hezekiah had demolished (2 Chronicles 33:3). The prophet Jeremiah complains that the Israelites burned their children in honor of Baal (Jeremiah 19:5). Also worshipped was the evil god Moloch (some think this name is an epithet of Baal),[18] known to demand children as sacrificial victims. The same biblical prophet speaks of those who "built the high places of Baal . . . to offer up their sons and daughters to Moloch" (Jeremiah 32:35). In terms of cruelty, the immolation of victims in this god's honor yielded to none. To believe some accounts, the pain elicited by their unspeakable torments made the victims contort their facial features in a convulsive grimace that looked similar to a horrible laughter, and hence originated the expression "sardonic laughter." Truth to tell, most historians have attached little credence to this version of the origin of the term.

The ancient Romans noted that in Sardinia there were no wolves and no snakes. A fanciful notion had it that the Sardinian soil was fatal to snakes

(Sardinians, though no less islanders than the Irish, could do without the services of St. Patrick). At one time, the same was said of the island of Crete: to rid one's property of snakes, all one had to do was to spread some wheelbarrow loads of soil brought from Crete over the ground one wished to protect. Absence of serpents and wolves, joined to the fertility of Sardinia, soon turned this island into "the granary of the empire." But, alas, there is no earthly paradise: the absence of some noxious animals coincided with the existence of plenty of creepy-crawly vermin and at least one mortiferous plant—the only venomous plant in Sardinia, according to Pausanias's indulgent view—which the ancient authors said looked like celery. In a popular version, this is the plant that was given to sacrificial victims in pre-Christian times to induce a convulsive laughter terminating in death. Pausanias was quite direct. He wrote: "This deadly herb is like celery, and they say that those who eat it die laughing. Wherefore Homer [in *Odyssey* XX, 300ff.] and men after him call unwholesome laughter sardonic. The herb grows mostly around springs, but does not impart any of its poison to the water."[19]

Thus, eaters of the Sardinian herb ended up dead, with a paradoxical smile on their faces. The Greeks called this plant *selinon agrion*, "wild celery." Today, it goes by the scientific name of *Ranunculus sceleratus*. *Rana* is the Latin for "frog"; *ranunculus* is the diminutive, i.e., "little frog." This curious name was given to the plant because several wild species grow in humid and marshy places, where frogs live. A botanist remarked that, for the reason just cited, a plant whose flowers are extolled as paragons of beauty was named after a creature that assuredly does not have a reputation for comeliness.[20] The species name, *sceleratus*, means "criminal" in Latin, a designation appropriate for an agent responsible for cutting short the life of human beings.

From a modern perspective, is hard to understand the enormous importance that physicians of past eras conferred upon a pathologic smile to which they had granted Sardinian naturalization. A huge literature was devoted to delineating its features and meticulously distinguishing it from similar clinical signs. Some confusion arose from an observation attributed to Hippocrates, according to which a wound that involved the diaphragm was followed by a convulsive laughter. Physicians thenceforth referred to it as "sardonic laughter," since, unlike a smile, it was sonorous and accompanied

by saccadic respiratory movements. Hippocrates' account of this condition may be read in book III of his *Epidemics*, a work that consists of a series of observations.[21] Observation number 95 concerns a man named Tychon, who was a soldier in the siege of the city of Datos, in Macedonia. He received a wound in the chest, and shortly thereafter was seized by a laughter that English translators of Hippocrates characterize as "tumultuous." "The physician who removed the wood [presumably the offending weapon was a javelin] seems to have left part of the lance in the diaphragm," reads the Hippocratic report. The patient was given a purgative and passed a most distressing night. The next day a consultant came to see him. Everyone thought he seemed better, but the consultant said that spasms would soon supervene and he would promptly succumb. This is precisely what happened: spasms appeared and the patient died after a few days.

Today we think that tetanus probably complicated the wound, a common occurrence in an age still ignorant of bacteriology. Moreover, there was no evidence that Tychon's wound had really involved the diaphragm; yet, for over a thousand years physicians appealed to Hippocratic authority to substantiate the contention that the diaphragm was the "muscle of laughter and merriment." The diaphragmatic muscle has a large, pearly-white, tough, fibrous or tendinous portion. A benighted epoch thought this area was of nervous constitution, further strengthening the idea that the diaphragm was the anatomic center that controlled laughter. In light of what we know now, tetanus seems the likeliest cause of the involuntary contractions of the facial muscles which imparted to Tychon's countenance the appearance of a sardonic smile. This must have been quite common in those who succumbed after war wounds. We ought to be grateful for living in an age that can successfully combat this dreadful disease. Physicians of the past, impotent to treat this disease, left us clinical descriptions admirable for their accuracy and thoroughness.

A person who has suffered a wound has a risk of contracting tetanus (any kind of wound: tetanus has been reported after a snake bite, a bee sting, a tooth extraction, etc.). Still, the risk is negligible in small, superficial wounds that are carefully disinfected and very high in deep, ragged, anfractuous wounds contaminated with soil and dirt. The latter led to what formerly was

called "surgical tetanus," in contradistinction to "medical" or "spontaneous" tetanus, a term reserved for the disease acquired in any other way. Regardless of how it was contracted, the main signs and symptoms are the same, and the cause is bacterial infection with a microorganism, *Clostridium tetani*, which elaborates a powerful neurotoxin. Up to the late nineteenth century, most physicians remained ignorant of this basic fact.

The patient afflicted with tetanus feels a dull soreness at the injured site; the surrounding flesh is swollen, reddened, and dry; the pain becomes more intense upon the slightest contact with exterior objects. Some clinicians called this intensification "secondary pain" and saw in it a presage of bad things to come.[22] Soon, transient contractions are felt in the muscles surrounding the wounded part, and extend to other parts of the body; the general rule is for the spasm to affect the masseter muscles, that is, the muscles of the mandible used in mastication (hence the name "lockjaw"). Here is a description by a mid-nineteenth-century physician:

> The patient becomes sad; he is overtaken by a sudden terror, which seems to warn him of the awful fate that threatens him; he is easily frightened without apparent motive; loses appetite; cannot sleep; his tongue is covered by a whitish coating; the movements of the head become difficult, painful. There is a sense of malaise, of tension at the base of the tongue, and this tension becomes a difficulty in swallowing. These manifestations seem to disappear, only to come back soon, separated by progressively shorter intervals until the definitive onset of a well characterized tetanus . . .
>
> The masseter muscles become hard [often said to be "wooden"]: they bring the dental arcades one against the other in such a way that to separate them, at first difficult, becomes impossible regardless of how much force is applied. The contractures may be so intense as to break the teeth; this is a symptom that Boyer considers pathognomonic and has received the name of trismus. At the same time the muscles of the pharynx and esophagus are convulsed, the neck is rigid. The voice pitch appears heightened several notes, the difficulty swallowing is great, deglutition becomes impossible. The salivary glands secrete a foamy, whitish juice, which . . . may dribble from the mouth involuntarily.
>
> After a variable yet short time, the rigidity is propagated to the muscles of the face; the eyebrows, less arched than usual, come close to each other, wrinkling the middle of the frontal skin. The lips slightly separated and

the commissures pulled back leave the teeth slightly uncovered; this state resembles a smile and, joined to the retraction of the eyebrows and eyelids, constitute what has been called sardonic laughter [sardonic smile, we are to understand, if mute]. Soon these symptoms increase in intensity; the contracture becomes stronger; the masseters are hard, protuberant; the lips, drawn back leave the teeth entirely exposed . . . the face is red and presents a frightful appearance; the voice becomes ever more acute and entirely unrecognizable . . . the muscles of the trunk and limbs are rigid, immobile, and adopt varied attitudes, depending on the predominance of action of a given locomotion system . . .[23]

Hippocrates believed that patients afflicted with tetanus died in four days; if they crossed that threshold, they cured. In apparent contradiction, another aphorism of the Corpus Hippocraticus places the threshold at the 7th or 14th day. More than a thousand years later, physicians generally believed that tetanus was a very grave disease, but that the chances of survival increased with the duration of the disease. With such dire prospects it became essential for clinicians to be well informed concerning every manifestation of the disease. Unfortunately, confusion reigned. The expressions "sardonic smile" and "sardonic laughter" acquired a multiplicity of meanings. Sardonic smile could denote—as it still does in our day—a countenance expressive of bitterness, or mockery, or the intent to inflict pain, or to make someone ridiculous. However, some observers failed to see a malignant or sinister character in this facial expression and equated it to simply "ironic"; others thought of it as "amused"; still others saw in it a species of ironic glee without being especially mordacious. Scornful? Mocking? Taunting? Arrogant? Amused? Startled? Which words best described the sardonic smile? When photography was imperfect or nonexistent, and the printed word the chief means of communication among medical professionals, it is not surprising that uniformity of opinion was elusive. Even when hospitals became large institutions where a physician could acquire a vast experience in a relatively short time, the few doctors assigned to such centers formed dissimilar notions of the same observation. This was because authoritarian chiefs of hospital wards were wont to impose on the subalterns their idiosyncratic (and usually invidious, rabidly intolerant) view of things.

The physician author of a medical *Dissertation on Laughter* (1812) reflected this confusion in his treatise. In an effort to improve things, he indicated what he believed to be a faithful representation of the much-discussed clinical sign. Here is what this author had to say about the appearance of the face of a patient with a "tetanic smile":

> We may see at the Napoleon Museum [in 1802, the Louvre was renamed the "Napoleon Museum"] the very well copied expression of a tetanic smile in the face of the iniquitous flayed judge, by Claissens. On the superb painting by Girodet, representing one scene of the Flood, the same physiognomic expression is rendered with a frightening truth in the features of the principal personage suspended from a fatal branch, and still sustaining the entire weight of his elderly father and his entire family.[24]

It seems that the author made a mistake. No painter by the name of Claissens (or its alternative spellings: Claessens, Clessen, and others) exhibited a painting of the mentioned theme. The writer probably had in mind a celebrated painting by a Flemish artist, Gerard David (c. 1460–1523), a native of Bruges, who represented a story told by Herodotus in the fifth book of his *Histories*. In this narrative, Sisamnes is a corrupt Persian judge who takes a bribe and renders an unjust sentence. King Cambyses II, the ruling monarch of Persia (reigned 529–522 BC), decides to punish him and has him flayed alive. Gerard David represented the whole affair in two oak panels painted in 1488: one shows the arrest of the iniquitous judge; the other depicts, in graphic detail, the judge being skinned alive (figure 5.2). Today, visitors at the Groeninge Museum in Bruges viewing the latter painting are quite impressed by the realism of the scene. The face of the tortured man purportedly expresses physical suffering beyond words; at least some physicians thought that his visage, tense but not wildly distorted, reproduces faithfully some features of the much talked-about "sardonic smile."

Sisamnes had a son, named Otanes. King Cambyses named him to the judicature and had him replace his flayed father. The king had the finesse to point out to the newly appointed judge that the chair on which he was going to sit while making his judgments had been recently upholstered, and that a fine leather of very terse texture had been used. No doubt this polite

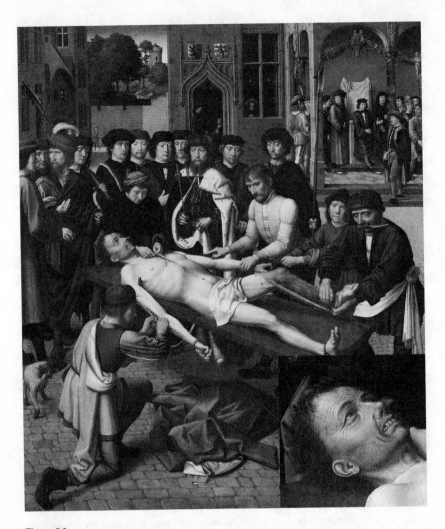

Figure 5.2
The Judgement of Cambyses (1498), one of two panels by Gerard David (1460–1523) depicting the sentence of King Cambyses against Sisamnes, a corrupt judge. Sisamnes is being flayed, in punishment for his crime. *Inset*: Close-up of the judge's face under torture. His facial muscles contract in an expression some physicians consider typical of the "sardonic smile." Groeninge Museum, Bruges, Belgium. From Wikipedia.

concern for his comfort contributed to the uncompromising adherence to high moral principles that the young judge showed during his entire tenure.

But the painting that most attracted the attention of the physician author of the *Dissertation on Laughter* was the handiwork of Anne-Louis Girodet de Roussy-Trioson, conveniently known simply as "Girodet" (1767–1824). This was the painting known as *Scene of a Flood* (figure 5.3), and it is no wonder that it should have made a strong impression, for it is a monumental composition 4.4 m wide by 3.4 m tall, or more than twice the size of the panel of *The Judgment of Cambyses*. Moreover, its theme is apocalyptic, its technique irreproachable, and its emotive charge overwhelming. The scene depicted shows five nude human figures. A strong man at the edge of a precipice is holding for dear life to a tree branch with his left hand while trying to prevent his entire family from falling into the abyss. He is carrying on his back his elderly father and with his right hand, at the end of an overstretched arm, he desperately grasps his wife by her left wrist. She, in turn, holds a baby against her body. Her head is forcefully pulled back by a second child, a young boy who is holding on to her hair as a way to avoid a precipitous fall. This harrowing scene is illuminated by lightning that rends the sky. Flowing draperies add to the theatricality of the scene, while affording to the artist the opportunity to show his virtuosity in the rendering of the naked bodies of the personages.

The painting created a sensation when first exhibited. Critics formed two factions: some raised a number of objections, others countered with emphasis on the strengths of the work. One of the complaints was that the composition lacked the grandeur and vastness called for by a biblical event. Great masters of the past had always endeavored to convey a sense of sublimity and imposing magnificence when approaching the theme of the Flood. Girodet, in a letter published by a newspaper, replied that he did not mean to represent the biblical Flood, but just a scene of a natural disaster: the mistake had originated in a misprint of the title of the work in the exhibition's catalogue. Many critics protested that scenes of hopeless, frantic despair and overwhelming tribulation should not be the work of artists; advocates counterargued that a moral and philosophical lesson was ensconced in the painting, which could be seen as an allegory of the gallant defense that men

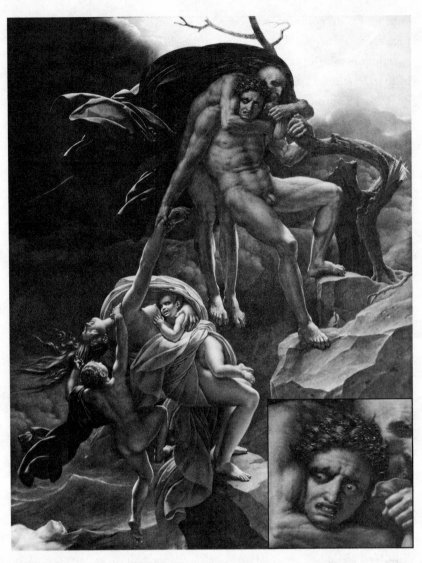

Figure 5.3

Scene of a Flood (1806) by Anne-Louis Girodet de Roussy-Trioson. Louvre Museum. *Inset*: Close-up of the facial features of the main personage, which a physician considered characteristic of so-called "sardonic smile." From Wikimedia Commons.

of able body and noble spirit undertake when protecting the vulnerable segments of society, the elderly, women, and children.

For the present discussion, the most important feature is the facial expression of the man who is trying to preserve his family from destruction. It is difficult to see why this expression should be called a smile; but beyond that, its characterization remains problematic. It seems a strange mixture of terror, unyielding, desperate firmness, and extreme muscular exertion. Although the lips appear retracted upward and uncover the teeth, the commissures are not drawn back to the degree seen in normal smiling. The eyelids are not retracted. The skin folds in the periocular region are not accentuated; and, contrary to what is seen in a regular smile, the eyes of the personage appear inordinately wide open. Physicians contemporary with the creation and first exhibition of this painting, lacking the technology of image reproduction that exists today, must have been confused by the contradictory descriptions of the sardonic smile and much intrigued by the true nature of this clinical manifestation.

It often happens in medicine that after the original description of a pathologic condition, a number of "variants" are reported that blur the lineaments of the initial depiction. The same thing happened with the sardonic smile. It was said that a malevolent, sardonic-like smile appeared in persons seriously ill with various diseases that fell into delirium, but if the smile looked benignant the prognosis was more favorable. No one explained how to ascertain the benignancy of the smile. Still, this notion was held since the times of Hippocrates, who stated in one of his aphorisms: "Raving delirium which is accompanied by laughter is safer; that accompanied by seriousness is more dangerous."[25] The cumbrous terminology and overabundance of synonyms must have deepened the confusion. Some authors called "sardonic" a pathologic smile that contorted the mouth to one side (facial palsy in today's terminology). Some proposed the term *tic cynique*, although a "tic" is a neurological dysfunction of very different significance. Additional names used, without clearly delineating the meaning of each term, were: *risus caninus* ("dog's laughter," because the upper lip is pulled upward, uncovering the teeth as in a growling dog); spastic tic; *risus cynicus*; *tic sardonique*; *trismus sardonicus* of Baumes; sardiasis of Linnaeus; *tortura oris*; forced laughter;

convulsive laughter; bastard laughter; and even "Saint Médard's smile / laughter" because, in Catholic countries, that saint was believed to have the power to cure toothache and oral ailments. His effigies represented him with a grimace that showed his teeth; and it was a widely shared opinion that this gesture resembled the clinical sardonic smile.

This state of affairs perhaps explains the eagerness of some physician to find what exactly was meant by sardonic laughter or sardonic smile. The earnestness of their desire for knowledge is illustrated in the following anecdote.

Théodore Tronchin (1709–1781), a prestigious Swiss medical doctor who practiced in France before the Revolution, became the physician and friend of the likes of Rousseau, Diderot, and Voltaire and enjoyed great popularity among the high aristocracy of the *ancien régime*. Madame de Genlis (Stéphanie Félicité du Crest de Saint Aubain, Countess of Genlis, 1746–1830) was one of his patients. This lady survived the Revolution and became a noted author. In her memoirs, she left us a vivid description of doctor Tronchin's passion for his profession.

Tronchin was taking care of a Monsieur Puisieux, who was his patient as well as his *very dear friend* (emphasis of the lady memorialist). As was common in those days when attending the rich and powerful, the doctor stayed in the patient's mansion. Singular times: doctors not only made house calls, they could be live-in "health care deliverers" as they are dubbed today. Still, in our story all the ministrations of Dr. Tronchin were useless. A severe pneumonia quickly sapped the vitality of his patient. After five days of futile struggle, during which the medical man rarely left the sufferer's bedside, Tronchin was forced to declare that there was nothing else he could do, that he was now withdrawing to his bedroom, and advised Madame Puisieux and Madame Genlis, who kept her company, to do the same. After about one hour, Madame Genlis sent a housemaid to the sick man's bedroom to find out how things were going. The servant came back to report that the doctor was back by his patient's bedside. This was most unusual, since Tronchin had firmly declared there was nothing else he could do. This made the authoress conceive new hopes: perhaps there had been an unexpected turn for the better! She rushed to Monsieur Puisieux's bedroom, and at this point we must let her speak:

I entered the bedroom, and I was seized by horror upon seeing the state in which he was. In the last moments of his life he had a sort of convulsive laughter; this laughter was noiseless, but one could hear it distinctly and continuously; this frightful laughter [Madame Genlis, in her distress, was probably confusing the stertorous respirations of the patient], with the impress of death covering his disfigured face, formed the most awful spectacle that one could imagine. Doctor Tronchin, sitting close to the patient, looked at him fixedly, and considered him with the greatest attentiveness. I addressed him and asked him if he had seen some signs of hope, since he again was by the side of Monsieur Puisieux. "Ah! By God, no!," he answered; "but I had never seen the sardonic laughter; and I was very pleased to observe it." I shuddered . . . *Very pleased* to observe that awful symptom of an imminent death! And it was the friend of the dying man that expressed himself that way![26]

Madame de Genlis's indignant tone is understandable. Tronchin suffered from that professional deformation that makes an oncologist speak of a "beautiful case of multiple myeloma" or a pathologist of "a wonderful specimen of cardiac cirrhosis of the liver." They mean no callous disrespect to anyone. The "beauty" that they perceive in direful pathology is entirely of an abstract sort: it derives from the perfect correspondence between theoretical concept and concrete reality. When the ideas propounded in medical treatises fit to perfection every detail of the reality encountered in practice, "beauty" is not an unfit term to denote that seamless meshing. Plato's disciples at the Academy would have no trouble understanding this. But the common reaction among the laity is to condemn the attitude that juxtaposes the term "beauty" to spine-chilling bodily disaster, and to accuse those who incur this fault of callous, unsympathetic insensitivity. Indeed, professional deformation may be carried to a loathsome extreme. A joke from past centuries subsumes this opinion. A surgeon, victim of depression, is visited by friends who inquire after his state of mind. He tells them: "I can't shake off the doldrums. Vacations, travel, good meals, and entertainment: nothing can cheer me up. I have tried everything. These days, not even amputating a leg or an arm can uplift my spirits!"

We have the good fortune of living in an age when tetanus can be completely prevented and advantageously treated. Medicine has shifted from

whimsical and speculative considerations about the outward signs of diseases to fundamental, scientific understanding of their causes and effective ways to treat them. The sardonic smile is now destitute of its former clinical fascination. Modern medicine casts a passing glance at the eccentricities and follies this celebrated grimace once provoked, and moves on. And so do we: it is time to advance to the next aspect of the fantastic mythical Corpus in which the lips are embedded.

THE KISS

The *OED* tends toward laconism in its definition of the noun "kiss" It is: "A touch or press given with the lips in token of affection, greeting, or reverence; a salute or caress given with the lips." We are informed that the word, of Teutonic origin, first appears in English as *cosse, cuss, cuse*, and so on. Its earliest record, still in its *cosse* shape, and always according to the *OED*, dates from the year 1000 and comes from the homilies of Ælfric of Eynsham (955–c. 1010), an abbot of the Anglo-Saxon church and amazingly prolific writer. Dictionaries of the Latin languages tend to be more expansive, partly because they usually list a closely associated word which in English may be rendered as "hand(s)-kissing" (Sp. *besamanos*, Fr. *baise-main*). It denotes a ceremonial act expressive of devotion, respect, or submission which consisted of kissing the hand of the king, or persons of royal status, dignity, or power. Only the influential had the "privilege" of kissing the king's hand. The common people had to content themselves with touching his cloak or mantle, or could salute him from a distance by putting their hand to their mouth. Hand-kissing was an established custom in all the courts of Europe. The Spanish conquerors found it already established among the Mesoamerican indigenous peoples.[27]

This act had a somewhat religious or sacred character, as it is known to have been part of idolatrous cults. In ancient times, the act of adoration consisted in the worshipper piously kissing his or her own hands. Pliny, discussing superstitions, wrote; "In the act of worshipping, we kiss our right hand" (*In adorando dexteram ad osculum referimus*).[28] And Job excuses himself of having addressed the stars with this superstitious act: "If I have looked at the sun . . . and my mouth has kissed my hand . . ." (Job 31:26–27).

The lips are a major instrument in that mute but intense form of communication, the kiss, which poets like to call "the language of the heart." It used to be said that a "universal instinct" confers this function on the lips, for seemingly everywhere and at all times the kiss has been a natural expression of love, respect, devotion, friendship, religious fervor, peace, or charity. Yet at the same time, scholars remind us that the kiss is culture-dependent[29] and therefore subject to all manner of changes. Thus the kiss is commonly trivialized, or its original purity perverted, as happens to rituals. It is well known that among the French, when friends encounter each other, they enact the custom of alternatively kissing each cheek: twice in total as a general rule, thrice in some regions (Saintonge, Belgium), and up to four times on certain occasions.[30] The 2020–2021 pandemic forced a pause in this age-old custom, but it is a safe bet that it will be reinstated in full as soon as it is no longer considered a risk to public health. As to perversion of kiss praxis, everywhere the "kiss of Judas" indicates betrayal; and the "kiss of death," in the style of members of the mafia, is the sign of a death foretold. The altered meaning of the kiss may take a positive turn: such as the stories of saints who kiss lepers and restore their health; or the Hapsburg counts who could heal stammering children with a mouth kiss;[31] or the power of a princely kiss to wake up Sleeping Beauty from a multigenerational slumber.

In stark contrast with the momentous significance of these kisses, there is also a kiss which, *by definition*, is possessed of no meaning whatsoever. It originated in France and is known as the "Kiss of Lamourette."[32] The story of its birth is as follows.

Abbot Lamourette was vicar general of the bishop of the city of Arras. He was also a close friend of Count Mirabeau (1749–1791), the leader of a moderate faction in the early stages of the French Revolution, famous for his powerful eloquence as an orator. Lamourette, on his part, was elected bishop of Lyon in 1791 and shortly thereafter became a deputy in the National Assembly. Politics were red-hot at the time: the attempted flight of the royal family had divided France and the Assembly into two mutually hostile camps. There was talk of establishing a republic. Deeply moved by the factional hatred and the division that so cruelly injured his country,

Lamourette climbed the tribune at the Assembly and, on the famous session of July 7, 1792, attempted to reconcile the two antagonistic parties. Impelled by a sincere, generous sentiment, he spoke of peace and union in the name of the fatherland, and the duty of all deputies to remain true to their oath of fealty to king and country.

It seemed that abbot Lamourette had acquired the legendary eloquence of Mirabeau. He was speaking from the heart, driven by a deeply rooted conviction. He exhorted all the deputies to forget their animosities, give up all malevolence, and rally around the Constitution. His words seemed to have a magical effect: the antipathies disappeared; partisans of the most rancorous, contrary opinions hugged each other, teary-eyed; the Assembly decreed that a report framed in terms of the newly found patriotic cordiality should be taken to the king and copies distributed in all the departments of France. King Louis XVI immediately came to the Assembly, where he was received with a standing ovation; the deputies *en masse* accompanied him when he went back to the Tuileries palace.

Alas, all the enthusiasm and heart-warming *fraternité* lasted a matter of hours. Three days later, the parties were at each other's throats. The royalists had insulted the revolutionists. The Assembly stoked the fire of revolutionary fervor with the formula "Citizens, the fatherland is in danger!" Mutual detestation, abhorrence, and poisonous rancor were, if anything, worse than before. Where were all the fraternal embraces provoked by the July 7 speech? They found a place in the expression *baiser de Lamourette*, "Lamourette's kiss," which thenceforward meant a transitory, insincere reconciliation.

In politics, this is common fare: we repeat the cycle with some regularity. We watch on television a politician speaking persuasively of canceling divisiveness and finding common interests "across the aisle." Our senses are seduced; our heart is carried away, so to speak, by our imagination; and our reason is obnubilated by hope. Beware! We are being furnished with the customary quota of Lamourette's kisses.

From all the foregoing it is clear that to draw up an inventory of the meanings attributed to the kiss is a formidable task. The need to circumscribe my theme leads me to consider a division of kisses into discrete subtypes. The ancient Roman grammarians cut through the great morass of sociocultural

meanings by classifying all kisses into three great groups: the *oscula*, or kisses given between friends to express friendship and affection, as, for instance, on the cheek in greetings; the *basia*, kisses which may fall on the lips and are definitely a notch higher in affective temperature than the previous category; and the *suavia* (older form, *savia*), passionate kisses with a heavy erotic charge, like those exchanged between lovers amid their torrid embraces. This distinction is not absolute; scholars assert that it is "not borne out in usage,"[33] since classical authors write "osculum" in a variety of situations, from chaste to obscene; similarly, "suavium," which supposedly carries a libidinous connotation, sometimes appears in a morally pure context, with not a shade of lewdness. Not to mention the fact that the Romans had many oscular subtypes, certainly more than three: they had a kiss of salutation among members of the same family, a kiss of farewell, and, in addition, kisses of reencounters, of funereal occasions, of thanks, of reconciliation, and of congratulation.[34] But, having acknowledged the futility of attempting a typology of kisses, henceforward the discussion will refer to the kisses of distinct erotic coloration: I mean the kisses of lovers; those that the ancient grammarians would have catalogued somewhere above the *basium* and into the realm of the *suavium*.

The Philosophy of the Erotic Kiss

Let us be clear. The question to be answered is this: Why is it that the mutual rubbing of lips, which as we have seen are structures that cover externally the oral cavity—the latter having mainly alimentary and phonetic functions—should suffice to send lovers into a state of ecstasy which they do not hesitate to compare to a trance or a mystical enrapturing?

In this analysis we shall follow the guidance of a philosopher. But wait! A philosopher who investigated the nature of erotic kisses? Where shall we find such a *rara avis*? In Renaissance Italy, of course: for that was the time and the place where a species of men sprouted whose emotional register was many times broader than ours: men who seemed equally sincere composing a devout religious homily one minute and slashing a rival in a tavern brawl the next. More than one philosopher of those times discoursed on the erotic kiss; but it was Francesco Patrizi (1529–1597), a Renaissance scholar born

on the Adriatic island of Cres (Cherso, in Italian), who reached the highest notoriety, thanks to a brief work that he wrote entitled *Il Delfino, ovvero del bacio* ("Delfino, or Of the Kiss").[35] This opuscule is written in the form of a dialogue between a wise hermit (in reality Patrizi himself) and a young man, named Angelo Delfino, not otherwise identified. The subject of their conversation is the erotic kiss, its meaning, and the sensation experienced by lovers in the act of kissing or being kissed. I will now paraphrase and partly abbreviate their conversation.

Delfino starts by asking why it is that kisses produce so much sweetness. Patrizi prefaces his reply with the caveat that he is a recluse, an anchorite who has renounced the world and therefore knows nothing about such matters. However, just as Socrates had a "daimon" who inspired many of his speeches, so Patrizi can invoke the spirit of Eros, the deity of love, and have this one dictate to him the appropriate answers. Thus, everything that he will say must be taken to be the words of Eros uttered via Patrizi's mouth. The conversation, in the style of a Socratic dialogue, starts with a series of questions and answers about innocuous, nonerotic kisses. This part of the dialogue ends as follows:

Patrizi: Have you ever been kissed by your mother or your father?

Delfino: Yes, why?

P.: And that kiss seemed to you immensely delicious?

D.: It did not, I assure you.

P.: Therefore, not every kiss is equally delicious.

Arrived at this first conclusion, the conversation proceeds to eliminate other oscular variants: Is a kiss on the forehead supremely delicious? No, that on the mouth is undoubtedly superior in this regard. But friends in Venice at the time practiced mouth-kissing as a salutation. Would that type of kiss suffice to provoke the intense sweetness? No, says Delfino, he means the kiss exchanged in a love relationship. The dialogue continues:

P.: But suppose that you have an erotic encounter with an ugly, malodorous woman, one with bad breath to boot. Would her kiss qualify as immensely delightful?

D.: Well . . . I would rather leave that experience to others.

P.: I see. Instead, you derive your delight from the kisses of a beautiful woman.

D.: I feel like agreeing with that.

P.: Well, I disagree. I have heard of some highly placed men who, when embraced by beautiful but ignorant and ill-behaved women, have rejected their kisses, as if such women were repugnant, beautiful as they were.

D.: I don't know about that. I have to take your word for it. But if it is a kiss of the woman that one loves, what would you say then?

At this point Patrizi makes a lyrical invocation of Eros, pleading for inspiration on what to say as the dialogue goes on:

P.: I believe, then, that the ineffable sweetness is experienced in the kiss of the person loved; and the spirit of Eros now advises me to tell you that it is love, and nothing else, which makes the delights of the kiss; for without love that kiss is dead and destitute of all flavor.

Delfino wants to know precisely how that comes about. Patrizi's answer begins with a recapitulation of many of the previous exchanges. The kiss of an ugly being is disagreeable. That of the parents is neither repugnant nor as intensely delightful as that of the lover. He summarizes:

P.: There is no burning without fire. By the same token, no kiss is seasoned with sweetness if it is not the kiss of someone in love. Hence it is love that confers the sweetness to the kiss, since this one, without love, has no sweetness, just as wood without fire can neither burn nor heat.

D.: You speak the truth.

P.: Therefore it is not the kiss in itself that procures sweetness; for if it were so, it would always be delicious, regardless of the person concerned. But this is not the case, since the kiss may be even repugnant when animated of a sentiment different from love. Hence, only the kiss between lovers is sweet, just as only that wood heats and burns which is on fire.

D.: Your spirit is dictating you the very truth.

Now the discussion takes a turn that we might deem more "technical":

P.: Now, Angelo Delfino, do you mean to tell me that you experience this sweetness about which you exult so marvelously only with kisses to the mouth?

D.: Where else? On the cheek, perhaps, provided it is not too prolonged. On the forehead? No, since that is not an erotic love-kiss, but just a token of tenderness.

P.: Here, I ask you to pray to the god of Love, that he may disclose to you the deepest secrets of his sweetness; for, believe me, without his grace you cannot pretend to know them.

D.: Oh, I do pray! I do! I pray to that powerful god most devoutly. I ask him to please make me a worthy contemplator of the arcane secrets of the pleasures he dispenses on us human beings.

P.: All right. I now hear this god telling me to let you know that the love kisses are those given on six parts of the beloved; six, neither more nor less; and the manners of giving them are four, not a single one more than that.

The secret revealed by the god is that the six parts are: the hands, the chest, the neck, the cheeks, the eyes, and the mouth. And the four modes of administration are: with the tip of the lips; with suction exerted by the lips; with bite; and with the tongue. There follows a discussion of the relative merits of each of the kissable bodily parts and each of the modes of kiss administration. A graduated scale is constructed. Least sweet to kiss are the hands; the chest is clearly sweeter. There is a curious detail, says the love spirit (through Patrizi's mouth, of course): even though the chest is a bodily part more delicate and softer than the neck, still there is more sweetness in kissing the latter than the former. But the kiss on the mouth is one that overcomes and surpasses all the others. Nonetheless, it admits four modes of administration: joining lips to lips; sucking the loved lips; giving the tongue; or receiving it.

P.: And do you know, Delfino, what is the chief difference between this mouth kiss and all the other oscular forms?

D.: No. What can it be?

P.: It is that all the other kisses—to the hands, chest, neck, cheeks, and eyes—are kisses that are given; but that on the mouth is given as well as

received. And of these two, which do you think is sweeter, the given or the received?

D.: Personally, I experience the greatest sweetness when it is the woman who kisses me.

P.: You are partly right and partly wrong. Consider the modes of administration. With the tip of the lips implies equal sweetness to both participants, since one neither gives nor receives more than the other. Hence the sweetness of this modality is inferior to the others.

D.: All right. But in those other modalities, which of the two participants derives the greater pleasure?

P.: Without a doubt, the one who loves more.

D.: But supposing the two love in exactly equal measure, which one of the two derives more pleasure, the giver or the receiver?

P,: Regardless of the kiss modality, it is certain that the one who receives gets more pleasure than the one who gives.

D.: That, dear spirit of Love, I find hard to believe. Admittedly, when there is tongue activity, the receiver experiences a greater sweetness. But in all the other modalities it is the other way around. In the kiss with lip-sucking, the sucker is the giver, since he actively creates the vacuum with his mouth, and he experiences greater sweetness than the sucked, who is the receiver. The same applies to the other modalities of the kiss: whether it be chest, neck, eyes, or hands, the receiver experiences little sweetness, whereas that felt by the giver is considerable.

P.: From a strictly materialistic point of view, your reasoning about the kiss is faultless, but I was referring to something else.

D.: And, pray, what may that be?

P.: I was referring to the origin of the sweetness in the kiss, which is the spirit of the person loved. And I say that the lover is nourished by it, and that is why so much sweetness resides in the kiss.

This answer disconcerts Delfino, but he senses that something important is behind those words, and asks for further clarification. He will get his answer, but it will come in a roundabout way. First, he must understand some basic concepts about the love passion, especially how it originates. This

gives Patrizi an occasion to descant on his ideas about this important matter. Now, Patrizi was one of the philosophers of the Neoplatonist school, the leading voice of which was Marsilio Ficino (1433–1499), whose philosophical reflections on love are related in his book Commentary on Plato's Symposium on Love, which eventually he referred to simply as "On Love."[36] Patrizi draws abundantly from this work, and from its inspirational source, Plato's *Symposium*. There is, however, an important difference between Ficino's and Patrizi's approaches to the erotic love theme: Ficino often has recourse to metaphysical concepts—after all, he is the coiner of the expression "Platonic love"—whereas Patrizi, who studied medicine, attempts to explain things as natural phenomena. Ficino, following Plato, says that love originates with God and that lovers, if they love properly, gradually turn inward to the soul, away from the corporeal realm, becoming progressively better beings in their ascent toward the ideal perfection. Patrizi, in contrast, alludes to medical traditions, which thought of love as a disease secondary to an imbalance of the so-called "humors."[37]

In discoursing on the origin of love, Patrizi follows closely the Platonic ideas expounded in Plato's dialogues (notably in *Symposium* and *Phaedrus*) and in Ficino's *Commentary*. There is no need to recount here in detail the chief concepts on love expounded in these works; these are now classical texts that contain some of the most beautiful poetical-philosophical dissertations of Western culture. In very broad terms, Patrizi repeats the idea that love arises from an "inner resemblance" of the lovers. God creates a human soul in heaven, and at the same time forms an "ethereal little body" (called "astral body" in Ficino's *Commentary*)[38] which acts as vehicle or means of transportation of the soul in its travel to earth, where it penetrates the body of expectant mothers and invests the material body of the human being before birth. In its travel from the Milky Way and across the various spheres of the heavens, the "astral body" will be exposed to the influence of the stars, each of which can imprint specific characteristics on the traveling soul. But the constellations are always moving, so the strongest or predominant star will not be the same at different times. The traveling soul will receive a forceful imprint by the reigning star, "just as when we stroll we are bronzed by exposure to the sun." Now, two different souls that are affected by the same

predominant star, or by some other star of strong brilliance, will resemble each other. This is the "inner resemblance" of which love is born. It is a resemblance of souls. But there is also an "inner resemblance" of bodies. This refers to the arrangement and proportion of the body's "humors" as conceptualized in Galenic medicine. The resemblance of the lovers' bodily components originates in a manner similar to that of the souls.

The other element that generates love is beauty, of which there are two kinds: corporeal and incorporeal. On this topic, the exposition adheres closely to the Platonic doctrine. More directly germane to Delfino's question is the way whereby love—born of beauty and resemblance—enters the human heart. Patrizi explains that the *eye rays* are the true arrows or darts of love, since they transport the *spirit* of one person to another. Both of these terms need to be explained.

That there are light rays emanating from the eyes is something that no one would deny in the Renaissance. The "proofs" quoted are many. Nocturnal animals have resplendent eyes: the eyes of owls, felines, and other creatures shine in the night. It is true that we do not see this shining in the normal human eye, but ancient physiologists affirmed that a kind of "fire" must exist inside the ocular globe. It suffices to push our eye globe toward the nose for us to see a clear circle full of light. This shows that there is light inside the eye. Many scholars maintained that the light originated in some kind of fire. When we receive a blow near the eye, we "see stars": those luminous points are the embers dispersed by the force of the blow. Nocturnal animals can see in the dark because their eyes send off light rays that illuminate the darkness before them. We would be unable to see their eyes, were it not that their resplendence is transmitted to our own eyes by the rays that surge from their eye globes. If one of these animals fixes its gaze on a perfectly flat, smooth surface, a small luminous circle will form on it, corresponding to the pupil. Human eyes may harbor such a strong light. Plutarch says that the magistrates of the town of Minturnae condemned Caius Marius to death; and, since none of the citizens dared to execute him, they sent a foreign soldier to undertake the task. Marius was lying in a dark room, and when the soldier went in, he saw such a strong flame coming out of Marius's eyes that the would-be killer threw his sword down on the ground

and fled from the room in terror.[39] Emperor Tiberius, when he awoke in the middle of the night inside a perfectly dark room, could see clearly the objects around him for a short while. This would have been impossible if his eyes were not harboring some kind of inner light active at least for some time.[40] Of Caesar Augustus it is recounted that his eyes sometimes shone with such intense refulgence that people who confronted him were dazzled, could not sustain his gaze, and were forced to bow their heads before him. All this shows that a source of light exists in the eye, whose rays are emitted to the outside through the pupil.

The other term that needs clarification is "spirit." What this meant to Patrizi it is best to let him explain. "Spirit," in his words,

> is nothing but a very subtle vapor of the blood produced in the heart by the natural heat of this one; and this spirit, through the veins [*sic*] that physicians call arteries, transports the heat of the heart into the smallest particles of the living body, which is thus kept warm and alive. It is the true agent of life and warmth for each one of us. And since things that are warm and subtle by their nature tend to rise up, a large part of the spirit thus formed will climb from the heart to the head, and to the brain, where it is rendered purer, so to speak, due to the temperature of the latter. Thus it becomes not only the instrument of life, but also of the cognitive powers of the soul and of the movements of the body, since thanks to suitably disposed channels, it is sent to the instruments of sensibility and will. Because of this, man is endowed with sensibility and will. Two vessels shaped like veins leave from little nerves of the brain and arrive at the eyes. These vessels are large enough to convey abundant purified spirit to the eyes. And because the spirit itself is clear, it makes the eyes of animals and men clearer and more resplendent than any other bodily part.[41]

Patrizi explains that the spirit, impelled by the cardiac beats, reaches the surface of the body, where it enters the tiny orifices that are called skin pores, and is dispersed. There are also minuscule, invisible pores in the eye; and the spirit joins the rays of light that emanate from the eye,

D.: All that sounds fine, but how can you prove this union of spirit and ray of light?

P.: The proof exists. If a woman during her menstrual period looks at herself in a mirror, this mirror will become stained by tiny droplets of

blood. The reason is that the spirit, humidified by blood, is transported by a light ray to the surface of the mirror; and there, due to the cold surface of the mirror, it condenses into droplets and forms a stain that is difficult to wipe off.

D.: Is this really true?

P.: It is. You can confirm it if you want, by personal observation. I learned about this from a friend, who communicated it to Aristotle, and this great sage wrote it down in one of his books.[42] But there are other proofs. For instance, you may fall ill if you watch too fixedly the eyes of a sick person.[43] This is precisely what happened to our great poet, Petrarch, who fell ill for having watched too fixedly the right eye of his beloved Laura.

D.: Yes, I know, for he said so in that sonnet that says: "What luck befell me when from one / Of the two most beautiful eyes that ever existed / Seeing it dark and by pain disturbed / A force came out that rendered mine sick and dark!" (*Qual ventura mi fu, quando da l'uno / de' duo i più belli occhi che mai furo, / mirandol di dolor turbato e scuro / mosse vertù che fe' 'l mio infermo e bruno!*)[44]

P.: Indeed; and you young people must know that this takes place not by a magical spell, but as a natural phenomenon. The spirit that comes out of their eyes together with the light rays are the active agents. And it was precisely this spirit which transported the disease to Petrarch's eye. Listen attentively, I will tell you how these things happen.

D.: I am all ears.

P.: Very well. The spirit that comes out joined to the luminous ray encounters the eye of the other person. At this point, it all depends on the relative force and abundance of the luminous rays. Say that one has more abundant and more brilliant rays than the other. In that case, the other person will be dazzled. Bedazzlement opens the pores and by this means the stronger spirit will introduce itself into the spirits of the receiving person. However, once inside these spirits, it will discover that they are not enemy spirits; instead, they are akin, and almost brothers, since they are under the same astral domination. Hence it admixes itself with them; and because it is subtle like them, it can go in their company to the heart that originated them. So it is that a foreign spirit enters into the host heart; and due to the resemblance that it has with the native spirits, the host heart will receive it

and will protect it most gladly. Up to here, Delfino, this exposé refers to the amorous intelligences. But recall that the spirit that entered through the eyes carries with it an image of the beauty from which it originated. Thus, the foreign spirit informs [in the sense of permeating or communicating the essence of a quality] the host heart's spirits of the form of the beauty that it has brought with it. The rational soul sees this form in the spirits, compares it with the idea it has stored, and recognizes that it resembles its own idea of the beauty of the human body. In making this comparison, it often happens that the contemplating soul is lured into trying to remedy some defects in the beauty by adding some perfection from its own spirit. From this allurement is born the common lure of the lovers who always see the beloved as more beautiful than he or she really is. In sum, this is how love gains entrance into our hearts. This is how foreign spirits enkindle, thanks to their heat and their resemblance, the flame and the sweetness that the lover experiences in his heart. And this is how love makes the spirits of the beloved sweet and soft, for it is via the intercession of spirits that love manages to sweeten those of the lover and make them similar to those of the beloved.

Delfino acknowledges that the secrets unveiled by the god of Love through the utterances of the anchorite are indeed of a marvelous nature. The discussion continues over specific details concerning the mode of action of the lovers' eyes and the mechanism of entrance of the spirits through the ophthalmic system. Gradually, the discussion narrows its focus to Delfino's initial question about the enigmatic origin of the sweetness of the erotic kiss. Patrizi zeroes in on this matter in the following way.

Physiopathology of the "French kiss"

P.: The lover's heart, insofar as it is heart, desires the renewal of its spirits (for the spirits get used up and become rarefied in the course of time); but insofar as it is an amorous heart, it desires the joy that such spirits procured it, which the wasting or rarefaction of the spirits weakens and might possibly extinguish. But this joy may be renewed thanks to spirits akin to those lost. A way to renew them is by seeing the eyes of the beloved, but more effectively yet by touching the beloved. This is because the heart of the lover, by its natural movements, draws in air through the arteries, and instead of air it draws the spirits of the beloved which

come to his heart by the same route, and are the lover's nourishment and delight.

This is how a lover feels a sudden surge of his ardor and an increase of sweetness. There are two arguments to prove this. The first is that the more numerous the bodily parts of the beloved that are touched by the lover, the higher is his ardor and the greater is his joy. The reverse is also true. The reason is that the quantity of spirits that the lover draws to himself depends on the number of arteries approached by the lover's tact. A second argument is that the sensation is not the same in cold weather. Cold contracts the pores, so that the spirits of the beloved cannot exit; consequently, the lover cannot draw them to himself. Note that the lover experiences greater sweetness in hugging the love object than simply touching it. This is because in a tight embrace the two hearts are out of breath, and this causes them to send off their own spirits and to draw in the spirits of the other with greater force and in larger quantities. It stands to reason that when those are sent off more abundantly and these drawn in similarly in increased amount, the sweetness and the ardor experienced should be greater.

And now, Delfino, I finally come to your original question about the sweetness of the kiss. The kiss is sweet to the lover for the simple reason that it allows him to draw in the spirits of the beloved, whether he kisses the hand, the neck, the chest, the cheek, the eyes, or the mouth. For the same reason, the kiss with suction is sweeter than the kiss with the tips of the lips only. For it allows him not only to draw in the spirits normally expelled, but thanks to the suction a lot more are drawn, of which the lovers are nourished. This explains that of all the kisses with suction that of the mouth is sweetest, because the mouth is a wide orifice which offers a larger passage to the spirits than the tiny pores of the skin. The inflow of spirits will be considerably greater. But within the category of kisses with suction, that of the tongue is still sweeter, because not only does it permit drawing in as many spirits as the kiss with suction, but still it draws in an excess of them, because it draws from the tongue, which is a thoroughly spongy body continuously being refilled with spirits. Moreover, this organ tastes of the inner, humoral constitution of the beloved's body. The inner humor contains in it a mixture of bodily heat and spirit. Therefore, in this kiss is found the mixed sweetness of a bodily humor and of abundant spirits drawn from the beloved's heart.

CONCLUSION

If following a passionate kiss the reader ever experienced a complex syndrome characterized by palpitations, weakness, shortness of breath, flushes, a certain languorousness that alternates erratically with a chipper state, or a combination of these and other strange symptoms, the preceding explanation from a Renaissance physician may have been illuminating. Actually, the reader has two choices to make sense of the disturbing symptomatology. One is to heed modern-day physiology, which speaks of endorphins, dopaminergic or serotonergic neurons, and activation of the complex "reward pathway" brain circuitry in the limbic system. With due respect to the formidable scientific data of present-day neuroscience, many people continue to feel greater sympathy for the second explanation. I mean the one expounded by Francesco Patrizi to the wide-eyed Delfino—or to the modern reader willing to listen: Your languishing state and your immoderate exultation are due to the sudden onrush or the brutal emptying of spirits: the spirits are being tumultuously injected into you or savagely sucked out of you by means of a curious maneuver, the so-called "French kiss."

6 ON SOME OF PHYSIOGNOMY'S GROWING PAINS

ASTROLOGICAL-DIVINATORY PHYSIOGNOMY AND ITS FOREMOST PALADIN

The part of physiognomy touching astrology and divination looms large in history. The Renaissance saw great practitioners of this art, almost all physicians. Divination falls naturally within the medical realm. Each time a physician makes a diagnosis, the patient wants to know what will happen to him or her: diseases carry a prognosis, and it behooves the physician to anticipate the likeliest outcome. In the Renaissance, however, divination was strengthened by a basic premise of physiognomy. The idea was that the features of the face, and of the body in general, not only revealed the character and temperament of the subject, but were written "marks" or signs imprinted by heaven that bespoke the destiny of the bearer. Experts who could "read" these marks would be able to guess the future of the person bearing them. Notable among all divinatory physicians was a man of extraordinary eccentricity and uncommon genius: the Italian polymath from Pavia (some say Milan), Girolamo Cardano (1501–1576); his name is usually transcribed in English as Jerome Cardan, a custom that will be followed here.

He was a physician, chemist, biologist, astrologist, astronomer, and mathematician of rare merit. As a clinician, he was the first to describe typhus fever; as a mathematician he wrote a treatise, *Ars magna* or *Great Art*, considered a cornerstone in the history of algebra and the first work in Europe to make systematic use of negative numbers. In his opus *Liber de ludo aleae* (*Book of Games of Chance*) he laid out a computation of probabilities

a century ahead of Blaise Pascal (1623–1662) and Pierre de Fermat (1607–1665), authors considered pioneers in probability theory and infinitesimal calculus. Jerome Cardan's writings made him a popular author: the two mentioned works continue to be printed today.[1] Of course, his popularity was not due to his works on mathematics, but to his writings of a philosophical and scientific tenor, mainly his *De subtilitate rerum* (*On the Subtlety of Things*) and his autobiography, *De propria vita*.[2] In these and other books he narrates anecdotes and indulges in such divagations as led one of his contemporaries, the physician and scholar Justus Scaliger (1484–1558), to say that "in some things he seemed above the wisdom of men, and in others below the intelligence of young children" (*qui in quibusdem interdum plus homine sapere, in pluribus minus pueris intelligere, videbatur*).[3] In fairness, we must recall that Scaliger was no fan of Cardan: he wrote a bitter and extensive refutation—over nine hundred pages—of the ideas which Jerome expounded in his book *De subtilitate*. Scaliger's uncharitable judgment became a stereotype. It was echoed in the eighteenth century by Joseph Addison, who wrote that Jerome "seems to have been much under the power of superstition and at times, not seldom, insane."[4] More recently, Cardan has been categorized as a "genius and charlatan combined"[5] whose "genius that was closely allied to madness."[6]

These opinions notwithstanding, when we consider the terrible misfortunes that befell him, the mean-spirited judgments begin to lose their sting. For much of what some writers call a madman's raving begins to look like the incoherence of a poor, depressed old man, exhausted by intense intellectual labors, spent by private woes, and mercilessly bruised by destiny.

Jerome Cardan's life, even before his birth, was harmed by cruel, lacerating blows. His mother was not married when she carried him in her womb. She sought to produce an abortion, but the drugs she took did not work. The childbirth was very difficult and lasted three days. Then, on 24 September of 1501, Jerome came to the world looking "as if dead," as he tells us, and could be revived only after being immersed in warm wine—an interesting neonatal reanimation technique that today finds no advocates. The suspicion (unfounded according to most of his biographers) that he was an illegitimate child hovered around him for the rest of his life.

In recounting his tribulations, Cardan singles out four as heaviest. The first was his sexual impotence: at the prime of his physical vigor, from 21 to 31 years of age, he was unable to have sexual relations. This he attributed to an unfavorable astral influence at the moment of his birth. He describes the unfortunate disposition of the "malignant" planets, which should have blighted completely the human form; but "because Jupiter was in ascendance and Venus was dominant," his injury was limited to the genital area, "forcing him to live deploring his destiny and envying that of all other men."[7] The second misfortune was the tragic death of his older son, Giambattista, who was also a physician of widely acknowledged talent and great promise. Sadly, the son made an unhappy marriage and, maddened by the suspicion that their children were not his, poisoned his wife. For this crime he was jailed, condemned to death, drawn out of his cell at dawn, and beheaded. Never could his father find consolation for this horrible tragedy. Jerome lists as his third misfortune his own senselessly cruel imprisonment, which he suffered for several months under the charge of heresy and lack of payment of some debts. The fourth affliction by Cardan's reckoning was the irregular life of his younger son, Aldo, a rogue and a villain who led a dissolute life despite his father's desperate admonitions, supplications, and physical punishments (one version says that he cut off one of his ears! If true, this brutal act was reminiscent of the absolute power of the *paterfamilias* in ancient Rome). In the end, Cardan was forced to disown him. It is not difficult to see that a life of this disastrous quality might disturb a man's mind and lead to rambling utterances and some disconnected, wandering ideas in old age.

Truth to tell, Cardan manifested troubling symptoms that raise the suspicion of a borderline personality disorder, if not a distinct sliding into mental illness. Assailed by self-destructive impulses, at times he would bite his lips or his left arm to the point of drawing blood, or he would distort his fingers to produce such pain as brought tears to his eyes. Why? Because, he said, "the highest voluptuousness is that state of well-being which follows after an appeased pain; and this one will be easily appeased, since it is voluntary."[8] More than once he thought of killing himself. He would ramble all night long in the street, lightly clothed in the thick of the winter. He said

he could fall into an ecstasy whenever he pleased, during which time it was "as if his soul separated from his body"; and he declared openly that he had a "daimon" (as did Socrates) or benevolent "spirit" that was always in attendance upon him, whispering to him important information, and sometimes forewarning him of events to come.

The Graces behaved rather niggardly with him, if we are to believe the description of his own person in the fifth chapter of his autobiography. In this self-portrait he says he is of middle height, narrow-chested, with exceedingly thin arms, and his right hand more grossly fashioned than the left. He claims that if a chiromantist should chance to read the lines of his hand, he would declare him rude or stupid (an interesting opinion coming from the man who would become the foremost bodily-line-reader of his time). His eyes he calls very small, and adds that he keeps them half-shut most of the time, to see things better. His gaze must have impressed people as intense, for they said that it often made him appear as if engaged in deep thought. His face, adds our man, was elongated; the head, narrow at the back; the chin he calls parted, and the same for the beard; the neck, thinner and longer than the average; the lower lip, thick and pendulous; the teeth, large; the forehead, wide and the hair thinning toward the temples. Add to this that he spoke in a high-pitched tone, and the physique that emerges is far from that of a charmer. Yet this account must be taken with a grain of salt. Cardan's autobiographical descriptions have been compared to the *Confessions* of Jean-Jacques Rousseau. In both there is a deliberate, conscious effort at appearing unabashedly candid; in both a morbid pleasure at embellishing the narrative style with lyrical self-deprecation. The fact is that the portraits that exist of him show an average physiognomy with nothing particularly striking, not to say repulsive (figure 6.1).

Jerome studied medicine in Milan and graduated with honors, but each time he tried to join the physicians' guild he was rejected. The corporation of medicos never ceased to reproach him for a perceived fault that was none of his doing, namely the suspected illegitimacy of his birth. His colleagues' insidiousness forced him into a precarious life, yet Cardan's brilliant and vast-ranging intellectual interests, joined to the astounding exuberance of his productivity, made him famous. His was truly a case of hypertrophic *libido*

Figure 6.1
Jerome Cardan (1501–1576). Reproduced from Wikipedia (Public domain).

scribendi: the posthumous edition of his work has been said to contain more than four million words.[9] His interests were so varied that he contributed some intuitions and even some practical considerations in physics, such as a theorem about the movement of hypocycloids and a demonstration of the impossibility of perpetual motion.[10] Eventually, his colleagues were compelled to accept his full rehabilitation. He taught medicine at the University of Pavia (his father's alma mater) from 1543 to 1562, and at the University of Bologna until 1570. Princes and potentates in various European courts sought his advice; some tried to recruit him permanently. He turned down lavish offers from the royal courts of Scotland and Denmark, avowedly for fear of the cold climate in those northern latitudes.

Cardan was deeply immersed in astrology. His medical diagnoses and prognoses were unwaveringly related to the movement of the stars in the sky. This method was congruous with a tradition that originated more than 2,500 years ago. Astrology's practitioners existed in hoary-towered Babylonia, and even before, in the temples of Chaldea and Egypt; and the tradition, handed down from generation to generation without a break across

millennia, extends to our own days. In the words of the distinguished American historian Anthony Grafton, this persistence "is unmatched in the intellectual history of the West."[11] All royal courts in ancient times counted one or more official astrologers. This is also a situation that has a parallel in our days. Many of us remember that a president of the United States, Ronald Reagan, and his wife Nancy consulted Joan Quigley, an astrologer in San Francisco, before any major presidential decision.[12] Reagan's "official astrologer" claimed that she was responsible for setting the time of press conferences, trips abroad, surgery, speeches, the takeoff and landing of the president's airplane, and so on. To believe her account, her forecasting was influential in momentous foreign policy decisions.[13] She was not the only astrologer the Reagans consulted. They also sought the advice of Carroll Righter, renowned author of several books on astrology and a syndicated advice column for hundreds of newspapers across the world.

That the celestial bodies are not always reliable became evident when no astrologer was able to predict that on March 30, 1981, at 2:27 p.m., EST, President Reagan would be shot in the chest during an assassination attempt. Quigley peremptorily affirmed that she could have predicted the regrettable episode, because it was "very obvious," if only she had drawn up his charts. Unfortunately, her occupations had precluded her from doing this.

Today, people's blind belief in the power of astrology to reveal the future strikes us as absurd, because our mental stance is radically different. Slowly, the realization set in that the future is unknowable; that we can only approach it by inference and conjecture. Franz Cumont put it colorfully: "with progress, knowledge learned how to ignore."[14] The rise of rationalism made it distasteful to subordinate one's life to astrological considerations. But in the Renaissance there was no stigma attached to them. Astrology came enshrined in the prestige of an exact science grounded upon an immensely long experience. It could make mistakes, because it was also an art, just like medicine. Inextricably interwoven with astronomy, astrology seemed to have the power to predict the major landmarks of a person's life with the same accuracy as astronomy could predict the date of an eclipse. Renaissance physicians relied heavily on astrology, whose precepts allegedly enabled the

expert to "read" the messages of the sky. For just as the body was believed to display signs of a hidden meaning decipherable only to the expert, so the sky used the stars—the true arbiters of our destiny—to send to our planet signs which only those well versed in astrology could interpret.

To say that the external features of the body are "marks" or signals sent from heaven and imprinted on each human being is a way of saying that our physiognomic features are God's handiwork. I believe this element of religiosity, of allusion to the divine powers, accounts for the enduring popularity of astrological-divinatory physiognomy described above. Well into the nineteenth century, an author concerned with the interpretation of exterior features of the human body, in particular those of the head, wrote in a language that resembles nothing so much as the utterances of the biblical prophets: "The Book of Nature is the handwriting of the living God . . . and bears on every page the ineffaceable impress of his glorious signet."[15]

The celestial signs were encoded not only in the physical characteristics of the stars and the planets, but especially in the specific configurations that they traced with their motions while traveling in the sky, along the seven spheres thought to surround the earth. Therefore, anyone who wished to penetrate the mysteries of astrology had to know the mathematical techniques used in calculating the movements of the celestial bodies; in other words, had to study astronomy. Thus, astrology has been called "the mother of astronomy." Eventually, the daughter found good reasons to disdain and repudiate her mother. But the mother-daughter symbolism was not always clear: the preeminence of each was disputed. Johannes Kepler (1571–1630), the founder of modern astronomy, looked upon this filiation with benignity. To those who inveighed against the silliness or "crazy" character of astrology and criticized the astronomers who made incursions into this field, Kepler replied: "If we had never had the credulous hope of reading the future in the sky, would you ever have become wise enough to study astronomy by itself?"[16]

In Jerome Cardan's time, astrology had relegated to oblivion ancient methods of divination, such as examination of the entrails of animals (*haruspicy*), or the observation of the flight of birds, or oracular pronouncements.

Strong with the prestige of a science dating from time immemorial and now partly based on mathematics, astrology swept away all the ancestral forms of divination. Initially, its power must have seemed formidable. For who can deny that the stars exert a powerful influence on plants, animals, and humans? Do we not see that the sun can either kill or invigorate the plants, and make the animals enter into a state of rut, or freeze them in a kind of suspended animation for months? Everyone knows that the sea tide is subject to the moon's influence; and that the human races display physical and psychological features that depend on the climate of the places they inhabit. In short, the astral influences exerted on the earth are undeniable.

However, by the late Middle Ages the reiterated errors of astrologers began weakening their theoretical pretensions. If the constellations at the moment of birth determine the precise time of a person's death, why is it that, in the case of a twin birth, the time of death of one twin differs from that of the other? Faced with the spectacle of a battlefield strewn with cadavers after a military engagement—an all too frequent sight in those troublous days—the inevitable question rose: Were all those dead soldiers born under the same constellation, since they all met their end simultaneously? Objections of this kind, obvious to the point of seeming childish, were countered with sophistical astuteness. Moreover, the deep-rooted, quintessentially Renaissance concept of *correspondences* between the celestial sphere and the earthly realm—the macrocosm reflected in the microcosm—strengthened the conviction that to read the one enabled predictions in the other. The individual man is the "microcosm" or "little world" that reflects the operations of the macrocosm. The laws that govern the whole universe also govern each individual human being. Yet, alongside this theoretical apparatus, the seed of skepticism, sown by eminent philosophers, such as Giovanni Pico della Mirandola (1463–1494), grew each day and brought more and more scholars to challenge astrology.

Cardan, like his fellow astrologers, defended himself by pointing out that their "science," insofar as it was a medical discipline, was also an art; consequently, some errors were inevitable. The ascertainment of the signs from heaven was an immensely delicate task—just as difficult and critical as the ascertainment of the signs of disease in an afflicted patient.

THE FOREHEAD IN ASTROLOGICAL MEDICINE

In his clinical work, Cardan revived *metoposcopy*, the art of divination by looking at the lines of the face, especially of the forehead (figure 6.2). Ancient authors had made brief mention of it: Juvenal, in his sixth *Satire*, lampoons the superstitious wives who "tend their hands and their brows" to soothsayers in the Circus. Suetonius, in his *Life of Titus*, speaks of a physiognomist who simply by looking at Titus and Britannicus foretold that only the former,

Figure 6.2
Diagram of the lines of the forehead and their different signification for the life of the subject. From *La metoposcopie de H. Cardan*, 1658 edition (see note 18).

not the latter, would become emperor.[17] Other passing references may be found in ancient writers, but none as detailed as Cardan's, who wrote a whole treatise, *Metoposcopy*,[18] in which he asserts that the forehead is, of all the parts of the face, the most important and characteristic; for by the simple inspection of this area a skillful physiognomist can guess the slightest nuances of a man's character.

The general structure of the forehead Cardan deemed important. A very elevated forehead with an elongated face and a pointed chin indicate a totally null intellect. A bony, prominent brow announces an obstinate and peevish character; if fleshy, it indicates a gross, vulgar character. But it is the type and disposition of the lines or wrinkles of the forehead that provide the most important information. The wrinkles ordinarily become pronounced with age; but even before old age they are perceptible, according to Cardan, and sometimes strenuous efforts render them visible even at a tender age. A weak and suspicious character is inferred from the obliquity of the forehead wrinkles. If these are straight, regular and somewhat shallow, they announce judiciousness, wisdom, and probity. A forehead with abundant wrinkles on its upper part, but devoid of them on the lower part would be a sure mark of stupidity. In addition to major horizontal lines, there are small "secondary" lines that intersect and may form different shapes, such as crosses, circles, triangles, starlike figures, and the like, each carrying its own signification. The expert metoposcopist must consider the number of lines, their course, depth, width, direction, branching, and so on.

Various physicians of those times, such as Thaddaeus Hagecius ab Hagek (1525–1600), Rudolph Goclenius the Younger (1572–1621), and others cultivated the art of metoposcopy, but Cardan was among the first to publish its major principles.[19] The basic underlying hypothesis is simple: the forehead is the scroll on which God wrote His sublime word. The deity does not act capriciously: these signs constitute a script left intentionally, so that humans could study it. They are, in Cardan's view, like "Divine Letters, by which the lives of humans have been inscribed and designated." In his astrological method of interpretation, seven major horizontal lines were distinguished in the forehead, each one connected to a different planet. The various conjunctions of the forehead's lines indicated which planetary concurrence was

going to be most influential in the life of the individual concerned. Thus, the information derived from the study of the forehead, complemented by other signs, revealed not only the temperament of the subject, but also the major events that would take place in his life: his destiny!

Nevertheless, the time of astrological medicine was ending. Scarcely a generation after Cardan's time, skepticism was voiced by the novelist and historiographer Charles Sorel, sieur de Souvigny (c. 1602–1674), in these terms:

> There are some curious [physiognomists] who, wishing to appear smarter and wiser than the rest, assure us that by the sole inspection of the forehead they know more than by the whole body. They look not only at its form, whether broad or narrow, round, oval, or square, but they observe the wrinkles and lines that they find there, and thence ascertain not just the person's temperament, but all that will happen to that person: whether his life will be long or short, attended by happiness or sorrow, and whether his death will be natural or violent. This would be an excellent thing, if only it could be done. It is beyond [the order of] Nature. However, those who intend to employ this activity in order to know things that lie hidden claim that we must trust their particular observations; they say that they depend on the power of the stars. . . . Scarcely can we judge the inclination or temperament of men by the best rules of the entire Physiognomy, and those people pretend to discern customs, diseases, falls, injuries, honors, or riches and death after consideration of a few lines. Those are willful observations made to deceive the most credulous.[20]

Astrologic-divinatory physiognomy was bound to encounter strong skepticism among the Renaissance intelligentsia. But a man must see to his own sustenance; and Jerome was constrained to prepare horoscopes to earn his keep. Nor did he lack rich customers, once he was famous. Furthermore, divination never lacked fervent followers, as its practitioners thrive under the cloak of infallibility. If the event predicted actually occurs, the prognosticator's clairvoyance will be deemed miraculous and the clairvoyant a being of preternatural acumen. But if the prediction fails to take place, the diviner can concoct elaborate reasons that will explain the failure, deflect the blame, and, in so doing, flaunt a profound learning in the esoteric art of divination.

Cardan certainly cut an impressive figure in all these aspects of astrological practice. Still, horoscopic prediction remains an inherently uncertain field, as our man had occasion to confirm more than once.

Thanks to his international renown, he was called to the then remote and barbarous Scotland to provide medical care for His Excellency, Bishop John Hamilton (1512–1571). Cardan treated the prelate's asthma with passing success. Then, asked to draw his horoscope, the astrologer-physician predicted that Hamilton would live happily, but would be in danger of dying from cardiac disease. What actually happened was that the bishop was taken prisoner during the capture of Dumbarton Castle, summarily condemned to execution, and hanged at Stirling in 1571, thus achieving the dubious distinction of being the first Scottish bishop ever to die at the hands of an executioner. The stars had misinformed Cardan, yet he was by no means at a loss for words to shed the blame and persuasively outline the unavoidable causes of his wrong prediction.

In 1553, Cardan visited England and stayed with Sir John Cheke (1514–1557), an influential statesman and remarkable classical scholar who had been tutor to King Edward VI. The king and his court, like most people in those days, were believers in astrology. The visit of an Italian scholar was a memorable event. Renaissance Italy was a country haloed by artistic and scientific splendor: a privileged land where beauty had been given new, spectacular means of expression; and where the wisdom of the ancients was being revived with brilliance and diligent care. The few English visitors familiar with the country returned to describe in awe the wonders they had seen. Therefore, Cardan's visit was a thrilling occasion to hear a man informed of the latest intellectual currents. He did not fail to make a horoscope for John Cheke, to whom he predicted a life of political as well as ecclesiastical power. Unfortunately, the stars, it seems, had spread misinformation once more. Cheke was accused of treason for conspiring to make Lady Jane Grey queen. He was imprisoned, released, imprisoned again; tried to secure his release by renouncing his religion; was forced to make a humiliating public recantation; and finally died in 1557. Of shame, some said. Not exactly the life of honors and happiness which Cardan had prophesied.

Cheke was the person who presented Cardan to King Edward VI (1537–1553), third of the Tudor dynasty. The famed Italian physician wished to dedicate to King Edward his newly written book *De varietate rerum*. The king was only fifteen at the time, yet able to converse with Cardan in Latin, one of several languages that the monarch spoke with complete fluency— "better than I," wrote Cardan flatteringly. The king inquired about the subject matter of many of Cardan's strange books. The Italian astrologer-polymath, as expected, lost no time in drafting the monarch's horoscope. To this end, he collected painstakingly detailed biographical information and made a prolonged, meticulous observation of the sovereign's features, during which he noted the apparent frailty of the young monarch. After this, he wrote a prolix, multipage forecast. Cardan's predictions were sometimes audacious, because he entirely trusted astrology. This time he foretold that the young king was going to live a long life; except that, upon reaching the age of fifty-six, his health would be threatened by several dangers. "He will lust as a man, but will suffer the curse of impotence. He will be wise beyond measure, and thereby earn the admiration of the world; very prudent and high-minded; fortunate, and indeed a second Solomon."[21] Admirable predictions; marvelous in their circumstantial account of future happenings: only someone with great occult powers would dare to lay out so detailed and itemized a description of events to come. Alas, this turned out to be a new, disastrous blunder.

Jerome returned to Milan. Barely six months had passed when, on July 6, 1553, the English king died suddenly: he was sixteen years old. Jerome wrote a monograph-sized analysis to explain his errors. He mentioned, although somewhat tangentially, the possibility of poisoning. Deaths of rulers in the sixteenth century were often suspected of being due to poisoning. However, King Edward VI had been in poor health: he had gone through an episode of measles and seemingly another of smallpox, or perhaps both at once.[22] He manifested progressive weakness, shortness of breath, and cough productive of bloody sputum. His physicians declared him to be "consumptive," that is, a sufferer of tuberculosis. At autopsy, his lungs showed destructive, cavitated lesions compatible with this diagnosis. Jerome argues, in his exculpatory report, that diseases may produce scars, tumors,

distortions, and other pathologic changes of the external body that markedly interfere with a proper reading of corporeal signs. Physicians writing at the start of the present century remarked that the association between tuberculosis and a febrile infectious disease, particularly measles or smallpox, has been recognized for centuries; and the measles virus is now known to cause immunosuppression and thereby reactivation or dissemination of tuberculosis.[23] Thus, the suggestion that Edward VI died of tuberculosis is plausible and accords well with present biomedical concepts.

Among other bizarre claims by Jerome Cardan, he said that he could tell the future by certain marks that formed on his body. For instance, a red spot appeared on his nails just before the arrest and imprisonment of his son; it disappeared right after his execution. He expatiated at length on the various meanings of these bodily marks in his book *De rerum varietate* (book VIII, chapter 43) and especially in his *De subtilitate* (book XVIII), one of his best-known works. But it must have been terribly frustrating for him to realize that all his knowledge of astrology and the occult did not allow him to predict his own imprisonment or the tragic death of his eldest son.

There is a tradition, possibly started by Julius Scaliger, that Jerome Cardan had engaged in all sorts of astrological calculations by which he determined the exact date—year, month, day, and hour—of his death. The fatidical moment approached fast, yet nothing seemed to indicate that he was about to breathe his last. Therefore, our man decided to lock himself up, refused to eat, and let himself die. Anything was preferable to one more humiliation and the ridicule of going down in history as the ne'er-do-well astrologer whose horoscopic accuracy amounted to naught. "He was a martyr of his faith," say his admirers. This narrative seems exaggerated and is probably apocryphal; but nothing should be surprising coming from Cardan. This extraordinary man had expressed a desire to terminate his own life and might well have chosen an extravagant way to do it. He died in Rome, aged seventy-five, while under the protection of Pope Gregory XIII, who had recognized his outstanding merits.

Jerome Cardan's name endures in the history of philosophy. His ideas, as variegated and multifaceted as his own complex personality, have been the subject of a recent revival, as shown by the appearance of comprehensive

studies on his oeuvre and his life, among which are two major monographs by distinguished American historians.[24] The pertinence of some of his concepts is yet to be fully explored. Not in vain Anthony Grafton compared students of Jerome Cardan's ideas to "caterpillars exploring tiny portions of an enormous flowering garden."[25] In point of medical praxis, however, it is not unjust to say that he left nothing. The advancement of the practical aspects of medicine has been so astounding in the last half-century that it is an exceedingly rare procedure or performance that has arrived to us fundamentally unchanged from centuries past. This is why I was no little surprised to see a clinical paper, produced within my lifetime by a group of American physicians, that might have been penned by the famous Renaissance Italian astrologer or any of his associates.

Clinicians working at the Walter Reed Hospital in Washington, D.C., studied the forehead's furrows in one hundred patients with a diagnosis of peptic gastric or gastroduodenal ulcer.[26] (Metoposcopy was alive and well in the twentieth century!) All the criteria required for this diagnosis at the time of the study were fulfilled (the patients had a typical clinical history and radiologic imaging studies using a contrast medium). Only those patients in whom the existence of a clear ulcer "crater" was demonstrated were included in the study; other deformities of the gastrointestinal tract were excluded. Another group of one hundred patients with various diseases but without ulcer symptoms and with a radiologic examination that ruled out the presence of an ulcer were used as controls. A third group, this one of two hundred patients from another hospital (26 with peptic ulcer; 174 controls), was later added to the study. All the patients were asked to frown, and the researchers carefully recorded the number of well-defined, vertical furrows formed in the forehead during this gesturing in the space between the eyebrows, within a distance of 1.5 cm from the midline. The number of vertical frontal furrows was found to be higher (two or more) in patients with gastroduodenal ulcer compared with the controls. Fully 87 out of 100 patients with confirmed ulcer had three or more vertical furrows in the forehead. In the control group, only 6 percent of non-ulcer patients had triple furrows.

This finding puzzled the clinician-investigators. Frowning is a facial expression in response to disagreeable sensations, such as anger, pain,

discomfort, and hunger. Frequent use of the facial muscles of frowning over a long time is thought to render the lines and furrows of the face deeper and permanent. Therefore, one would expect that any condition associated with chronic distress could bring about the formation of an increased number of vertical furrows in the forehead. But this expectation was not supported by the findings, since in the control group there were many patients with diseases apt to produce long-standing pain, yet the higher number of frontal furrowing remained a peculiarity of the ulcer sufferers.

This report caused no great ripples in the medical milieu. It appeared as a letter to the editor; the findings were never elaborated into a formal medical article; the number of cases was too low to attain statistical significance; and no further champion of Cardan's clinical ideas entered the field in over fifty years following that valorous attempt to hoist anew the banner of metoposcopy. But we would be wrong to heap ridicule on this attempt. As the late Dr. Lester S. King laid out in a penetrating essay,[27] metoposcopy and other "kindred arts" are based on principles that we cannot ignore, namely that much of an individual's temperament and disposition manifests itself outwardly by certain physical signs; that these signs allow some degree of prediction of future "behavior patterns"; and that medicine rests on *a theory of signs* or "phenomena which *stand for the thing signified.*" In all this medical science shows, as Dr. King pointed out, "an uncomfortable similarity" to astrology.

Can we say that metoposcopy, like all astrological readings of body signs, is dead, gone, or irremediably destroyed? In idle moments, it pleases me to imagine that there may come a time in the future when science will restore the now lost belief in the universal harmonies of nature, so central to astrological thought; that perhaps future supercomputers will delineate the tight interweaving of effects with causes throughout the universe, or at least across an immensely vast realm of nature. Thus, a new and vivid light would be thrown upon the realization that nothing is indifferent in nature; that a small pebble sliding down a hill is somehow connected with a cosmic upheaval. Of course, astrology will not be reconstituted in all its original ignorance and superstition, but perhaps a new science will be created, proud to bear the ancient, immemorial name of astrology. This new science would recognize that the astral light receives and preserves the impresses of all visible things,

and therefore would be capable of transmitting their influence to our world. In this imaginary vision, this fantasy, the position of the stars would not be wholly irrelevant to the destiny of the child being born, who, in the words of Eliphas Levy, by this very act of birth "enters into the universal harmony of the sidereal world."[28] But all this, I insist, is strictly futile, idle dreaming. At the present time, for all its irrationality and superstition, astrology stands firmly nestled in the hearts of many people, and the reasons are not difficult to understand.

In effect, the feeling of being related to the "sidereal world" confers a certain dignity on human existence. Pessimist philosophers may shout themselves hoarse proclaiming the meaninglessness of human life; existentialist thinkers may exhaust themselves declaring that we are thrown willy-nilly into an absurd world where we are, as Sartre put it, "condemned to be free" with a freedom made of implacable constraints from our society and our individual history. In contrast to such dispiriting propositions, an astrologist's horoscope encourages us by revealing our high dignity, which comes from our kinship to the entire universe. What if someone objects that to accept that our entire life is determined by the motions of the stars reduces us to the status of puppets pulled by invisible strings? The least we can say is that such a cosmic predetermination is preferable to the vile and paltry-minded views of negativistic philosophies. So what if our lives are subject to a cosmic predetermination? No one knows whether the movements of the stars obey a grandiose plan. No one knows whether there is a planner, or an ultimate goal, or a pattern to the astral motions. All this is a mystery, perhaps something beyond human comprehension. Meantime, to be a part of the universal motion communicates a feeling of incomparable grandeur. And, if it is true, as some scientists believe, that the universe originated by pure chance, as the result of a fortuitous explosion; then to be in harmony with the universe confers a certain meaning on human life. For, in contrast to philosophies that make us the children of blind hazard, astrology says that we are part of the grand albeit incomprehensible cosmic drama. We may be the "walkers-on" of the dramatic production, the "extras" who play a fleeting, nonspeaking part in it, but we are nonetheless legitimate members of the cast. We have a role, however minor, to play. Therefore we are necessary, not

superfluous beings senselessly thrown upon an absurd world stage for no purpose whatsoever.

PHYSIOGNOMY AND THE MYSTERIOUS RADIANCE

At present, the authoritative *OED* defines physiognomy as "The art of judging character and disposition from the features of the face, or the form and lineaments of the body generally." Its divinatory pretensions are no longer mentioned. Note that the word used is "art." As a science (a status to which physiognomy long aspired), it is fair to say that it has accomplished next to nothing; in the course of centuries no corpus of scientifically validated physiognomical knowledge has been built.

Alphonse de Lamartine wrote that physiognomy is a visible phenomenon, yet one that remains forever a mystery. Because, he wrote, "it is in physiognomy, more than anywhere else, that we can see the junction of mind [soul] and matter; but to define in a physiognomy what belongs to matter and what belongs to mind, *therein* lies the challenge of nature; it is the boundary where the two things are confused."[29]

In front of this enigma we can only "worship or be annihilated," says with characteristic impassioned utterance the romantic poet. Predictably, he saw the impossibility of speaking of physiognomy as a science. But as a *feeling*, physiognomy has long endured. Throughout the ages, a "physiognomonic feeling" has influenced our social interactions. We encounter someone; we know nothing about his character or temperament; yet we say to ourselves: "This man is not to be trusted." Or else the reaction to an individual perceived for the first time may be positive: he, or she, somehow "inspires confidence." We confuse this first impression with actually "reading" the face in an attempt to understand its owner's character. Hence we delude ourselves into believing that there must be some truth in the old-fashioned physiognomists' claims.

This first, immediate reaction constitutes an interesting phenomenon. Theorists of psychology observe that it is not elicited by human faces only; we are impressed by the "crafty" look of a cat, the "vicious" appearance of a hyena, the "elegant" demeanor of a swan, or the "shy" aspect of a hare.

Furthermore, this impression has been carried to a realm totally destitute of rational inference, as when we speak of the "melancholy colors" of a sunset, the "threatening" appearance of gathering dark clouds, or the "bold" sounds of a musical march. The eminent art historian and critic Sir Ernst H. Gombrich (1909–2001) wrote that these reactions are evidence of a much larger psychological phenomenon, namely the constant scanning of our environment in order to ascertain whether the things that surround us are "good" or "bad," i.e., friendly or hostile. For this reaction, which categorizes things as "smiling," "menacing," "favorable," "hostile," and the like, Gombrich used the term "physiognomic perception," which in his view, and in keeping with current concepts of psychology, is one of our earliest and most basic responses.[30] Gombrich was of the opinion that what we call the "expressive" character of sounds, colors, textures, or shapes (expressivity which the teachers of art and art appreciation always enjoin their students to search after) really boils down to a capacity to evoke "physiognomic" reactions.

Let this be as it may, it is a common observation that each face possesses a sort of affective resonance, like a halo that surrounds it. All of us, whether we realize it or not, come under the influence of this sensitivity halo—Gombrich's "physiognomic perception"—which seems rooted in the radiance of the face. This effulgence incites in us sympathy, curiosity, fear, distrust, attraction, or some other reaction. Irrational though these responses may be, our very existence sometimes depends on their nature and timing, as happened on at least two occasions in the life of Michel de Montaigne (1533–1592), by his own account.[31]

Montaigne lived in an epoch in which wars—local, international, political, religious, socioeconomic, or purely wanton—were rife as flies in midsummer. Bands of unruly soldiers, freebooters, and outlaws roamed freely about. Trusting a recently published declaration of a truce between contending armies, Montaigne ventured on a trip with a few servants. He was advancing through a small open glade when suddenly a group of fifteen to twenty masked soldiers emerged from their hideout and surrounded him on all sides. His efforts to escape were in vain. In no time he was robbed; his luggage ransacked; his valuables snatched; his horses and servants assigned to new masters. The soldiers talked with him about the price they would

put to his ransom; and they debated among themselves what might they do with his life. Montaigne kept insisting that he had gone on a trip trusting the proclamation of a truce; that they should be satisfied with what they had already taken from him, which was not little; and that he could not promise any further ransom. But when recalling the experience he says in utter candor that he feared the end of his days had come.

Things were at this point when an unexplainable change took place. The soldiers' chief came back addressing him in a more friendly tone, searched for his dispersed properties, some of which were already distributed among the soldiers, and ordered that the scattered objects be returned to their rightful owner. But the most precious thing returned to him was his liberty, for the rest did not concern him all that much. He was told to go free and undisturbed, and was even warned of the possibility that other bands of soldiers might surprise him at certain places. The cause of such a welcome change and miraculous repentance he simply could not understand, but when leaving the place he asked one of the soldiers, who removed his mask and even told him his name when answering. The soldier's reply was, says Montaigne, "that I owed my liberty to my face, and the liberty and boldness of my speech, all of these being things that set me above having to endure such a misadventure. It is possible that the Divine goodness may have wished to make use of this vain instrument for my preservation."[32]

On another occasion he found himself surrounded by the henchmen of a predatory, rapacious neighbor, a domineering feudal lord who coveted his land: they had gained entry to his castle under false pretenses. He was expecting the worst when suddenly, as in the previous adventure, their master changed his plans and ordered the men to withdraw.

In recounting these episodes of his life, Montaigne forces us to reflect on our belief that there are "favorable" and "unfavorable" physiognomies. Imagine for a moment that you are part of a group fallen captive to a band of outlaws. The chiefs are dividing the prisoners into cohorts. You look anxiously at your captors and it is inevitable that you should hope to be allocated to this one, not to that one. You do not know precisely why you feel that way; but there is something in the facial features and in the whole demeanor of one abductor that leads you to expect greater clemency in him

than in the others. On a more trivial plane, if ever you lived in a country with a paralyzing bureaucracy that blocks your ordinary affairs, such as getting a permit, certificate, identity card, and so on, you are probably acquainted with the sense of disconsolate impotence that seizes those waiting in line in some bureaucratic redoubt. Does your turn assign you to the desk attended by the round-faced, smile-prone agent? Your business is likely to run a normal course; but if to the desk with the lean, morose, or surly civil servant, your documentation—regardless of its completeness—is going to be found wanting, and you will go home frustrated, hoping for better luck next time.

Nevertheless, if we are to draw a fair picture, we have to admit the possibility of error in the "physiognomic perception." The employee that seemed peevish and intractable receives us with a warm smile and affably expedites our affair; the man whose appearance struck us as timorous and mousy turns out to be a war hero decorated with the medal for valor. Our expectations are refuted as new information becomes available, and each time we are forced to amend our initial guess. Much flexibility of mind is required, which is certainly not an abundant commodity in this world. We must give up our first impression and make adjustments as needed without the least compunction. This may not be easy, but it is a necessary step in the cognitive process. Philosophers concerned with epistemology tell us that our "first impression" serves as the initial stimulus to form a hypothesis: it is the essential starting point in configuring our final opinion.[33] Without it, we would be at a loss, not knowing even where to start. The problem lies in believing that the first intuitive response is the same as understanding fully what we see.

Therefore, the immediate response which human faces and things evoke in us is not something contemptible: it is not a shameful, primitive reaction that should be quenched. On the contrary, Gombrich opined that "there is a good deal to be said for exploring and developing these sensitivities, but only on one condition: we must not confuse response with understanding, expression with communication." And he aphoristically declared: "The intensity of a personal intuition is no measure of its correctness."[34] The ancients were aware of this risk. They scrutinized the external appearance of people and, for good or ill, deduced character, proclivities, and aptitudes from their mien. But, much like us, they often confused Gombrich's "physiognomic

perception" with understanding of the object seen. The celebrated, semi-legendary philosopher Pythagoras (c. 582–500 BC) admitted as his disciples only those men whose facial features, bodily form, and bearing were first carefully examined.[35] Only after being thus "physiognomized" would a solicitant be admitted to the Pythagorean school, there to observe silence for a period of at least two years, never speaking or asking questions, but listening to what others had to say. The length of silent initiation was not the same for all: in some cases this period was shortened, and the decision to abbreviate their mutism had to do not just with their capacity to learn but, one suspects, with the initiate having a "favorable" physiognomy. On the other hand, several famous anecdotes plainly show that the ancients did not ignore the unreliability of such assessments.

An oft-repeated story says that a man named Zopyrus pretended to be an unerring physiognomist.[36] He claimed that he could read the disposition and habits of men by the simple inspection of their bodies. This braggadocio did not sit well with some philosophers, who decided to put the man to a test. They brought before him an ugly man and challenged him to pass a diagnosis based on his appearance. Zopyrus examined him very carefully. He noted the little attention that the subject paid to his appearance: his disheveled hair, his protuberant belly, his thin legs, his bombed-out forehead, and his snub nose open to the outside; all these features, said Zopyrus, bespoke the dull, stupid nature of a lascivious man inclined to laziness and drunkenness. As he pronounced this diagnosis with his accustomed professorial air, Alcibiades and other members of the audience burst out in hearty laughter. For the subject they had presented to the haughty physiognomist was none other than Socrates, a man well known for his unattractive, faunesque appearance, but at the same time a model of righteousness. Indeed, Socrates' exemplary, virtuous life has been compared to that of Jesus Christ. It must be said that when Socrates heard of the joke played on Zopyrus, he defended the physiognomist's diagnosis. Zopyrus had been right, said Socrates. It was his nature to be lazy and inclined to vice; only he had tamed his vicious nature by the assiduous study of philosophy.

Other anecdotes from classical antiquity follow the same drift. A portrait of Hippocrates, the "father of medicine," was taken by two of his students to

a physician named Philemon, reputed as great physiognomist. They asked him what it was possible to conclude from the external features of the portrayed man. Philemon, after examining it carefully, called the portrait a semblance of an ignorant man who was also a deceiver and a lewd fellow.[37] The two students were indignant at this gaffe, and called the pretended physiognomist a cheat. Philemon remained unfazed, and answered that he acknowledged that the portrait was a semblance of the wise and virtuous Hippocrates. Nevertheless, he added, he had been asked to tell what his "science" had to say about the external features of the man in the portrait, and he had told his questioners precisely what this knowledge advised. The two students returned to Hippocrates and reported to him what had taken place. Hippocrates replied that Philemon had been right on the mark; that he, Hippocrates, knew that vice and moral baseness were nestled in his soul and had to be rejected. It was by inuring himself to abstinence and renunciation that he had been able to triumph over his immoderate inclinations.

These ancient narratives do not make much sense. One suspects the "physiognomized" subjects who vindicated a diagnosis that showed them in a negative light were exaggerating their propensity to debauchery. Father Benito Jerónimo Feijóo y Montenegro (1676–1764), Spanish Benedictine monk and science divulgator, remarked that lasciviousness tends to be represented larger by those who more diligently strive to suppress it, "because fear of the enemy augments his forces in the idea, so that Socrates, although he may have had an ordinary inclination to lasciviousness, probably judged it excessive; and Zopyrus may have inferred it not from Socrates' bodily features, but from the common knowledge that very few men exist who do not acknowledge within themselves this domestic enemy."[38]

Montaigne is careful to tell us that a "favorable physiognomy" has nothing to do with beauty, and puts forward his own case as an example. He was not especially handsome; therefore he attributes his good luck in the predicaments he describes to his general attitude: his openness, candidness, and calm demeanor. These are features that inspire confidence and gain sympathy. The look of the gesture and the inflection of the voice often say more than the words themselves. Modern research has been concerned with discovering the basis of what Gombrich called "physiognomic perception."

The hypothesis that decisions about whom to trust are based on certain stable facial features has won remarkably wide acceptance among researchers.[39] In one study, the width of the face was measured, and it was found that, under the defined conditions of the experiment (involving the playing of a game of chance), people tended to trust men with narrow faces and distrusted those with wide faces.[40] And this, the researchers were careful to emphasize, was independent of their attractiveness.

Still, there is no point in denying that comeliness, by itself, may be overpowering. An old prejudice, deeply ingrown in the mind of most people, equates beauty with virtue. "The beautiful is the good," runs this preconception; and "the good" implies the truthful and the just. It follows that the ugly, being the opposite of the beautiful, is also the antithesis to the mentioned virtues. Since our childhood, we are used to seeing the hero in stories, fables, and legends as handsome, whereas the villain is deformed, repulsive, or monstrous; and this prejudice has been endorsed by preeminent historical figures. But these two momentous, antithetic states—beauty and ugliness—decreed for us human beings by a higher power and seemingly distributed blindly, as if through the casting of lots among the members of our species; these two conditions meted out to us so erratically and with consequences calamitous or happy; these things, I must insist, deserve separate treatment. They are best dealt with in separate chapters.

THE POWER OF BEAUTY

Try this simple experiment: send your CV with a personal photo to prospective employers. Then send it a second time, altering your photograph to make you look pockmarked, obese, or otherwise decidedly uncomely: the effect will be devastating. It is amply demonstrated that the social benefits of physical attractiveness encompass multiple aspects of social interaction and influence. Too many people believe the stereotype that says "beautiful is good."[1] Thus, attractive people are generally thought to possess more socially desirable personalities; to be happier, better spouses, and more successful than the unattractive. When looking for a job, the possibility of being hired is considerably increased for attractive applicants after being interviewed in person.[2] This, mind you, even when the handsome applicant is clearly inferior to an uncomely competitor. Worse yet: suppose the good-looking applicant is a shameless criminal. Even so, he can rest assured that the "privilege of nature" will come to his aid. Society will look upon his misdeeds with benevolence: research indicates that having a pleasing face will diminish the seriousness of a crime in the perception of other members of the community.[3] Studies have also shown that the amount of the bail imposed for attractive-looking individuals arrested for a crime tends to be lower than that assigned to the ill-favored in similar circumstances.[4]

The truth is that the appearance of a face tells us nothing about the morality of that individual, or how pleasant will be his or her closer acquaintance. But in the hustle and bustle of our daily social interactions there is

no room for hesitancy: we adopt a firm, resolute attitude from the start: ugliness is rejected because it interferes with the immediate pleasure of our relation with the other. Beauty, in contrast, grants straightaway, without any further ado, a measure of agreeableness in our contact with the other. Beauty is therefore a social advantage which is based on our natural indolence; for we rather yield to pleasurable first impressions than take the trouble to discriminate the dross from the gold.

Historically, the power of comeliness has been much in evidence, especially for women. Narratives of every provenance celebrate semilegendary women whose sublime, inexpressible graces, says the hackneyed cant, "altered the course of history." But beauties of lesser fame have left their names in the local chronicles, like stars whose appearance in the firmament had to be recorded in the official ephemerides. For some, the glorification of their charms reached the height of an apotheosis. Such was the case of a woman born in the sixteenth century in the city of Toulouse, France.

Her name was Paula (*Paule*, in her native language) de Viguier. She was born in 1518, to a noble family of Gascony. Winsomeness and harmonious physical features soon earned her all manner of flattery. A panegyrist-versifier intoned: "The Graces were three, ere Paula was born / She who would surpass their renown" (*Car trois Graces étoient, n'étant encore née, / La Paule qui devoit vaincre leur renommée*).[5] In 1533, King Francis I, the celebrated "knight-king" of the Renaissance, made a solemn entrance into the city of Toulouse. The authorities decided that Paula should present him the keys of the city. This she did, and harangued the ruler in carefully memorized verses, which she delivered with aplomb while robed in a white dress, her head garlanded with roses. She "dressed as a nymph, and looked like one," people said. The king received this homage in good grace and called her *la belle Paule*, a nickname that clung to her person indelibly. For all of his fame as a chivalrous, charismatic, and romantic ruler, this "Prince of the Renaissance," as a biographer once called him,[6] was, like so many other powerful men of that era, a sexual predator. Hence the comment of two nineteenth-century writers that Francis I "did better than just giving her a nickname: he respected her innocence."[7]

Paula's biographers say little about her private life. It seems that her heart was captivated by the dashing Philippe de La Roche, baron of Fontenilles, but her parents constrained her to marry a counselor of Toulouse's Parliament, Sieur de Baynaguet, who at least had the good sense to leave her a widow, and childless, in her twenties. She could then marry Philippe de La Roche, with whom she had a son, who unfortunately died before reaching manhood. Not much else is known of her private life. We are led to surmise that she was gratified upon taking the mate of her choice after a somewhat prolonged circumvolution. It may be that this happy event caused her beauty to reflourish, because in 1563, when she was already in her mid-forties, Queen Catherine de' Medici toured the area, paid her a visit, and was impressed by Paula's fairness, delicate grace, and dignity. The queen was surveying the regions of Languedoc and Guyenne with the young king Charles IX in order "to clean" the realm from rotten elements, which in plain language meant to exterminate the Huguenots. The young king pursued this task with a level of ruthlessness and cruelty truly despicable. It was by way of distraction from that exhausting malevolence that the queen decided to visit Toulouse and take a look at the beautiful Paula. Instead of the matronly-looking woman that she probably expected, she found a splendiferous, elegant beauty. Catherine de' Medici famously surrounded herself with a group of alluring young women, humorously referred to as the "flying squadron," who, following the queen's instructions, used sex to weave intrigues in favor of Her Majesty. Given the formidable power of sex to ensnare, deceive, and hoodwink men, this branch of the monarchical government must have been a powerful political instrument, indeed. It also shows that Catherine was well versed in the strong points of feminine allurement, so that her praiseful judgment of Paula's beauty corroborates the truth of the many praises addressed to the Toulousian belle.

I know of no reliably authenticated portrait of this famous beauty. One of dubious authenticity used to be shown in the château de Fontenille, Paula's homestead by marriage. Perhaps no great painter was appointed to immortalize her. But if no limner ever plied brushes and pigments in the attempt to capture the harmony of her features, plenty of panegyrists tried

to do it with words. Of these, the most enthusiastic was Gabriel de Minut, baron of Castera, apparently her cousin and her most ardent admirer. This man wrote what he called a "Paulagraphy" (*Paulegraphie*), a book entirely devoted to praise Paula's beauty.[8] It was published in 1588 at Lyon by Charlotte de Minut, the author's sister, an abbess, and dedicated to Queen Catherine de' Medici. In this curious work, Paula's bodily perfections are minutely described one by one, not excepting those which succeeding, more prudish ages would have preferred to omit. Critics were surprised that such a book should have seen the light after being canvassed by an abbess and received approvingly by a queen of France.

The author of the "Paulagraphy" says that Paula's head was "perfectly rounded" (one hopes he meant perfectly *oval*); her face smallish and her forehead little.[9] The latter feature does not align with present-day taste in matters of feminine beauty. This is why commentators felt obliged to interject that narrow-browed women were once fashionable, and were all the rage in ancient Rome; thus Petronius, in depicting the charms of a belle, lists *frons minima* (*Satyricon*, section 126); and Horace speaks of Lycorida, a beauty "remarkable for her low forehead" (*insignem tenui frontis Lycoridam*).[10] Paula was blonde. In a region of France where blondes were scarce, this feature may have enhanced her attractiveness. Her eyes were light blue, large, lively, shiny, framed by eyebrows that were wider in the center than in the extremities, and traced with admirable precision two well defined, symmetrical semicircles. Her mouth was small, well outlined, and vermilion-hued; her lips "vied for freshness and éclat with the morning roses." There is no point in repeating the hyperbolic commonplaces used from time immemorial to laud feminine charm and unabashedly reiterated in the "Paulagraphy." The panegyrist ends his lofty encomium by saying that she was "so well carved out, swatted, traced with the square ruler, delineated with the subtle etcher's needle, and cut out with the delicate scissors employed by nature, that this one, nature that is, had therewith accomplished a masterpiece."

Exaggeration aside, Paula must have possessed a prodigious beauty. It is recounted that every time she appeared in public the crowd pressed to see her and a veritable tumult was produced. To avoid causing serious accidents, the Toulouse authorities decreed that she had to appear in public twice

a week. Apart from these mandatory public exhibitions, she led a rather home-bound existence, and was known to cover her face with a veil when occasionally going out, presumably to prevent a public disturbance. She lived until her late eighties. Tradition has it that she kept some vestiges of her pulchritude and her distinguished demeanor intact until the end of her days.

Truly famous persons tend to become, as it is put today, "household words." Thus it is that Paula's name became incorporated into a sixteenth-century rhymed proverb. When enumerating the most remarkable things of Toulouse, people used to say: *Le Bazacle, Saint Sernin, / La Belle Paule, Matalin*. The "Bazacle" refers to a famous mill and other structures constructed on the banks of the river Garonne; "Saint Sernin" alludes to the basilica of Saint Sernin (Saturninus in Latin), one of the oldest temples in the region (c. 1080–1120) and a pilgrimage site on the route to Compostela; "Matalin" was a distinguished musician who became royal violinist under King Henry IV. The enshrining of this man's name in the proverb was owed, as far as I can tell, to its rhyming with Sernin.

QUESTING FOR THE ESSENCE OF BEAUTY

How can we define the fundamental nature of beauty and its opposite, ugliness? Philosophers have descanted interminably on these questions without definitively settling the matter. It has become a hackneyed commonplace that beauty—especially human beauty—is subjective; that it differs according to the epoch, the fashion, the country, and in general with the cultural context and taste of the observer. What is beautiful here may not be so elsewhere. In David Hume's (1711–1776) words: "We are apt to call *barbarous* whatever departs widely from our own taste and apprehension. But soon find the epithet of reproach retorted on us."[11] We all agree in extolling elegance, distinction, and other such qualities, and in blaming vulgarity and affectation. But, much to our consternation, it is a fact that different people attach different meanings to these expressions.

In Mauritania, for instance, a woman is considered a beauty if she is morbidly obese. Young girls are force-fed—a practice called *leblouh* in Arabic, or *gavage* in French, a term for fattening up geese in the production of

foie gras—and harshly punished if they refuse to ingest a diet of about 16,000 calories daily, with the foreseeable adverse consequences to their health. The practice exists in other African countries, especially those of Tuareg tradition.[12] No great perspicacity is needed to see that equating beauty with morbid obesity is, among other things, a stratagem for oppressing women, who are kept restrained and nearly immobile under heavy adipose shackles. Some preliterate societies afford notorious examples of artificial facial and bodily alterations done in the name of beauty—lip deformity, neck stretching, nose piercings, teeth filings, etc.—that, from the vantage point of our Western culture, we are likely to find shocking. Many of us are tempted to call these customs pitiless and cruel, but perhaps should fear that these and other epithets might be "retorted on us," given that the excessive emphasis on thinness imposed in our part of the world—Western cultures have been called "lipophobic,"[13] because thinness is overvalued and obesity mercilessly denigrated—has precipitated severe psychogenic anorexia and sometimes death in young women.

The subjective nature of beauty has rarely been expressed in more colorful language than that used by Voltaire in his *Dictionnaire philosophique*. Here is what he says:

> Ask a toad what is beauty, great beauty, the *to kalon* [the term for beauty used by the ancient Greek philosophers]. He will answer you that it is his she-toad with two big, round eyes protruding from her little head, a big, flat mouth, a yellow belly, a brownish back. Question a black man from Guinea: for him it is a black and oily skin, sunken eyes, a pressed-down nose.
>
> Question the devil: he will tell you that beauty is a pair of horns, claws, and a tail. Finally, consult the philosophers. They will answer you with a farrago, an assemblage of nonsensical, confused words. They need something to conform to the archetype of the beautiful in essence, the *to kalon*.[14]

The temptation is great to shorten all the preceding considerations into the old saying, "beauty is in the eye of the beholder." Contemporary science, however, challenges this bit of folk wisdom. Some research indicates that there is substantial agreement between individuals from the same culture, and from different cultures, as to what constitutes a beautiful face.[15] In other

words, the judgment of facial beauty would not be an individualistic matter, but would depend upon a specific set of features and proportions.[16] Still, it should be noted that this question is not settled. There is also research which indicates that in judging facial attractiveness, both private and shared taste are equally important.[17]

Biologists hypothesize that in our remote past certain qualities were shown to be socially advantageous (e.g., being resistant to highly prevalent diseases, able to provide a safe environment for the family, and so on). Mates would be chosen preferentially among people possessing those qualities, who, on their part, would be likely to leave more genes behind in the next generation. Attractiveness, in this view, is the external appearance thought to predict the existence of such genes in an individual. Features found relevant in this context are symmetry, "averageness," skin health, and facial cues associated with certain personality traits,[18] as concisely summarized next.

Symmetry of the body is achieved through an exquisitely programmed and flawlessly executed process of development. The genetic plan dictates that we should have a heart on the left side, a liver on the right; and the external frame in which the organs are contained should be symmetrical. As a pathologist, I have seen unimaginable, nightmarish deviations from this plan: the heart may lie on the right (dextrocardia); the liver in the center; and the normally left-sided stomach may sit entirely on the right (heterotaxy syndrome). The right and left lungs, which are morphologically distinct, may exchange places; alternatively, both may look like the right lung, having three lobes (right isomerism). Sidedness aberrations of the body are too numerous and too complex to be detailed here. But we can say that perfect external bodily symmetry reflects a flawless development which, having skirted innumerable potential mishaps, promises healthy genes. Hence facial symmetry and attractiveness are correlated. Some studies using manipulated face images, in which vertically bisected half-faces were aligned with their mirror reflections, have yielded discrepant results, but this work has been criticized as introducing unnatural proportions into the artificially created symmetrical face.[19] Studies using more sophisticated graphic methods have confirmed the general preference for symmetry.[20]

The concept of symmetry, however, is more complex than is commonly assumed. People often think of it simply as the quality of having similar parts facing each other around an axis. Symmetry, from the Greek *summetria* (συμμετρία), indicates relation, proportion, or regularity of the parts necessary to form a beautiful whole; from *sun* (σύν) with, together, and *metron* (μέτρον), measure; that is, a *common measure* or a relation of equality among the parts of a whole. A scholar has stated that, to the Greeks, "symmetry meant commensurability, and two magnitudes were said to be commensurable if there exists a third magnitude which divides into both without remainder."[21] Thus, in analyzing a statue or a building, a part was sought after which could serve as conspicuous, apprehensible module; then, if other parts were exact multiples of it, the statue or the building was said to be symmetrical. This was the basis of the conception of beauty or perfection, which was thought to apply in nature as well as in art. The object evaluated, whether a product of human art or of spontaneous nature, was said to be beautiful in the degree to which it approximated this ideal set of proportions. This "modular" approach was incorporated in the canons of antiquity, the most famous of which was the *Canon* of Polyclitus, in the fifth century BC.

The ancient Greeks' conception of symmetry and beauty was much reinvigorated during the Renaissance. However, it is no longer uncritically accepted by artists. Today we know that rigorous adherence to ancient canons, or to the "golden proportion" (see below), or to any of a number of mathematical formulas, does not automatically produce a beautiful work of art. Our concept of beauty is now more emotional and expressive than strictly geometrical. I could summarize this by saying that it is more sensuous than intellectual. Not in vain has it been contended that the traditional concept of symmetry was radically different from what we understand it to be today; so much so "that 'symmetry' can no longer be regarded as a correct translation of the Greek word *symmetria* from which it derives."[22]

"Averageness" means that the face is not too different from the majority of other faces within a population. Hypothetically, an average face reflects a greater diversity of genes in its possessor[23] (whose progenitors along multiple generations mixed extensively within the group), and thus the ability

to draw from a greater variety of proteins that may help in contending with parasites or other harmful agencies.[24] In fact, averageness has been shown to be associated with better health and higher attractiveness.[25] Additional elements of facial attractiveness include the secondary sexual characteristics. In other words, features of maleness are found attractive to females; and those of femininity, as expected, to males.

In 2012, the British firm Lorraine Cosmetics announced the winner of a contest titled "Britain's Perfect Face." The event rested on a simple concept: to compare the faces of about 8,000 female contestants—all of them without makeup, and without any history of plastic surgery—to a mathematical algorithm supposed to represent the ideal proportions of facial beauty, developed from a series of studies done in 2009 by investigators from the University of California, San Diego, and the University of Toronto.[26] These researchers claimed to have found "the golden rule" that puzzled philosophers and scientists for centuries, that is, the exact measurements and proportions of different facial structures which, when present, make a face beautiful or attractive. They determined that in the "perfect" face the interpupillary distance is 46 percent of the face's width; and the vertical distance between the eyes and the mouth is approximately 36 percent of the face's length. The winner of the contest was 18-year-old Florence Colgate, a student from Kent, England—a dazzling beauty by any standard (figure 7.1)—whose ratios were 44 percent and 32.8 percent, respectively.[27]

It should be apparent that the modern researchers were echoing an ancient postulate which tried to rationally "explain" the nature of beauty. This postulate sets down that the main cause of the sense pleasure that we experience upon contemplating a beautiful image, a painting, or a living form, is the *geometrical order* that we discern, more or less distinctly, in the object of vision. Artists and thinkers of the past concluded that among the major elements in the organization of a beautiful painting is a mathematical principle that has been called, among other names, "the divine proportion," "the golden number," "the golden ratio," or "the φ (phi) ratio." Vitruvius, Roman architect of the first century BC, concisely enunciated this principle: "For a whole that is divided into unequal parts to seem beautiful, the proportion between the small and the large part must be the same as that between

Figure 7.1
Miss Florence Colgate, 18-year-old winner of the 2012 competition "Britain's Perfect Face." Image reproduced in her own Twitter website and in magazines, newspapers, posters, etc. throughout the world.

the large part and the whole."[28] This formulation is commonly represented in graphic form (figure 7.2).

There is no need to enter into the mathematical peculiarities of the golden ratio. Interested readers today have easy access, via Internet, to innumerable sources of information on this subject. Suffice it to say that the golden ratio is visualized in countless patterns of nature. It is present in the arrangement of leaves on a stem (phyllotaxis); in seed heads like the sunflower; in logarithmic spirals, such as the one traced by the nautilus shell. In short, observers claim that the golden ratio is embedded in the configuration of many productions of nature, from constellations in space down to objects and phenomena at a molecular or atomic scale.

In the medical realm, orthodontists are concerned with defining the qualities of the jaws and mouth that contribute to the total beauty of a face; plastic surgeons scrutinize various parts of the face and their role in facial aesthetics. Many insist that scientific analysis of a beautiful face must be based on mathematics. This cannot fail to elicit a discussion of the relevance of "the golden ratio" or "divine proportion" in facial attractiveness. Thus, it

$$\frac{a}{b} = \frac{a+b}{a} = 1.618... = \varphi$$

Figure 7.2

The "Golden Ratio." A line is divided into two segments, one longer (a) and one shorter (b). The two segments are said to be in the golden ratio if the ratio of the whole line (a + b) to the longer segment (a) is the same as that of the longer segment (a) to the shorter (b). The symbol φ represents the proportion of the longer to the shorter length (approximately 1.618); 1 − φ represents the proportion of the shorter to the longer length (approximately 0.618). (Diagram by the author.)

is pointed out that the distance between the eyes and the top of the forehead (*trichion*) should be in golden ratio with respect to the total length of the face. A "reciprocal" golden ratio should exist between the distance from the wings of the nose to the lowest point of the chin, and the distance from the nasal wings to the top of the forehead. Likewise, eye-to-mouth distance should be in golden proportion to mouth-to-chin distance. Transversely, if the width of the nose at the lateral nares is taken as a unit value of 1.0, then the width of the mouth should be 1.618, or φ. Many other curious instances of the golden proportion have been remarked.[29] Allegedly, a face will be beautiful in the measure that these mathematical relations are respected; and ugly in the degree to which they are neglected or ignored.

BEAUTY SCIENTIFICALLY EXPLAINED REMAINS NO LESS MYSTERIOUS

Is beauty therefore a simple question of mathematics? Hardly. The organizers of the aforementioned British competition were careful to name the contest "The Most Perfect Face," not the most beautiful. It is not the same thing.

To pass a judgment on the beauty of a human face remains an exceedingly complex task. Measurements and morphologic parameters are important, but the human face comes with a heavy symbolic load that no other object has. To human beings, the face is an essential tool for communication and seduction. Evolutionary "sexual selection," anthropometrics, symmetry, averageness, and mathematical ratios do not fully account for the mystery of beauty. Before accepting as a dogma that the "golden number" is an absolute determinant of beauty, it is good to remember that if we calculate the ratios of every possible pair of structures in a human face, we are bound to find some with a value close to that of φ. The "golden ratio" was developed as a mathematical-geometrical concept and is best adapted to paintings and photographs, which are two-dimensional images. Intuitively we feel that its value as a criterion of beauty may not be quite the same when superposed on a three-dimensional object. But, most importantly, the human countenance is animated; it engages in gesturing, it smiles, and its mimicry is very much a part of its beauty. Skin texture, radiance, vivacity and rapidity of expressive gestures: all these contribute to the perception of beauty, to say nothing of the techniques of beautification and seduction painstakingly perfected along millennia and bequeathed to us. The aesthetic judgment of a human face must take into account a whole dynamic of expressivity, of youth, of sensuality, as well as of maturity, strength, good health, but also—why not say it?—that undefinable poise and ineffable demeanor whose attractiveness has been thought to come from intelligence,[30] self-command, and inner life.

The ancients were fully aware of this. The rhetorician Dio Chrysostom (c. 40–c. 120 AD) discusses human beauty (male, in this case) in the twenty-first of his *Discourses*,[31] a text written in the form of a conversation between the author and a younger man. This work deals with the appreciation of beauty of the entire male body, not just the face, in imperial Rome.[32] In the Western world, we are inured to think of the face as the "mirror of the soul" par excellence; but this notion may not have been as dominant in the collective conscience of pagan antiquity. Today, we do not find it unusual for a lover to make the face of the beloved the high point of erotic desire. In our time, a writer can declare that the surest way for a man to tell whether the strong feeling experienced toward a woman is true love is to realize that

"the face of the beloved inspires stronger physical desire than any other part of her body."[33] Such a statement causes no great surprise, but it might have seemed nonsensical to an ancient Roman, in whom eroticism was not so intensely focalized.

In Dio Chrysostom's discourse, the two speakers are watching a seminude young athlete doing his workout. Roman thinkers were troubled by the homosexual eroticism fostered by nudity in the gymnasia, a custom brought from Greece. Romans, however, were as one in rejecting homo-eroticism.[34] In fact, the idealized beauty of the male body in classical Greece was not supposed to promote effeminacy. It propounded an athletic, "sculptural" muscular frame that had to be appreciated from the vantage point of *sophrosyne*, that is, self-control, temperance, and decorum. Accordingly, Dio and his companion, impressed by the seemly, demure attitude of the athlete, declare that beauty by itself is not enough: it must be united with virtue if it is to attain its full force. They conclude that beauty is more than perfection of forms; for it to attain its highest degree it must be combined with moral excellence. They remark that the young athlete displays such modesty as makes even brazen-faced men feel abashed and turn away. Dio compares the reflection of true modesty to that of the sun: brightest when it shines directly; but there is also a dazzling reflection of the sun's light in the water, which one can see moving and dancing on walls. Just so the reflection from true modesty impacts the beholders who surround the athlete and makes them appear to be abashed.

Xenophon (c. 430–c. 354 BC), in the *Symposium*, argues in like vein: "the essence of beauty is something regal when its possessor joins to it modesty and sobriety."[35] Interestingly, Xenophon uses the same metaphor that equates light with the beauty-plus-virtue alloy. When the handsome Autolycus, admired for his moral qualities, enters the banquet hall, everyone feels compelled to look at him. For "just as a sudden glow of light at night draws all eyes to itself," so the beauty of Autolycus, framed by the glow of his modesty, draws the gaze of all the onlookers to him.

And so we see that, starting with the ancient Greeks, human beauty is dragged into the domain of moralists, a relocation which we never know whether to celebrate or to lament.

Trials and Tribulations of Beauty at the Hands of Moralists

Historically, austere moralists have been unkind to human beauty. They are against its enhancement, which they find unnatural and reprehensible. To them, jewelry, creams, rouge, face powder, and cosmetics in general are the artifice of disguise, trickery, deceit, and imposture. They are the tools that deface and disfigure what should be the core of personal identity: the face. Women, said the acerbic Tertullian, should not try to adorn themselves over and above their "tunics of skin."[36] The moralists' condemnation of beauty is based on the ills that it can inflict on third parties. For beauty is, at bottom, a snare: it is the net with which love traps the incautious. Moralists were never short of illustrative examples on this score; in the past, it was common to hear them recite a litany of archetypal cases instancing the ruinous effects of beauty, some of which I reproduce next.

Two heroines of antiquity, Virginia and Lucretia, would have aged in peace and tranquility, if only they had been less beautiful. But the latter inspired a mad passion in an Etruscan prince, who raped her and precipitated her suicide; and the former, in order to avoid a similar fate, had her throat slit by her own father.[37] Beauty's vicious afflictions beset equally women and men. Flavius Julius Crispus, eldest son of Constantine, the first Christian Roman emperor, was, to his chagrin, too handsome. Flavia Maxima Fausta, his own stepmother, fell in love with him; he repulsed her, and she, full of spite, accused him of adultery. Constantine had his son tried at Pola, condemned to death and executed in 326 AD. Shortly thereafter, he had Fausta killed by immersion in an overheated bath.[38] (A cold shower at the right time, I think, might have been best for preventing the tragedy.) Holy Scripture recounts how Joseph was falsely accused of assaulting the woman who tried in vain to seduce him (Genesis 39:6–20); and how Tamar was raped by her own half-brother, Amnon (2 Samuel 13). Beauty was a major cause of these and many other crimes. The beauty of a Greek woman, Helen, was as baneful to the Trojan people who took her as to the Greeks who fought to return her. Henry Howard, Earl of Surrey (1516/1517–1547), was to sing centuries later:

. . . how that in those ten years war
Full many a bloody deed was done;

And many a lord that came full far
There caught his bane, alas, too soon;
And many a good knight overrun,
Before the Greeks had Helen won.

. . .

So long time war of valiant men,
Was all to win a lady fair.[39]

The beauty of an Egyptian female, Cleopatra, was no less baneful to the Roman Empire. The Turks extoll Sultan Murat (or Amurat) as a mirror of justice, remarkable for his abstinence and contempt of pomp. But this paragon of temperance fell in love with the beautiful daughter of Susman, despot of Serbia, and was ready to go to war to obtain her.[40] The thought of killing thousands of innocent people did not outweigh the vehemence of his lust.

Crimes and wars have been frightful effects of beauty. Yet the moralists of the past were more worried by calamities of silent and invisible nature, namely the deleterious effects that beauty wreaks not on the body, but on the soul. Everyone knows that chastity and continence are beauty's sworn enemies: so rarely are they seen together that cynics say those are the virtues of the ugly. But if beauty manages to elude this danger, it is often at the expense of falling into the sin of pride. As it is said that where there is smoke there is fire, so it may be said that where there is beauty there is also pride and vainglory. The beauteous are ceaselessly exposed to blandishments and cajoleries; little wonder that these should go to their heads. But, should they turn a deaf ear to flattery, there is always a mirror nearby, the most malign of flatterers.

The mirror appears in history as a device indissolubly linked to woman. Presumably, the symbol that indicates femininity—a circle with a long inverted cross stemming from its lowermost point—represents a portable mirror and its handle. (The symbol for masculinity—a circle from which an arrow comes out, pointing obliquely up and to the right—most likely represents the idea of hunting or warfare.) The fact that she watches her image at all times gave rise to the topos that lovers all over the world have used in poetry and song: "Would that I were your mirror, that your beautiful eyes

should always be reflected on mine!" or "that you held me constantly close to your divine face!" This, of course, only while the face therein reflected is a thing of beauty; for when beauty fades, the mirror ceases to be a flatterer and becomes an abhorrent denouncer or informer. An epigram of the sixth century AD depicts a courtesan retiring from her profession and offering a votive present to the goddess of love in these words:

> Laïs, whose resplendent beauty the time has withered, can bear no proof of her age or her wrinkles; she has conceived a hatred for her mirror, cruel witness of her past splendor, and consecrates it to her sovereign. Receive from me, Cythera, this disk that was the companion of my youth, since your beauty has nothing to fear of the passage of time.[41]

Clearly, moralists worry about the untoward effects of an attractive physiognomy. To protect humankind therefrom, they devised the prophylaxis, and failing this, the therapy, of beauty-induced damage. Prevention was a straightforward matter: beauty penetrates through the eyes of the beholder. Hence the need to curb any acts tending to enhance beauty's power of visual enchantment. Ideally, woman should walk about in humble garb; in the misogynous formulation of Tertullian, "as Eve mourning and repentant" (mourning her own death to the blessed life of Paradise, and repentant from the ignominy of the original sin). Tertullian's austere ideal is, of course, unattainable; therefore, moralists resigned themselves to condemning all beauty-enhancing devices and warning potential victims from looking at the beautiful too keenly.

Johannes Andreas, a fourteenth-century theologian who taught at the university of Bologna, was fully aware of the visual peril. He had a beautiful daughter, curiously named Novella, who became a learned woman. When he could not come to teach his students, he sent his daughter in his place and "so that her beauty should not disturb the mind of the students," she brought with her a little tentlike device with a curtain in front of her face. The theologian's biographer, who was his contemporary, academic colleague, and fellow ecclesiastic, commented: "It is strange that a fact of this nature, so rare, so singular, is not to be found in any of the authors who have dealt with the life of Johannes Andreas."[42] And he goes on to discuss, in true academic

style, whether the girl impeded or promoted students' learning by hiding her beauty from them. On the one hand, her beauty was distracting. On the other hand, one listens better to utterances that come from a beautiful mouth, and one is more easily moved and persuaded thereby. "For we see women who, because they stare avidly at a good-looking preacher, do not retain any less well the things he preaches."

The fact is, looking is a double-edged or bidirectional danger: to look at the beautiful is risky, but the gaze of the beautiful cuts to the quick, worse than cold steel. Although the female sex was sometimes represented as basilisks that destroy with their eyes, an English author remarked that a beautiful woman is more aptly compared to a porcupine that sends an arrow from every part,[43] although his quaint metaphor was grounded on the myth that porcupines eject their darts. In any case, men ought to heed this admonition: the best is not to look, but if you must, do not tarry in contemplation, for deadly shots can come from a cheek's dimple, and the most cautious men have been felled by a totally random shot from a pair of glistening eyes.

But what if the damage is already done? The unvigilant fellow looked where he should not have, and now he is caught whole. He thinks of her day and night; he cannot get rid of her image. He feels as if chained to her by invisible, soul-gripping shackles. The beauty-inflicted laceration is festering. What can the moralist do? The problem is as old as recorded history. It is the quandary to which innumerable works have been devoted, all of which may come under one title: *How to Fall Out of Love*. From millennia of experience moralists educed so many curious therapies that even a cursory review would fill many ponderous volumes. Not to stray too far from the main subject of my narrative, I will briefly touch upon the theme of the Remedies of Love, as conceived in past ages.

Excursus: Some Historical Remedies of Love

It seems imperative that a discussion of the known ways of curing oneself of the wounds of love should start by citing the classical work of the Roman poet Ovid (Publius Ovidius Naso, 43 BC–AD 17), who wrote, two millennia ago, a poem which, on account of its grace, originality, and mockingly didactic tone, is still read with interest in our day. The book, *Remedia amoris* ("Love's

Remedy" or "The Cure for Love"), was meant to instruct the reader, in 814 lines, on how to get over the emotional distress of a lost love. This opus is a section of a three-part collection of poems in which Ovid dispenses advice to lovers. The first part, *Amores* ("The Loves"), describes, in elegiac poetical style, marriage, love affairs, and the general effects of Cupid's malfeasance. The second part, *Ars amatoria* ("The Art of Love"), is the best known; it counsels on how to achieve a seduction. The third, *Remedia amoris*, expounds on how to avoid the suffering of a breakup. His advice ranges from psychological strategies—keep busy, constantly occupy your mind with absorbing, provocative, or enticing matters; go to war if need be (signing up with the Foreign Legion was the desperate resource of jilted lovers centuries after Ovid); concentrate on the physical or psychological defects of your beloved, and magnify them with all your mental powers—to dietary measures, such as avoiding foodstuffs believed to be aphrodisiac. A commentator remarked that, were Ovid's books newly published today, booksellers might place them under the category of "Self-help," "Do it yourself," or "How to" books.[44]

Ovid's work has encountered severe criticisms. Different ages have found him excessively frivolous, too often drawn away from his subject, and even falling, at times, into abject sycophancy. Yet the charm and enduring pertinence of Ovid's writing is attested by the fact that after two thousand years his books are still widely read. Today one can find, on the internet, modern tips derived from Ovid's *Remedia amoris* on "how to get over a breakup."[45]

Successive ages copied Ovid's precepts and injunctions, but also elaborated upon them. There is an old therapeutic measure against the love passion which may be named the "anatomical dissection method." Ovid could not have known it, since anatomical dissections were not done in his time. The cure goes something like this:

If the absence of your beloved is a torture greater than you can bear; if you yearn to have her in your arms; if you long to kiss her, and hanker for her presence and her contact, there is a way to wean your mind from these cares and becalm your restlessness. Think of her face, but represent vividly to yourself what lies under her skin. Know that you will find a muddy, sanguineous, colored mass covering her bones. Yes: she is red blood, foul gleet, viscous phlegm, and raw meat, just like the rest of us. That which you adore would

make you shudder in horror if you could see behind the surface. Beautiful or ugly faces and attractive or repulsive bodies: they are all the same: all are made of arteries, veins, nerves, flesh, fat, bile, feces-filled intestines, and what not. Is this what you want to embrace? Is this the scruff that you yearn to kiss? The beauty that you see is a deceitful image produced by the weakness of the eyes of the body. Train yourself to see with the eyes of the mind. Then you shall see your love object as she really is: a velvet-covered pot brimful of filthy refuse; a sepulcher whitewashed outside and full of rottenness inside; a mud pit covered with snow. Yes, your adorable beauty is like the apples of Sodom, which flaunt a luscious, terse skin, but if you cut them open you find nothing but stench and ashes.

It is hardly necessary to say that this technique met with widespread failure. To begin with, not many people have a firsthand acquaintance with anatomical dissection. It is thus very difficult to represent in the mind what is encountered upon removing the facial skin. And for those of us, members of the trade, who have been forced into close contemplation of anatomy's bloody intricacy, the truth is that the initial shock and horror become attenuated by habit. Such is human nature. Inurement makes the spectacle of dissection more interesting than harrowing.

In the seventeenth century, bleeding was considered a panacea. Prominent physicians recommended this procedure for practically any illness, not excepting hemorrhage. (Incredible as it seems, it was orthodox therapy to treat bleeding with more bleeding!) Hence, it is not surprising that blood loss enjoyed some prestige as a remedy of love. Jean Regnault de Segrais (1624–1701), French poet and novelist, recounts that the prince of Condé was madly in love with a Mademoiselle Vigean. He fell seriously ill at Philipsburg after the battle of Nördlingen. His physicians, prompted by therapeutic zeal (read bleeding fury), bled him white. Somehow he recovered and thought no more about Mademoiselle Vigean. Everyone was surprised, and "he said to those who talked to him about her, that his love must have been entirely in his blood, for it had gradually disappeared as his blood was being removed."[46]

The same author narrates another story of those turbulent times.[47] An aristocratic German lady accorded her favors to a man of inferior rank and had him living with her. In time, she saw fit to transfer her affection to a

second man, while summarily dismissing the first. The rejected lover, desperate, thought of making a final, dramatic scene: he threw himself at her feet imploring her pity. On his knees, in front of her, he unsheathed his sword, placed it in her hands, and in high-sounding terms constrained her to face a tough dilemma: either to take him back, or plunge the sword into his chest, for life without her he judged unlivable. He did not mean to be taken literally. In his experience, such grandiose posturing was bound to soften the sensitive feminine soul. But, alas, would you believe the belle's heart so callous that it made her take the second of the two choices set before her? Without hesitation, grasping the sword's hilt with her two delicate hands, she made two vigorous thrusts into the wretched lothario's rib cage. He survived, but it took him three months to recover. At the end of his long convalescence he must have realized that overdoing in gesture and speech is great for effects on the theatrical stage, but not always recommendable in daily life. He also confirmed that his former perfervid sentiment toward the stone-hearted lady had completely disappeared. He could look at her with total indifference. He concluded that the abundant blood he had shed through his wounds was the cause of the semiportentous cure.

Occurrences of this kind were reflected in the theater. Scholars have noted that in the English theater of the modern age a doctor was rarely represented on stage bleeding a patient by cutting a vein (phlebotomy), or in any other way. However, lovelorn individuals were many a time shown sustaining a wound as part of a theatrical play, and thereby being cured of their passion.[48] For instance Passionate Lord, an appropriately named protagonist of the seventeenth-century drama *The Nice Valour* by the Jacobean authors John Fletcher and Thomas Middleton, languished under the wounds of love. Nothing had availed to cure him, not even sexual intercourse (the therapeutic method boldly recommended by some physicians of the past, much to the indignation of moralists and the Church). Yet, after being stabbed by a soldier, he recovers completely: the sword wound had the effect of a therapeutic phlebotomy. In another play of the same epoch, *A Very Woman* by Philip Massinger and John Fletcher, a dishonorable lover falls victim to his rival in a duel. His disorderly love is expelled with the blood lost through his wounds, for he can tell the doctor who tends him:

Talk no more of love, for
It was my surfeit, and I loathe it now
As men in Fevers meat they fell sick on. (Act IV, ii, 50–51)

These apparent cures gave rise to the hypothesis that passionate love is predominantly a hematologic condition: a love principle had to circulate in the arteries and veins admixed with the blood components. In particular, "black bile" was the "humor" believed instrumental in producing the love melancholy. As the old blood was removed and replaced by the newly formed, the love principle would be diluted and finally eliminated. Thus, the theoretical basis for recommending bloodletting in lovesickness was to expel corrupted humors, chiefly black bile. But we must not forget that blood has a symbolic meaning, and in the symbolic realm the expulsion of blood also meant to purge the body of evil.

There were other assumed beneficial effects of bloodletting. One was to diminish the amorous impulse in general, since it was accepted that a "sanguine" temperament inclined or predisposed to passionate emotion. Another effect of blood loss was believed to be a depletion of semen, since it was thought that heated and refined blood was the material from which semen originated; and it was commonly held that "seed" was the cause of erotic desire.

Against the hematologic hypothesis was the sobering observation that love remained unchanged in some cases after bleedings so frequent and so numerous that one could surmise the totality of the original blood volume had been evacuated. Much to the frustration of the medicos, the hypothetical love principle could not be expelled with laxatives, purgatives, enemas, diuretics, diaphoretics, emmenagogues, sialagogues, antipyretics, or analgesics. Clearly, the problem was psychological and required subtler, more sophisticated techniques to combat it. It did not escape thinkers that lovesickness appeared to originate from a profound impression of beauty upon the mind. Therefore, it was conceivable that a second intense psychological impression, surpassing the first in vehemence and fury, could supplant the undesirable passion. This is how an early version of shock therapy was started: it was the famous "Leucadian leap."

The history of this remedy is well known. Lovers wishing to be cured of their affliction were taken to the top of the Leucadian cliff, a steep limestone rock at the end of Cape Doukato, in the southwest end of the Greek island of Leucas (now Lefkada). It is a wild and rugged coast. Out of the waters rises the mighty, white (thence its name) Leucadian cliff, of immense height and unrelieved steepness. Its top is lost among the clouds, its bottom mantled by the white spume of the waves that come crashing against it. At the cliff's summit there used to be a temple of Apollo, where an expiatory rite was performed each year, on the day of the feast of this god. A criminal condemned to death was thrown from the cliff to the sea below, where boats disposed in a circle waited for his fall. The curious detail is added that sometimes birds were tied to the victim's body, in the childish hope that the fowls' attempts to fly might mitigate the violence of the fall. The poor volatiles never suspected they would be dragged to a watery grave! If the hurled man survived, he was allowed to live, but was banished to exile. Perhaps from this ancient rite originated the tradition that lovers wishing to get rid of their woes could climb to the top of the cliff and try the kill-or-cure jump: if they survived, they stopped loving. Menander, the Greek playwright who flourished in the fourth century BC, said in some verses that the great poetess Sappho was the first to try the big leap, allegedly in order to forget the pain of unrequited love. Various authors claim that Sappho was preceded by a number of other celebrated jumpers.[49]

After the big leap, some jumpers lost their passion, others lost it together with their lives, and still others lost neither. But the Leucadian leap and the "anatomy-dissection" method for ridding oneself of obsessive erotic ideation share in common the belief that strong emotions are replaceable; that they may be thought of as *extensive*, in a manner of speaking: for they take up space in the mind, which is their receptacle. And when a new emotion arrives, if it is bulkier, heavier, or stronger than the rest, it has the power to displace them and occupy their place. It was noted that worry and fright, when intense, can take the place of exacerbated lust. However, these general observations must have seemed trivial to thinkers during the Enlightenment. The time had arrived for a rational, science-based explanation. And it was Father Benito Jerónimo Feijóo y Montenegro (figure 7.3), the Spanish

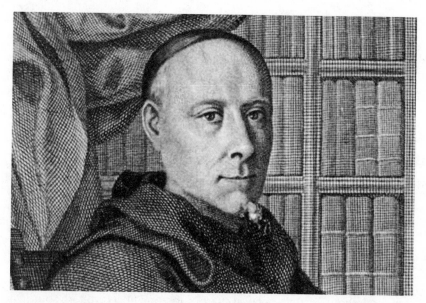

Benedictine monk whose work we have had occasion to mention previously
in this book, who came up with one such hypothesis. He devised a cure of
physiopathologic basis in his monographic study *The Remedies of Love*.[50]

Without quoting any physicians or any neurophysiological study—
unlike his contemporary and fellow churchman, the great naturalist Lazzaro
Spallanzani (1729–1799), Feijóo was not a physician and never performed
experiments—the Benedictine friar discourses in general terms on the emo-
tions being produced by "vibrations" in the brain fibers. We must recall
that the concept of the cell as the unit of structure in living beings was
unknown in his time. It was not elucidated until the nineteenth century
by the likes of Theodor Schwann (1810–1882), Matthias Jakob Schleiden
(1804–1881), and Rudolf Virchow (1821–1902). In the eighteenth century,
the idea that the living body was made up of elementary "fibers" enjoyed
great popularity among scholars. The famous *Encyclopédie* of Diderot and
D'Alembert devotes many pages to this subject. "Fibers" were defined as "the

simplest filaments that enter into the composition and form the structure of the solid parts [of the human body]."[51] Thus, fibers could be ligamentous, osseous, nervous, muscular, etc., according to the bodily parts to which they belonged. It was also noted that "every fiber, regardless of the part of the human body, is furnished with some elasticity." This may not be apparent in the osseous parts; "however, the sound elicited in bones when they are struck denotes well enough that the osseous substance is elastic." But there is no occasion for this property to be shown in the human body "because there is no natural effort that could put the bones in a state of elongation."[52]

Considering that massive numbers of nerve fibers exist in the brain, where they form countless bundles, varying in magnitude from microscopic to grossly visible, and given the elasticity of these fibers, it was natural for Feijóo to embrace the notion that the emotions are produced by the agitation of vibratile cerebral fibers. This conjecture today seems pure nonsense, but it is not without a certain poetical charm: vibrating fibers evoke the plucked strings of musical instruments, and it is meet that our different moods should correlate with an appropriate musical piece: *pianissimo* and with feeling for our quiet moods; *crescendo* for growing irritation; *strepitoso* when the irritant pushes us beyond the bounds of temperance.

Feijóo starts by acknowledging that previous psychological therapies were based on the proposition that intense emotions may displace each other. In metaphorical terms, as the nerve fibers vibrate, the louder musical notes produced prevail over the softer and slower. This explanation applies to the Leucadian leap or to more common perturbations of mental stability. A man may be in the throes of passionate rapture, when suddenly lightning strikes next to him, or he receives news of a disastrous loss touching his estate, or he sees an enemy coming to kill him, weapon in hand. Happenings of this kind will distract him from his amorous transport. Not just momentarily, for it will take a long time before his mind recuperates its original ecstasy. The "association of ideas" is another phenomenon of crucial interest to the Spanish Benedictine. If you encounter two persons at a given place, later when you think of one of them the idea of the second one intrudes spontaneously into the mind. By the same token, when you think of that place, the thought of the two persons comes to the mind.

Armed with facts of observations such as these, Feijóo was ready to propose his therapeutic plan. Its theoretical base was quite simple: "that the imagination of one object, be it terrible, or irksome, or melancholic, should attenuate or extinguish in the passionate individual the [idea of] the love-object." In practical terms, this means that he who wishes to cure his obsessive love must choose a terrible or pitiful object—the one he knows by experience to be aptest to move him profoundly—and then exert himself in linking the idea of this thought with that of the beloved. The choice of terrible or pitiful object will vary with the individual. To some, the mere thought of suicide by fall into a precipice is more than they can bear; others are horrified by the actual sight of a man burned to death; and still others may be haunted by the memory of a bloody murder that they witnessed. The choice of mental representation will depend on the sensibility and experience of each person. The important thing is to choose the thought that makes the deepest, most disturbing mental impression. Let it be the most terrifying, the most horrid, or the most disgusting thought that can be vividly brought to the imagination. Then the seeker after a cure for love must practice an "exercise" that consists in switching the mind's focus from the horrifying thought to the love object. This should be reiterated several times. Ten or twelve times, sometimes less, will suffice, says Feijóo, to achieve the desired result,

namely *that it will be impossible for the lover to think of his beloved without the horrible or pitiable thought irrupting into his imagination at the same time.*

Twentieth-century panegyrists of the Spanish friar say that he was prophetic; that he anticipated by two centuries some of the techniques later used by psychoanalysts. They spoke of him as "Feijóo the psychiatrist" long before Sigmund Freud came to the world. It is true that his medical opinion was often sought after, notwithstanding his lack of formal training as a physician; it is also true that his advice sometimes achieved good results. But the cases in which this happened were mostly conditions of nervous quality, whose improvement is largely dependent upon "moral influence," or *suggestion*. In this Feijóo was uniquely skillful, as has been shown from an analysis of some of his works.[53] His imposing presence, his power of suggestion, and the patient's faith and hope—those two precious auxiliaries in treating every

form of human turmoil and trouble—must have helped him to cure cases of hypochondriasis, and all sorts of psychogenic maladies then called hysteria, melancholy, and other names. But one has to wonder whether his therapeutic method of linking the idea of the beloved with the mental representation of torture, dismembering, burning, decapitation, and sundry scenes of terrifying cruelty might not have pushed the love passion down the sliding ramp of sadomasochism. If so, this would be a singularly bizarre instance in which a Catholic priest of the Order of the most holy Saint Benedict was actually recruiting members for the confraternity of votaries of Sade and Masoch: S & M affiliates, as is now said!

8 ON BEING UGLY

THE UGLY PREJUDICE ON UGLINESS

Madame de Sévigné, the renowned seventeenth-century letter writer, commented in a missive to her daughter that the lawyer Paul Pellisson (1624–1693) "abused the permission that men have to be ugly." These words reflect the uncharitable tendency to display great ingenuity in taunting and twitting those found wanting in physical graces. Actually, the portraits that exist of Pellisson show that while he was no Adonis, neither was he as bad-looking as Sévigné's witticism has since made him appear. It is likely that his personal embroilments with the government (he was secretary to Fouquet, the disgraced finance minister under King Louis XIV) led to his incarceration as well as to his demonization. The latter term is used advisedly, in view of the following anecdote, probably apocryphal, about him.

One day, Pellisson was approached by an elegant lady who, without saying much to him, took him by the hand and asked him to follow her. Feeling flattered, the lawyer obliged. They went to a secluded house, climbed some stairs, entered what seemed to be an artist's shop, and a painter came out to meet them. The lady said to him: "This is the man! I want it exactly like him," and with these words, she left in a hurry. Pellisson remained confused, not knowing what all that was about. He found out that the lady was a rich aristocrat who had commissioned the artist to paint the temptation of Jesus Christ in the desert. She had been unhappy with the rendering of the face of the devil. None of the models chosen by the painter had seemed to her sufficiently "diabolical" until she came across Pellisson's physiognomy.

It is impossible to know whether this experience had anything to do with Pellisson's conversion from Calvinism to Catholicism. He died a Catholic after obtaining a rich ecclesiastical preferment. Still, the anecdote vividly underscores the widespread tendency to associate evil with physical ugliness and, as natural counterpoint, goodness with beauty.

When discussing the old prepossession that says "the beautiful is the good," I find it useful to refer to Father Feijóo; for the notions that he sets down are representative of the sort of opinions that men of the cloth entertained and diffused in his time. The friar lists, in his appropriately monachal Latin, the following quotations that reinforce the mentioned prejudice.[1]

St. Ambrose pronounced: *Species corporis simulachrum est mentis, figuraque probitatis* ("The type of body is a simulacrum [i.e., an image] of the mind, it is the form of honesty"). Feijóo attributes to none other than St. Augustine the saying *Incompositio corporis inaequalitatem indicat mentis* ("An ill-composed body indicates an unequal mind"). However, the Spanish monk warns us that "ill-composed body" refers to disorder of movements and a lack of gravity and modesty in the person's bearing, not to ugliness. To Rhazes (845–925), the Persian physician, is attributed a saying that in its Latin form says: *Cujus facies deformis, vix potest habere bonos mores* ("He whose face is deformed, scarcely can have sound customs"). Jacob Menochius (1532–1607), Italian jurist and Bible commentator of the Renaissance, reached the extreme conclusion that a deformed person could not possibly be good: *Fieri non potest, ut qui omnino difformis est, bonus sit* ("It is impossible for a man who is utterly deformed to be good"). The concept (today we would call it "blather") that ugliness was the way God or Mother Nature had "marked" certain individuals became a callously insensitive apothegm; it added insult to injury upon the unfortunates born with repulsive features. Feijóo nonetheless claims that Aristotle used to repeat that we ought to "beware of those whom nature has marked" (*Cavendos quos natura notavit*). The Benedictine friar finishes his enumeration of Latin sayings with a quotation from Martial, the usually earthy, often obscene, yet masterful Roman epigrammatist:

> *Crine ruber, niger ore, brevis pede, lumine luscus,*
> *Rem magna proestas, Zoile, si bonus es.*

("Red-haired, black-mouthed, short-footed, boss-eyed,
What a big accomplishment, Zoilus, if you are a good fellow!")[2]

Red hair must have been extremely uncommon in ancient Rome, and probably impressed a superstitious populace as a freakish aberration portending misfortunes to come. This superstition dates from very long ago, and was grounded on the fanciful tradition that Judas Iscariot had this kind of hair. From various medieval chronicles it appears that red hair was believed to be a dishonorable feature. The Benedictine monk Guibert, abbot of Notre-Dame de Nogent (1053–1124), medieval theologian and historian, declared that "the red-headed carry a burning mark of infidelity." A medieval anecdote says that a poor man who happened to be red-haired was ashamed of this bodily characteristic: inside a church he covered his head with his gown, and never dared to enter a temple where a bishop was praying. This brings to mind the clever repartee of a russet-haired man who, finding himself in a southern European country where the mentioned prejudice was widespread, was targeted for ridicule by a Jesuit. As the man approached a group of people where the Jesuit was talking to some friends, he heard the ecclesiastic say: "This man is red-haired, like Judas!" To which the offended subject replied: "Sir, there is no proof that Judas was red-haired. But what no one can deny is that he was in *the company of Jesus!*"

Uncertainty troubles Friar Feijóo and the many authors who have discussed the "beautiful-is-good" stereotype. As late as the nineteenth century, Friedrich Schiller (1759–1805) could still write that "physical beauty is the sign of an interior beauty, a spiritual and moral beauty."[3] Moralists have often opined that external beauty depends, at least partially, on personality traits. A calm, peaceable disposition is reflected in a serene gaze and fewer skin lines and wrinkles than those present in the face of a tense, irritable individual. An even temper, a tranquil mood, and a kind attitude are personal attributes that countervail to some extent the irregularities present in a physique. Or so the edifying writings and lectures of moralists keep telling us. But cultural stereotypes incline people to expect close correspondences between bodily type and personality, and have a role in molding the character of the subjects considered. If people consistently think that attractive persons are

high-minded, noble, and honest, the attractive individuals will be habitually treated with higher regard than the unattractive. Now, since our inner self is fashioned by the way others think about us and recognize our worth, those accustomed to being treated as virtuous may actually become so. Unfortunately, there is plenty of evidence that the converse is also true: those who are systematically humiliated and made objects of derision are likely to become rancorous, reticent, and vindictive.

The physically ill-favored, but endowed with sharp wit, manifest a rare talent for requital against would-be teasers. A story says that Athenis and Bupalus, two famous Greek sculptors active in the sixth century BC, made a statue of the poet Hipponax, their contemporary. The features of the notoriously thin, little, and ugly Hipponax were grotesquely exaggerated in this effigy. The sculptors used to take a perverse pleasure in making impudent jokes for the amusement of the friends who came to see the caricaturesque statue. Hipponax did not take kindly to this mockery, and, since he was a great poet known for bloody satires that spared neither his parents nor the gods, he replied by composing a lampoon in iambic verse against the makers of his caricaturized likeness. The composition was so violent and so extensively diffused that, in one version (which Pliny rejects), it drove the sculptors to hang themselves.[4]

Feijóo, without giving us his source, quotes a Sicilian story of a gentler retaliation devised by a man offended on account of his ugliness. A certain Gallias, a remarkably ugly man from Agrigento, was commissioned to carry out some business in the town of Centoripo. The authorities provided him with the necessary documents that deputized him as ambassador. But such is human malevolence that no sooner had Gallias arrived at this destination than the commission of Centoripians who came to receive him exploded in laughter at what they thought was the comical appearance of the envoy. Customs were then less urbane than now; the receptionists made no secret of the cause of their hilarity: they told the bewildered Gallias how amused they were at the sorry appearance of the man the rulers of Agrigento had seen fit to charge with the business at hand. Gallias, unfazed, replied to them: "It is an ancient custom in Agrigento, when a legate is to be sent to a grand and noble city, to choose for the job a man of great physical beauty, uncommon

strength, and proud carriage. But when the embassy is to take place in a vile, ruinous, and miserable town, then the ambassador is chosen among the ugliest inhabitants of the city." A witty response it was, no doubt; but one not exempt of risks for the ambassador.

Those constantly exposed to the public, if physically unsightly, run a higher risk of encountering jeers, taunts, and ridicule. Dumirail, a French actor of the Comédie Française noted for his ugliness,[5] was representing the role of Mithridates in the play of this name by Racine. There is a moment in act III, scene 5, when an actress tells him: "Ah! Milord, your face is changed." Some wag in a balcony shouted: "Leave him like that!"

The masterful satirist Lucian of Samosata (c. 120–190 AD) imagined a "postmortem conversation" taking place in Hades among these three dead personages: Menippus, a Greek philosopher who flourished in the third century BC and adhered to the Cynic school of thought founded by Diogenes; Thersites, the ugliest of the Greeks who fought in the Trojan war; and Nireus, a weak military man who is called by Homer "the comeliest man of those who came to Troy" (*Iliad*, book II, lines 672–673).[6] By congregating the handsomest and the ugliest Greek warriors in the Trojan campaign, Lucian cleverly set the stage for his biting satire.

We are to suppose that vanity accompanies the souls of the dead into Hades; for Nireus, even in his ultraterrestrial existence, still hankers after adulation and the confirmation that he is, unquestionably, the handsomest. He is in conversation with Thersites, who shows no inclination to provide the requested puffery. Nireus then approaches Menippus and asks him: "You be the judge, Menippus: which of us two, Nireus or Thersites, is more handsome?" To his frustration, the philosopher does not seem to know which is Nireus and which Thersites. An inhabitant of Hades, he has not heard of either, nor does he care one iota about ascertaining the difference. When informed of the judgment passed by Homer, he remains unmoved and plainly tells Nireus that his earthly privilege counts for nothing "down here," since in Hades all the osseous skeletons have the same value. "Your skull," he says, "can only be told from that of Thersites by its brittleness."

Thersites is elated. "I, with my sugar-loaf skull and thin hair," he exclaims, "can be just as handsome as Nireus in the Kingdom of the Dead."

More handsome, indeed, if Menippus is to be believed when he said that solidity, not beauty, is the most valued characteristic of skulls in the realm of the departed. Thersites is literally thick-headed, whereas the cranium of Nireus is "frail and unmanly." A wonderful idea: in death, the criteria for beauty are fundamentally transformed: solidity, not harmony and proportion, is what counts. Outward form now matters little, since in general all skulls look alike. The mighty egalitarianism behind this idea reminds me of the *calaveras*, the popular satirical strophes that circulated (each time less, it seems) in loose flyers, magazines, and newspapers in Mexico's Day of the Dead celebration. I still recall one of these, whose final stanza leveled off the powerful of the earth with an inexorable reminder:

> *El Emperador Maximiliano*
> *Y el Pontífice Romano*
> *Duques, reyes, concejales*
> *En la tumba son iguales*
> *Calaveras del montón.*

("Emperor Maximilian / And the Roman Pontiff / Dukes, kings, counselors, / Inside the grave they are all alike / Skulls in a heap.")

THE QUEST FOR THE NATURE OF UGLINESS

Ugliness is just as difficult to define as beauty. We hear it said that the latter is the opposite of the former. And the former? Why, of course, the opposite of the latter. We thus engage in the astute game commonly played by dictionaries when encountering terms of perplexing, undefinable meaning—what philosophers of yesteryear used to call an *aporia*: they remit the reader to another entry, which, in its turn, sends the reader back to the original entry. This elegant circular loop (which takes polygonal form when synonyms intervene) gives the impression of erudition, thereby saving the dictionary's honor without clarifying the meaning of the problematic word.

To say that ugliness is the lack of harmony and good proportions is tantamount to reaffirming the subjective nature of ugliness. As in the case of beauty, definitional criteria are relative: they change with the epoch and

the prevailing culture. Umberto Eco makes a good case for this when he notes that medieval architects thought of the form and dimensions of a gothic cathedral as supremely beautiful, whereas their counterparts in the Renaissance believed that harmonious, well-proportioned structures were those built according to the accepted canons of construction, such as "the golden rule" and other formulas of design and decoration derived from classical Rome.[7] To Renaissance builders, the medieval cathedrals were "gothic" in the original sense of the word, that is, belonging to the barbarous Goths. The *Oxford English Dictionary* tells us that the term "gothic" was used mostly in reprobation before becoming associated with a specific artistic or architectural style. The following acceptations of the word "gothic" are still current: "barbarous," "rude," "uncouth," "unpolished," and "of savage temper." Taste changed again in the eighteenth century, as Goethe in an eloquent and patriotic essay inveighed against those who deem the gothic architectural adornments confused, arbitrary, and unnatural. He had nothing but contempt for critics who called the German architecture "barbaric without knowing the meaning of this term."[8] Goethe tells us how profoundly moved he was when he first saw the Strasburg cathedral: he was seized by the "feeling of an immense grandeur" before which there is nothing to do but to bow and revere. The gothic style was, in his view, the most sublime expression of Germanic sensibility in art and architecture.

Philosophers agree on the need to consider the whole and its parts in making an aesthetic judgment. Things may seem beautiful in isolation which appear ugly when placed in the wrong environment. The opposite is also true: things that individually considered are ranked as ugly may become elements of beauty when forming part of a larger whole. Marcus Aurelius develops this last point in his *Meditations*. He notes that the scraped-off parts of the crust in a baked bread impress us as thwarting the baker's design. Nevertheless, those breaks in the crust have "an appropriateness of their own"; and we can see that, in a painting as in real life, the cracks in the bread's surface have a way of attracting attention, of stimulating the desire for food, and thereby contribute to the beauty of the whole.[9] He mentions certain things—figs that gape open on account of their ripeness, full ears of corn that bend down, the foamy secretion issuing from the jaws of a wild boar, and so

on—which considered apart from their setting are ugly, but when looked at "as resultant from the operations of Nature" acquire an added charm and may be used in artistic representations that attract our admiration.

Truth to tell, some of us urban dwellers accustomed since our early years to find in the supermarket figs neatly arrayed in little baskets, and ears of corn in packets wrapped in plastic and cellophane, are not as receptive to Marcus Aurelius's rhetorical images as those who grew up in the countryside. But we understand the main point of the Roman emperor-philosopher: wisdom confers the ability to discern the way in which apparently inconsequential things, which many find unappealing, become adjuncts to charm as parts of a larger whole. Wisdom, or in his words, "sensibility and a deeper insight into the workings of the Universe," will enable us to appreciate beauty even when it is concealed from the common eye. Only thus shall we be able to see in the aged of either sex "a mature prime and comely ripeness, and gaze with chaste eyes upon the alluring loveliness of the young."[10]

Gotthold Ephraim Lessing (1729–1781), the leading voice among the German philosophers of the Enlightenment, devotes three chapters of his celebrated opus, *Lacoon*, to his ideas on the nature of ugliness.[11] He says that the artist who tries to represent ugliness should not dwell too fastidiously on the features that compose it; for whenever a poet delves excessively into the elements that make a thing ugly, ugliness disappears. Ugliness belabored, he seems to be saying, is ugliness effaced. This idea may have been suggested to Lessing by a book of his illustrious contemporary and friend, the philosopher Moses Mendelssohn (1729–1786). In that work, *Philosophical Writings* (*Philosophische Schriften*, published in 1761), Mendelssohn was discussing beauty, not ugliness, as will now be explained.

Mendelssohn imagines two friends, the young Euphranor and the older, more mature Theocles, engaged in an epistolary conversation during which they discuss the nature of human feelings. In the first letter, Euphranor sets forth the idea that reason is inimical to (mental or aesthetic) pleasure; for too careful an analysis of things pleasurable ends up disrupting this very pleasure. This, he says, is because enjoyment depends to a large extent on the surprise which beauty provokes in our senses. But the reasoner, the savant who is always trying to clarify his own feelings, becomes hardened to that

surprise and is thus rendered impervious to the sweet sentiment of pleasure. For instance, those who read the great works of literature just for the sake of analyzing the writing style, or to study the use of plot development techniques, may become learned professors in various aspects of literature, but are no longer able to feel the beauties they praise so highly when speaking to their students.

Next, Euphranor advances a pithy example. Suppose, he tells Theocles, that you catch sight of a beautiful woman and that you are instantaneously smitten. Two shiny, large, beautiful eyes; the face a perfect oval covered with a radiant, terse skin; a lively, joyful, vibrant expression; these are some of the many features that put you in a sweet state of confusion from which you are at pains to disentangle yourself (but at the same time not wishing to be freed, because you find the entrapment uniquely pleasurable). Now suppose that you are an inveterate analyzer, so that instead of concentrating on the beautiful, bright eyes you direct all your attention to the effect of the light as it is reflected on the fluids and the structures responsible for the diaphaneity of the eye; and instead of concentrating on the lively, vital expressiveness of the face your attention is wholly devoted to discerning the slight contraction of the various facial muscles whose coordination composes each charming facial expression. In that case, "your pleasure would perish and you would have, instead of a sweet rapture, a set of arid truths."[12] The pleasure in this case is based on confusion; on an obscure feeling whose origin you ignore, but which will disappear when you try to shine the light of reason upon it. In short, Euphranor concludes that reason, by conflicting with the sensation of surprise, is a killjoy that will not let us feel the pleasure of beauty.

The wise Theocles does not agree with Euphranor's opinion; how could he? His reply starts with an explanation of why perfectly distinct concepts seem (but are not) incompatible with the feeling of beauty. The reason for this is the limited capacity of the human mind to grasp a multiplicity clearly all at once. Every time we want to think distinctly we withdraw our attention from the whole and focus on the component parts one by one. We proceed this way also in the appreciation of beauty. The world is manifold, but our powers are limited and apt to be exceeded, so to speak, by the multifaceted complexity of the things of the world. But this does not mean that we should

renounce seeing things clearly and distinctly. An obscure sentiment should not be the source of pleasure; for "the pure gratification of the soul must be grounded in the positive pleasures of our soul and not in its incapacity, not in the limitation of its original powers."[13]

Theocles' answer to Euphranor's query comes framed in an airy, metaphysical tone. It is likely that the young Euphranor would have preferred to hear a concrete, easily digestible explanation as to why the enjoyment of feminine charm requires shunning the prolix analysis of its causes. Instead, Theocles answers him with abstract generalities: the concept of beauty must be based on clarity, he says. He advises the young questioner to train himself to contemplate all sides of a beautiful object clearly and distinctly, and then switch from the parts to the whole, and do this in such a way that the parts affect the mind while remaining in a state of equilibrium and proportion to one another, and "do not shatter the perception of the manifold, but only make it easier to grasp." Should he succeed in doing this, he shall see that "the whole alone radiates from [the parts]." There is reason to doubt whether Euphranor felt fully satisfied with this exalted and rather abstruse philosophical account.

We may now come back for a minute to Lessing's dissertation on ugliness. He notes that, contrary to the precept that warns poets against delineating ugliness in too great detail, Homer does precisely this in his description of Thersites, the ugliest of Greek warriors in the Trojan War. But this is because the genial founder of epic poetry did not intend to emphasize the uncomeliness of that man: instead, he wished to make him an object of derision. Homer makes Thersites ugly in order to make him laughable, says Lessing. This laughable quality does not derive merely from his ugliness, for ugliness is imperfection, and laughableness requires "a contrast between perfection and imperfection." In the case of Thersites, the contrast is to be found between his physical ugliness, his vile character, and the lofty idea he entertains of his own importance. There is also a glaring contradiction— i.e., a laughable contrast—between the malicious chatter that he employs in abusing others and the effect his words have, which is to bring humiliation only to himself. In the end, Thersites is punished in front of the troops. Here, Lessing introduces a caveat. The contrast must be "of no moment." Make it

of severe, weighty consequence, and the laughableness disappears. Suppose that instead of punishing Thersites with a couple of whacks on the back in front of the soldiery, the punishment consists in having him decapitated. We would then cease to laugh at him. "For this monster of a man is yet a man, whose destruction will always seem a greater evil than all his frailties and vices,"[14] concludes Lessing in the spirit of profound humanism.

By the same token, innocuous ugliness may be laughable, but seriously mischievous ugliness cannot be so. So long as the buffoon-like prattle of Thersites causes no disruption, he may be ranked with the ridiculous or buffoonish. But suppose his words have a great effect upon the soldiers and initiate sedition; suppose the ranks revolt, and a mutiny breaks forth in which the leaders are killed. Again, laughableness disappears, and in its place remains the terrible. Ugliness therefore, according to Lessing, has two possible derivative or transformative avenues: the laughable and the terrible.

A STRATEGY FOR MANAGING THE LAUGHABLE SIDE OF UGLINESS

Human nature harbors a fund of ungenerous malevolence. Or so it seems when we consider the many ways invented to mock, taunt, and ridicule those who are branded as ugly. But, as we have noted, the strategies used by these to counteract the scoffing have been equally ingenious and diverse. One ruse has been to assume the attribution of ugliness, to jest about it, and display it proudly. John James Heidegger (1666–1749), a vivacious Swiss man, used this stratagem. He went to England as a businessman, impresario, and manager of Italian opera at the King's Theater in London, and was soon notorious for his unsightliness. To his credit, he did splendidly well in English high society. He brought into fashion "masquerades" (masked balls), which became the town's favorite pleasure despite the condemnation of the bishop of London, who on January 6, 1734 preached a sermon against these amusements. That King George II was fond of operas, and by no means averse to masquerades, no doubt contributed to Heidegger's social success. He was initially known as "Swiss Count," and later nicknamed "Count Ugly." A socialite lady described him as "the most ugly man that was ever

Figure 8.1
John James Heidegger (1666–1749), also called Johann Jacob Heidegger. Portrait by John Faber Junior after Jean-Baptiste van Loo. (From Wikipedia.)

formed." This was an obvious hyperbole: his portraits show a rather ordinary-looking, middle-aged man (figure 8.1). Alexander Pope alluded to him in his epic-satire, the *Dunciad* (book I, lines 289–290):

> And lo! Her bird (a monster of a fowl,
> Something betwixt a Heidegger and owl).

Heidegger pushed his burlesque to the point of betting with Lord Chesterfield that no one could find a man surpassing him in ugliness. Lord Chesterfield, by temperament a man apt to follow this kind of joke, took up the challenge. After painstaking investigations, he found an old woman of truly horrible mien in one of the London slums. The old crone and Heidegger appeared together in front of the judges of the bet, who found that the woman was the uglier of the two, and therefore Lord Chesterfield had won. Heidegger appealed the verdict, alleging that in order to produce a just ruling the two contenders had to present themselves to the judges in complete

equality of circumstances. He took hold of the woman's hat, put it on his own head, and in this new guise he appeared so frightfully hideous that the judges had no recourse but to adjudicate the victory to Heidegger.

He died in 1749, at the age of 83. His comical self-deprecation served him well. This colorful man once said: "I was born a Swiss and came to England without a farthing, where I have found means to gain 5,000 a year—and spend it. Now I defy the ablest Englishman to go to Switzerland and either gain that income or spend it there."[15]

In terms of sheer ugliness, we must agree that Heidegger was not exceptional. He was not deformed or congenitally misshapen; facial features similar to his have always been common in middle-aged men in all walks of life. But as soon as we imagine his face framed by feminine apparel: topped by a lady's coif; surrounded by bows and ribbons; possibly adorned with earrings or other facial ornaments; and on top of this, if we picture him grimacing; then we are bound to acknowledge that his repulsive qualities must have been sufficient to make him the uncontested winner.

We tend to forget that just as there are beautifying techniques that conceal the blemishes and enhance the comeliness of a face—cosmetics and expert makeup techniques can accomplish startling transformations—there are also deforming or disfiguring techniques employed to distort the facial features, to disfigure and disproportion the countenance in order to produce disgust. The search after a displeasing effect is presently confined to the theatrical stage or the movie scene. However, it has an ancient history, in the course of which some individuals accepted ugliness, invested themselves formally with it, and turned it into the means of achieving distinction. Not content with being merely ugly, they aspired to the title of King of the Unsightly.

In the late Middle Ages, competitions of male unsightliness were held at which the winner received material prizes along with the approbation of his neighbors. One such contest took place on January 6, 1482, and is described in the first chapter of Victor Hugo's famous novel, *The Hunchback of Notre Dame*. Such a contest used to be part of the so-called "Feast of Fools" or "of Madmen" (*Fête des fous*). This was one of several festivals of a grotesque character yearly celebrated in France at the end of December and

beginning of January. Scholars contend that these feasts originated when the Christian faith had just begun to take root. Presumably, the people were used to the bombastic, unrestrained and often licentious nature of pagan celebrations; consequently, they found it hard to accept the style of the new cult, largely confined to the hearing of sermons and homilies, praying, and singing sedate religious hymns. The clergy esteemed prudent to introduce into the rites some practices more in keeping with the taste of the newly converted. They began by allowing, inside the temples, scenic representations of the life of Christ and the most moving and morally edifying episodes recounted in Holy Scripture. Unfortunately, an ignorant and superstitious populace exaggerated the "humanization" of the divine personages in those representations; triviality and vulgarity soon found their way into them. A touch of pagan reminiscence completed the process of degeneration of a festive ceremony originally meant to strengthen the faith. The feast became an ignoble parody of the things the Church held most sacred.

For instance, in the Feast of Fools clerks and priests could appear dressed as women; they wore masks, sang dissolute songs, and danced with repulsive contortions inside the temple's hallowed space. The altar, most sacred place of the house of worship, was changed into a "buffet" table where people could eat all sorts of viands, or play dice and other games of chance. Lay brothers would be seen wearing sacerdotal vestments that had been rent or were worn upside-down. Elsewhere, a mock religious service was represented, in which the assistants wore spectacles, only instead of glasses these had circles made of orange peel.[16] There were mock cardinals, kings, popes, and other Church potentates. They were called "fools' bishops." Scholars report that a true bishop, Guillaume de Mâcon, who died in 1308, donated his own episcopal apparel in order to dress a "fools' bishop."[17]

Another feast, which certainly did not yield in extravagance, was called the "Feast of Asses." It was celebrated in Beauvais. A beautiful maiden was chosen to ride a richly harnessed ass carrying a pretty baby in her arms. In this state she rode from the cathedral to the church of St. Stephen, followed by a procession which included the mock bishop and clergy. Once inside, she placed herself near the altar and the parody of mass began. The ass was the object of respectful genuflections by those present. The priest addressed the

parishioners with a mock preaching that sounded more like a malediction; and the attendees, at the end of every period, instead of saying *Amen, Amen* answered *Hihan, hihan, hihan!*, in imitation of the braying of the animal! Isaac Disraeli called these ceremonies "an imbecile mixture of superstition and farce."[18]

THE GRIMACE

It was in the course of these extravagant (impious?) feasts that contests of uncomeliness were organized in which the ugliest man won. Each contestant would grimace, frown, scowl, and try to contort the countenance as best he could. These curious competitions lasted through the Renaissance and beyond. As late as the last quarter of the nineteenth century, a French newspaper reported that in the Belgian commune of Meldert, in East Flanders, a curious society had just been formed, the "Grimacing Society" or "Society of Grimacers" (*Société de Grimaciers*), whose bizarre purpose was to cultivate "the grimacing art." An advertisement was affixed in several public places, announcing the inaugural ceremony: "There will be prizes for those who will make the drollest, most laughable, outlandish and bizarre grimace." The public was exhorted to participate in distorting the mouth to simulate beak, muzzle, horse's mouth with bit or hackamore, etc. The announcement further stated:

> The contest will take place at the domicile of Joseph Vanden Bossche, cabaret owner at Meldert. Next Saturday, at this locale, extraordinary buffooneries will be performed; the strangest grimacing ever seen on the human countenance will be done. The representation will begin at two-thirty in the afternoon. All the lovers of this art are invited to come and give proof of their skill. The first prize is a silver pipe with cover; the second, a silver pipe; the third, an *écume*[19] pipe,

and so on.[20]

The English word "grimace" is defined by the *Oxford English Dictionary* as "a distortion of the countenance, whether spontaneous or involuntary, expressive of some feeling (esp. annoyance, embarrassment, ill-humor, or

pain) tending to excite laughter; a wry face." It lists Hobbes's *Leviathan* as the earliest (1651) recorded English use, in this expression: "Sudden Glory is the passion that maketh those Grimaces called Laughter."

The aforementioned journalistic note informed its readers that Belgium was not the birthplace of the "art" of grimacing. Indeed, long before they made their appearance at festivals and country fairs, the so-called *grimaciers* (English, "grimacers") were a known presence on the streets of Paris and other cities, along with a number of mountebanks, quacks, and sundry fast-talking hucksters. Two grimacers, who performed together, achieved some celebrity. One of them used to wear a white wig, donned an enormous, clownish pair of cardboard spectacles, and played a violin or a trumpet. His drolleries, although very funny, remained mild-tempered. The other one was Italian, younger and good-looking. He wielded a cane or a stick on which was suspended a bladder, said to be an attribute of satirists (was it because it symbolized the bile, urine or other offending effluent about to be poured on the targeted victim? or perhaps it was a special-effects device, by virtue of the laughable sounds produced when strongly compressed). The younger grimacer specialized in abrasive, wounding satires and the reproduction of "strong emotions," to the delight of his many female devotees.[21] A public of saunterers gaped at them in utter amazement, while the grimacers contorted their faces in the grotesque semblances of fright, surprise, sadness, joy, and all the commotions of the soul that manage to reach the countenance. An observer systematized the expressions of the masterful performers into distinct types, among which are listed: *simple* grimace: a laughing, gracious, rounded visage; *compound* grimace: half-laughing, half-afflicted; *laborious*: sullen, with inflated cheeks and swollen nose; *sad*: eyes large and tearful, lips trembling, some moaning; *boisterous*: eyes closed, mouth open, tongue protruding, shouts, laughter, and tears. Several other types evinced the versatility of the performers.

A jaded society such as ours generally feels that to watch a man engaging in multifarious facial contortion is a species of puerile entertainment belonging to benighted times past, when people lacked the sensorial hyperstimulation that our technological age liberally dispenses on everyone; or else, that the grimacer is appreciated only by those deficient in native shrewdness. But

a propensity to watch the morbid or unwholesome has ever attended our nature. So it is that grotesque spectacles are often profitable to impresarios. At the turn of the century, a Mr. Morimoto, Japanese music hall artist and "maker of faces," came to America. This *grimacier extraordinaire* was said to excel at impersonating the Japanese "hermit god Daruma." Daruma is actually Bodhidharma, a monk credited with founding the Zen tradition of Buddhism between the fifth and sixth centuries AD. It is recounted that during his travels he settled in a cave to meditate, and this he did, seated in an unchanged position and looking at the wall for seven years, without breaks. He flinched once only, but this weakness made him so wroth against himself that he cut off his eyelids, that he might never slumber again. Legend has it that at the place where the eyelids touched the ground, there sprouted green tea plants, and ever since green tea helps anchorite-meditators and other night owls to stay awake. Tourists in contemporary Japan often buy cute "Daruma dolls," with large eyes fixed in a blank stare, and plenty of facial lines presumably charged with symbolic meaning.

Mr. Morimoto allegedly represented Daruma-Bodhidharma in alternate tranquil and turbulent moods; now in the peace of his mystical trance, now in the violent commotion of his struggle against demonic passions. What the fascinated spectators saw was the appearance and progressive deepening of grooves all over his face: on the forehead, cheeks, and around the eyes. Gradually his face disappeared: stunningly, the cheek skin and the lower lip, apparently with the lower jaw as well, were pulled upward, so that the nose was covered by these structures (figure 8.2). Wrote a reporter: "The mouth is completely gone . . . the face gets buried in deep wrinkles, perhaps to portray the enormous abstinence of the hermit or loner god." Another witness said that in each of his characterizations "you not only saw a new face, but you felt a deep expression of the soul, something so powerful, so emotional, that you could not deny him his art."[22] Present-day opinion would probably deem this exalted language disproportionate and ill-fitting to what many would call a circus show or a gross, vulgar, and perhaps somewhat sordid form of entertainment.

The heyday of such spectacles is gone, but it is still possible to find individuals who obtrude themselves to public notice by displaying a shocking

Figure 8.2
Left: Mr. Morimoto's face in resting state. *Center and right*: Progressive distortion of Morimoto's face, until his mouth "disappears" and his nose is covered by his lower jaw. Photographs ca. 1880–1890. Unidentified photographer. From Luminous lint at http://www.luminous-lint.com /app/image/09157437108380901819/.

hyperextensibility of their facial skin. They do this for financial gain, or merely to attain notoriety in today's social networks. It has become generally known that some of these persons suffer an inheritable disorder of the connective tissue, the Ehlers-Danlos syndrome. Those affected with the full-blown form of this disease exhibit excessive skin extensibility and joint hypermobility, features on account of which a sufferer sometimes is nicknamed "rubber man," or something of the sort. But it is wrong to think of these unfortunates as medical curiosities, for they are exposed to serious, potentially deadly complications. A congenitally weakened connective tissue may result in a spontaneous visceral perforation, rupture of a blood vessel wall, or a split in lung tissue with spontaneous emphysema. There is a spectrum of clinical severity: there are over a dozen clinical variants, each with its own clinical characteristics and each associated with specific biochemical defects of the collagen fibers in the connective tissue.

The grimace is an act that has little relevance in our lives. Admittedly, it is possible to discover remnants of the medieval grimacing competition. In the town of Egremont, on the Cumbrian coast of northwestern England, an annual celebration takes place after harvest time known as the "Crab Fair." It was first held in 1267 and, except for necessary interruptions during the world wars, has been held continuously ever since. Sports events, such as

horse and bicycle racing, wrestling (of a special type, called "Cumberland wrestling"), and many other festive activities are featured in the celebration. Among them is a "gurning" competition. The word "gurn," according to the *Oxford English Dictionary*, is dialectal form of "girn," one of whose acceptations is "to show the teeth in rage, pain, disappointment, etc; to snarl as a dog." The gurner-competitors at the Crab Fair put their heads through a horse collar—which enhances or serves as a foil to the contestant's visage— and try to make themselves as ugly as possible by contorting their faces into the most grotesque, bizarre, and comic expressions possible. This is clearly a residuum of a hoary, medieval celebration akin to the Feast of Fools, albeit with modern modifications: there are now junior, senior, and female categories; foreigners from all over the world are entrants in the competition. Apparently, the elderly do best in this event, because their skin is redundant and moves with greater facility while grimacing.[23] This we may easily infer from watching grandma.

Whatever one may think about the annual feast celebrated in that Cumbrian village, it is refreshing to reflect that the elderly are acclaimed in the major highlight of the event. In a world where the aged are ignored, discriminated against, often derided or contemned; where youth and beauty are held as the worthiest modes of being, and any departure therefrom as a loathsome decline that must be avoided or concealed at all cost; in such a world, it is most gratifying for us elderly persons to hear that a competition exists where the old often take the prize, for according to one of the organizers, "it is a distinct advantage to be without any teeth."[24]

In our societies, the cultural significance of the grimace is varied. Sometimes it is purely ludicrous. We think, for example, of the well-known photograph of Albert Einstein sticking his tongue out while looking at the camera. The gesture was designed for play or amusement. It was March 14, 1951, and the savant was celebrating his 72nd birthday. A crowd of photographers had importuned him to pose for them until he got in the car that was to take him home. One photographer still tried to persuade him, while he was already sitting inside the car, to smile "for his birthday picture." Instead, he stuck out his tongue, and what became an iconic photograph was shot. The

editors of the news agency debated vigorously about the appropriateness of the photo. The decision was to publish it, and it became a commercial success and one of the most celebrated photographs of its time.

The grimace constitutes "an irruption of the principle of pleasure," in the words of David Le Breton,[25] and thus a pleasurable activity apt to be enjoyed by children. In the act of grimacing the child plays with his or her own facial expressive apparatus, exploring the sensations that come from activating the muscles of the face in a ludicrous ritual that is part of the process of self-discovery. At the same time, the child is greatly amused by the strong reactions elicited by his grimacing: his playmates will laugh heartily and may join in the game of countenance distortion. Alternatively, the reaction will be one of indignation; adult observers are often upset. A common maternal admonition takes the form of ominous augury. Many of us may recognize this from the time of our childhood: "If you do not stop that, your face is going to stay like that forever!"

Grimacing has been given a religious tonality in literature, thanks to the creative power and imagination of Miguel Angel Asturias (1899–1974), the Guatemalan poet, novelist, and diplomat who drew the attention of the world to the culture and customs of the Maya people of his homeland. His rich and innovative work earned him the Nobel Prize for Literature in 1967. The remarkable novel in which grimacing occupies an important place is enigmatically titled *Maladrón* and dates from 1969. It is a fascinating narrative situated at the time of the Spanish conquest of the Maya territories, yet it is by no means a traditional historical novel.

The title comes from of the Spanish expression *mal ladrón*, which means "bad thief." It is an allusion to the so-called "impenitent thief" crucified alongside Jesus according to the gospels. The tradition is that two bandits suffered the same torment together with the Redeemer. One showed signs of repentance, asked for mercy, and told Jesus: "Remember me when you come into your kingdom" (Luke 23:32–43). The other one taunted Jesus for not saving himself, and remained rebellious and obdurate to the end: he is the "impenitent" or "bad thief" in the blend word *maladrón* coined by Asturias. In the novel, a group of Spanish soldiers during the conquest of American indigenous kingdoms leave their regiment and embark on a half-Quixotic,

half-greedy quest of discovery. They are convinced that there is a place where the waters of the Atlantic and Pacific oceans come together, possibly joining through an underground passage. They hanker after the glory of this momentous discovery, and dream of the untold riches and environmental blessings that they imagine attending the undiscovered strait.

There are many fascinating aspects of this novel, such as the dialectical contraposition of the indigenous people's cosmic vision and that of the European conquerors, or the stylistic techniques used by Asturias, who in unfolding his narrative sometimes seems to be describing the image-hieroglyphs of the Maya codices. But of special interest to us here is the novelistic idea that among the Spaniards there was a group who adhered to a strange religion, believing that the true martyr of Golgotha was not Jesus but the Bad Thief. Their unorthodox credo dated from biblical times. Presumably, it had originated within a priestly sect of Jews, the Sadducees,[26] active between the second century BC and the destruction of the Second Temple of Jerusalem in 70 AD. In Asturias's novel, the Spanish soldiers come under the influence of a prisoner condemned to serve as a galley slave in the boat on which they make the trans-Atlantic cruise. The name of this man is Zaduc, and he is a convert to the strange religion. It so happens that, historically, Zaduk was the name of the founder of the Sadducees, from which they derived their name (Sadducees = Zadukim).[27] Unlike the rest of the boat's crew, this mysterious personage, "short, stocky, with a beard made of saffron threads," does not attend Mass, does not go to confession, does not take communion. However, he is seen to kneel for hours in an attitude of great devotion in front of a cross made of spider webs; only, instead of praying, he would contort his face in all kinds of grimaces. He belongs to the Sadducee-derived sect of the "Grimacers" or "Gesticulators."

In arch-Catholic Spain, to be at variance with accepted doctrines meant to be branded as a heretic, persecuted and perhaps tortured and killed by the Inquisition. Zaduc, a member of the strange sect, manages to live, although enslaved as an oarsman in the galley and charged with the vilest menial chores. During the cruise, he transmits his unorthodox teachings to the soldiers of the Asturias novel. This is how the writer sets forth some beliefs of the *Maladrón* faithful:

The Bad Thief, the *Maladrón*, was the true martyr of Golgotha, yet he was executed as a bandit, even though he had been a philosopher, a politician, and a scribe. Although a descendant of high priests, he was tied to a cross and dealt with as a human beast, when actually he had been a Stoic and almost an Epicurean, as attested by his unperturbability during his martyrdom, his supreme apathy when he kept silent about who he was, and his acceptance of an anonymous death.[28]

The tenets of the sect seemed uniquely fitting for a number of the Conquistadores. The image of the Bad Thief, "his turbulence, his cruelty in the mockery he showed toward the last minutes of an innocent," accorded so well with the attitude and behavior of some of the Spanish soldiers that Zaduc's doctrine "took" among some troopers. The converts, however, proliferated in the lower ranks without reaching the hidalgos of the higher ranks, among which there were, "as in the clover fields, some who counted three or four exalted bloodlines."[29] But there were limits to the propagation of the odd creed among the troops. The soldiers, already ill-disposed to engage in prayer, were much less disposed to fall into concentrated grimacing. The few who were seen doing this became the laughing-stock of their comrades-in-arms.

A detailed analysis of Asturias's interesting and complex novel would be out of place here. My focus is confined to the intriguing description of a "grimacing sect." Was there ever such a thing? *Maladrón* is strictly a novel; as far as I know it never pretended to factual, historical verisimilitude. However, it has been claimed[30] that Asturias was inspired by the formidable erudition of Marcelino Menéndez y Pelayo (1856–1912), Spanish writer, historian, and philologist extraordinaire, who in his impressive multivolume history of Spanish unorthodox thinkers (*Historia de los heterodoxos españoles*) single-handedly reviewed practically every heretical doctrine that ever thrived in the Iberian peninsula from the Middle Ages to his day. Trudging through this admirable scholarly tour de force—a singularly wearisome task, since the work, like others of this indefatigable author, lacks an itemized subject index—I found no trace of a Gesticulating or Grimacing sect.

Nevertheless, the idea is highly suggestive. A sect whose members, instead of praying, "make faces"! What could this mean? It may be thought of as a reflection of a pagan Feast of Fools. Or perhaps it is the attempt of

a gifted novelist to take the grimace to its ultimate signification. For it is to be noted that the grimace is often a gesture of rebellion expressed by the downtrodden and impotent. A cruel and powerful dominator abuses a subordinate; this one replies by sticking his tongue out at the offender . . . making sure his gesture is unseen! The grimace is directed *at* the abuser, but never frontally: it is deployed to his back. The act of grimacing becomes a childish expression of wrath and despair among the powerless subservient, those who have been cowed into submission by threats and superior force. Dispirited, acquiescing to inactivity in front of the oppressor, all they can do to vent their anger and frustration is to grimace without being seen.

Perhaps the "grimacers" imagined by Asturias are venting a long-suppressed fury. Their prophet was discredited; made an object of derision or execration for centuries; denounced as a "bad" thief, when they believed he was a holy man; cursed and ridiculed as ungrateful, when in the believers' view he was the incarnation of a superior soul. At the time of his death, his face was distorted by physical pain and discomposed by "the convulsions of agony and the tempest of remorse." His disciples, his continuators and votaries, decided to take this tragic gesturing, this mimicry, and transform it into a religious rite.

All this is evidently nothing but the product of a novelist's fertile imagination. But there is something strangely disquieting in the depiction of a group of men driven by pillage, greed, and bloodshed who pray without words. They do not hesitate to extend the power of the sword over the conscience of the conquered; yet they continually have in view the future of their own souls and the fear of damnation. And what do they do? Instead of the suppliant words and the inner collectedness of prayer, they choose long sessions of mute grimacing designed to celebrate the rancor and defiance of the Impenitent Thief. And instead of obeying the Redeemer's exhortation to carry out the free exercise of evangelical virtue, they pride themselves in following a creed of impudent defiance, savage independence, and vile mockery. It seems only fitting that this religion of a brutal, rough soldiery and of unruly mercenaries should have made a liturgy of grotesque facial contortions.

9 THE FACE OF A VERY TRIVIAL DEATH: A SHORT STORY BY WAY OF EPILOGUE[1]

It has been justly remarked that of all the objects that our eyes can see, none engrosses so large a share of our thoughts and emotions as one we see every day: that little patch of bodily surface—so small that it is almost completely covered by the stretched palm of a hand—which we call the face. For here lies embodied and supremely condensed the entire strength and vulnerability of the human condition. Here lies our social identity: to this part of the body we owe our social recognition. We "are" through the face: our individual, irreplaceable specificity is thereby acknowledged by our fellows. But here lie also the crucial sensors of the apparatus that makes possible our relational life: the receptor organs of sight, hearing, smelling, and tasting—the openings of our corporeal being to the external world—are all found here, in that tiny surface area circumscribed within a few inches. Hence the strong desire we all have to understand the mute eloquence of the face and to decipher its strange, cryptic, gestural symbolism. But in those of us who studied medicine many years ago, this desire was reinforced by indoctrination. For our mentors insisted that the systematic scrutiny of semblance and demeanor was essential to a sound medical practice.

Fifty years ago, biomedical technology was not as advanced as it is today, and medical students were still taught to rely heavily on the data provided by the unaided senses. In particular, it was emphasized that the careful inspection of a sick person is invaluable: often the first landmark on the road that leads to the establishment of an accurate diagnosis. No self-respecting physician of those days denied that the inspection of a patient's physiognomy

generated the earliest idea about the state of the disease, and a suspicion that future investigations should go this way or that. We were taught that a physician confronting a person incapable of describing his or her complaints, say a child or an adult whose state of consciousness is perturbed, might uncover the true nature of the malady through careful study of the *facies* and other parts of the body.

Even today, the physical examination, beginning with the inspection of the facial features, retains much of its diagnostic prestige. Physicians of deep knowledge and long experience were, and still are, the objects of unbounded admiration among medical students on account of their ability to make snap diagnoses after what everyone deemed a cursory gaze at the patient. For instance, a diagnosis of gout could be made by simply looking at the subject's ears and recognizing the presence of "tophi" (from Latin *tufa*: calcareous and volcanic deposits), small nontender nodules formed on the auricular edges from deposits of gouty urate crystals. Or a diagnosis of coronary artery disease was suspected in a young patient if one looked at his ears and found an oblique, deep crease in the earlobe.[2] In like manner, intestinal polyps may be diagnosed in a young child by simply looking at his lips: the so-called Peutz-Jeghers syndrome is an inheritable disease characterized by the association of intestinal polyps and 1–5 mm pigmented spots on the mucocutaneous junction of the mouth. The examples may be greatly multiplied of clinical maladies which, under certain well-specified conditions, are diagnosable "at a glance," with the consequent enhancement of the diagnostician's reputation. In the nineteenth century, entire treatises were devoted to the examination of the face by simple inspection and the diagnostic benefits derived therefrom.[3] Today, the time and effort necessary to sharpen a physician's visual keenness are thought to be better invested in cultivating other necessary skills; yet this does not mean that facial inspection is neglected. Ample scientific evidence continues to support the proposition that the face furnishes innumerable clues of disease as well as health to the alert observer.[4]

Perhaps my past experience as a medical student at a time when the physical examination was preeminent explains the inclination I had to canvass attentively the facial features of the people I met. I felt inclined to do this

before my retirement, and indulged in this activity everywhere I could without appearing impertinent, even with the strangers I crossed on the street.

Thus, I became familiar with the mien of some persons that I used to encounter in my daily walk to the hospital where I was employed as a pathologist. For instance, I recall an old man, talking to himself in an undertone and strolling aimlessly: one might have said a loose autumn leaf, now wafted along in a linear direction, now whirled about in a fitful gust of wind. His nose pointing downward, his sunken lips and jutting chin lent him a resemblance to the grotesques drawn by Leonardo. The many wrinkles of his brow were like the script traced by the hand of destiny, where a Renaissance expert in the now-defunct art of metoposcopy might have read the chronicle of a life ill-spent and the dire augury of a hopeless, friendless death.

In contrast, there was a young fop, pert and presumptuous, of attractive oval face and big, bright eyes, basking in the widespread misconception that "what is beautiful is good" and enjoying the social advantages attached thereto. Few lines ran on his face, but a line-reader of old would have concluded that those few were superintended by the planet Venus, because apparently the high point of this young man's ambition was to be an exquisite nabob and to besiege the heart of the closest belle. And there was also, among others of my recollection, a young working mother, bearing I know not what burden on her shoulders, and on her face the marks of a premature aging induced, I supposed, by the cares and clamors of a grievous domestic life. These were some of the persons that I spotted often on my way to work.

One day, as I turned a corner, I noticed a commotion at the end of a small plaza. I heard the young fop exclaim: "It looks like a guy has collapsed over there!" And I also heard an adolescent boy say to a friend, with a pitiless, cruelly gleeful accent in his voice: "Come on, hurry, let's go take a look at the bum!"

In effect, a middle-aged man, whom I had not seen before, had collapsed on the plaza's pavement. Swarthy, stocky, broad-faced, and short-necked, his features differed from those assigned to individuals of Caucasian lineage. His denim garb, torn and soiled with white paint, identified him as a menial worker—the kind who fails to attract your attention if you should spot him atop a scaffold, lining up bricks in a construction site; the kind you

readily avert your sight from, should he irrupt into your visual field, washing the windows of your office or apartment while suspended from a rope. An immigrant, probably. Undocumented, very likely.

How long had he been there? It is difficult to say, but knowing the ways of the tumult of this world, I would wager that it was no brief spell; moreover, that passersby had commented "He's drunk!"; that many a one had studiously avoided approaching him; and that, at length, a compassionate soul came by who realized that disease, not drunkenness, had first tottered, then felled, that human frame.

I got there when an ambulance had just arrived. The man was very pale, but conscious, sitting, his back propped against the wall, while someone tried to give him air by agitating a magazine with fanlike movements before his face. But what impressed me the most was hearing him say to those who surrounded him, in a weak, tremulous voice: "I am sorry . . . I am very sorry . . . please excuse me."

The man apologized! For what? For obtruding the spectacle of his misfortune into the uncaring lives of others? What he meant to say was: "I am sorry to trouble you with my personal misery." "Kindly excuse me if I have offended you by reminding you of what you prefer to ignore." In his day of adversity, with his threadbare clothes soiled with paint and his whole life stained through and through with the sweat of his brow; in a world so full of anguish and struggle and disappointment, this man deemed it a lack of delicacy to appear in public with his toil-worn body beset by illness and discomposure. As I recall, he seemed not afraid of dying: rather, he was ashamed of being seen dying among men, women, and children. I could not avoid feeling deeply touched by this example of sublime politeness, this most respectful, ingratiating regard for the Other.

The ambulance took him away, and that day I thought of him no more. But now and then I gazed with delight at the recollection of his conduct. I remembered his coarse features, and by a curious act of fancy, I superposed his image to the likenesses of other people long sedimented deep in my memory. His features melted and reshaped into a different semblance each time, over and over. In the end, I saw my dead father's face, which as a small boy I briefly gazed at through the open coffin, when an officious mourner,

during the somewhat macabre ceremony of the wake, lifted me by the waist, without asking my permission, "so that I could take a last look" at the man who, they said, "had brought me into the world." It was a frowning face that has intrigued me ever since. Did that knitted brow mean astonishment? Puzzlement? Fatigue? Simple bodily pain? Johann Caspar Lavater, the eighteenth century's "messiah of physiognomy," believed that the inner nature of man shines forth through his exterior most strongly at crucial moments, such as the end of life. He advised his students to visit the wards of hospitals in order to watch the faces of the dying, for he believed the correspondence between inner disposition and outer structure was then closest, and most apt to validate his theories.

The fallacy of physiognomy is now evident, its basic postulates rebuked and discredited. But the juxtaposition of faces in my imagination told me that, at some fundamental level, all human faces are mutually equivalent: the grotesque semblances of Leonardo's drawings, the angelical lineaments of Botticelli's personages, the contrite semblance of a sick man who falls in the middle of the street, and my dead father's undecipherable grimace: they all add up to the same tally. For as Holy Scripture puts it, in what is probably its hardest statement: "All go unto one place, all are of the dust, and all turn to dust again" (Ecclesiastes 3:20).

I had forgotten the street incident when, a week later, I was assigned to perform the autopsy of a patient who had died of myocardial infarction. Imagine my surprise when I realized that the deceased was the same man who, only days before, had collapsed in the street. For a while, I stood perplexed, contemplating that lifeless, inert body. Then I readied the dissecting instruments, and looked once more at that face.

During life, I thought to myself, each human being is divisible into two: an exterior being, superficial, which we can see from outside, and an inner being that inhabits the realm of consciousness and is utterly private, known only to the individual concerned. In this case, the inner man was no more, yet how much of the outer one still remained! For it is here, in the face, that our identity largely resides; here is the highest sign of our individuality. And yet the face conceals more than it reveals; it dissimulates and announces at the same time. The coarse features of the man I was about to dissect did not

bespeak the acts of generosity and nobility of soul of which he was capable. For a man is more than his facial features; more, indeed, than a collection of organs; he is his acts, his history, his yearnings, and his aspirations.

Having made these reflections, I took the scalpel in my hand. And then, without thinking, almost automatically, I did what seems to be a universal, ritualistic act among cadaver dissectors: I covered the subject's face with a towel. Only then did I get ready to perform what a writer called ironically "the last cut," but which, for those of my trade, is really the first.

Notes

INTRODUCTORY NOTE

1. Samuel Johnson, *A Dictionary of the English Language* (London: W. Strahan, 1755).

2. J. C. Lavater, *Essays on Physiognomy; for the Promotion of the Knowledge and the Love of Mankind*, translated by T. Holcroft, 3 vols. (London: G. G. J. and J. Robinson, 1789), 1:19.

3. Fernand Baldensperger, *Études d'histoire littéraire*, 2nd ser. (Paris: Hachette, 1910), 61–62.

4. See note 1 to the entry "Physiognomy" in the 1910 edition of the *Encyclopaedia Britannica: A Dictionary of Arts, Sciences, Literature and General Information* (New York: Encyclopaedia Britannica, 1910–1922), 550.

CHAPTER 1

1. Gordon de L. Marshall, *Ships' Figureheads in Australia* (Kalamunda, Western Australia: Tangee Pty Ltd., 2003), 4.

2. Heinrich Zschokke, "Essai d'une apologie du nez," in *Les Matinées Suisses*, 2nd ser., French translation by A. I. and J., vol. 2 (Geneva: Cherbuliez, 1831), 143–159.

3. Luigi Pirandello, *Uno, nessuno, centomila* (book I, sect. V: "Com'io volevo esser solo"). I used the paperback edition published by Limovia.net, 2014, 16.

4. Ibid.

5. Joseph Duvigneaud, *Introduction à la sociologie de l'Islam. De l'animisme à l'universalisme* (Paris: Maisonneuve, 1958).

6. Y. Guerrier and P. Mounier-Kuhn, *Histoire des maladies de l'oreille, du nez et de la gorge* (Paris: Dacosta, 1980).

7. G. Sperati, "Amputation of the Nose throughout History," *Acta Otorhinolaryngologica Italiana* 29 (2009): 44–50.

8. The photograph of the magazine cover is reproduced in Wikipedia at: https://en.wikipedia.org/wiki/Bibi_Aisha#/media/File:Bibi_Aisha_Cover_of_Time.jpg. A biographical note on the young woman is also available at: https://en.wikipedia.org/wiki/Bibi_Aisha.

9. The complete works of Han Fei in Chinese and in English may be consulted online at: http://www2.iath.virginia.edu/saxon/servlet/SaxonServlet?source=xwomen/texts/hanfei .xml&style=xwomen/xsl/dynaxml.xsl&doc.view=tocc&chunk.id=tpage&toc.depth=1&toc .id=d2.20&doc.lang=bilingual.

10. E. Muller, *Curiosités historiques et littéraires* (Paris: Ch. Delagrave, 1897), 8–10.

11. *BBC News*, "Danish Astronomer Tycho Brahe Exhumed to Solve Mystery," November 15, 2010. See also, same date, *The Guardian*, "Tycho Brahe's 'Murder' Investigated," https://www .theguardian.com/science/2012/nov/15/astronomer-tycho-brahe-death-scientists.

12. Edmond About, *Le nez d'un notaire*, 2nd ed. (Paris: Michel Levy, 1862).

13. W. Hoffacker, "Case History of a Severed Portion of the Nose Which Was Completely Detached from the Body for Twenty-Five Minutes," *Medical Annual* 2 (1836): 149; quoted in Z. Niazi et al., "Successful Replantation of Nose by Microsurgical Technique, and Review of Literature," *British Journal of Plastic Surgery* 43 (1990): 617–620.

14. Carnavalet Museum, "Migrants. Un porteur d'eau auvergnat à Paris au XIXe siècle," Musée Carnavalet of the History of Paris, *Dossier pédagogique / Juin 2011*.

15. Georges Duveaux, *La vie ouvrière sous le second Empire* (Paris: Gallimard, 1946).

16. Nicolas Andry, *Orthopaedia, or the Art of Correcting and Preventing Deformities in Children: By Such Means as May be Easily Put in Practice by Parents Themselves, and All Such as Are Employed in Educating Children. To Which Is Added a Defence of the Orthopaedia by Way of Supplement by the Author. Translated from the French by M. Andry* (London: A. Millar, 1743).

17. Riccardo F. Mazzola and Salo Marcus, "History of Total Nasal Reconstruction with Particular Emphasis on the Folded Forehead Flap Technique," *Plastic and Reconstructive Surgery* 72, no. 3 (September 1983): 408–413.

18. Haresh Yalamanchili et al., "The Path of Nasal Reconstruction: From Ancient India to the Present," *Facial Plastic Surgery* 24, no. 1 (2008): 3–10.

19. P. Toma et al., "Gaspare Tagliacozzi, Pioneer of Plastic Surgery and the Spread of His Technique throughout Europe in 'De Curtorum Chirurgia per Insitionem," *European Review for Medical and Pharmacological Sciences* 18 (2014): 445–460.

20. Claus Walter, "The Evolution of Rhinoplasty," *Journal of Laryngology and Otology* 102 (1988): 1079–1085.

21. Daniel Joseph Hauben et al., "On the History of the Free Skin Graft," *Annals of Plastic Surgery* 9, no. 3 (1982): 242–246.

22. The word "nock" is British and means a slit or a crack. Thus, the verse alludes to the slit between the buttocks, nates, or fundament. By extension, it came to mean the bottom or extremity of anything. See notes of Rev. Treadway Russel Nash to Samuel Butler, *Hudibras*, vol. 1 (London: John Murray, 1835), 28.

23. Ibid., 27.

24. A "sutler," according to the *Oxford English Dictionary*, was a petty tradesman, a servant, or a person in charge of menial duties, often near military barracks or accompanying regiments. "Suttling" is used attributively for persons who perform the duties of a sutler, selling provisions, etc., to soldiers.

25. Joseph Addison, essay in *The Tatler*, no. 260 (December 7, 1710). See *The Tatler in One Volume* (Philadelphia: Woodward, 1831), 416–418.

26. Jill Grimes et al., *Sexually Transmitted Disease: An Encyclopedia of Diseases, Prevention, Treatment and Issues* (Santa Barbara, CA: Greenwood, 2014), 583.

27. Ahmed Maher, "Iraqi Families Sell Organs to Overcome Poverty," *BBC News (BBC Arabic)*, April 20, 2016, https://www.bbc.com/news/world-middle-east-36083800.

28. Tazeen H. Jafar, "Organ Trafficking: Global Solutions for a Global Problem," *World Kidney Forum* 54, no. 6 (December 1, 2009): 1145–1157.

CHAPTER 2

1. Eden Warwick, *Nasology: or, Hints towards a Classification of Noses* (London: Richard Bentley, 1848).

2. Joseph Jacobs and Maurice Fishberg, "Nose" entry in *The Jewish Encyclopedia: A Descriptive Record of the History, Religion, Literature, and Customs of the Jewish People from the Earliest Times to the Present Day*, 12 vols., Isidore Singer, managing editor (New York: Funk and Wagnalls, 1901–1906). See also Joseph Jacobs, "On the Racial Characteristics of Modern Jews," *Journal of the Anthropological Institute* 15 (1886): 23–62.

3. Sarah Lipton, "The Invention of the Jewish Nose," *New York Times Review of Books*, November 14, 2014.

4. Don Harrán, "The Jewish Nose in Early Modern Art and Music," *Renaissance Studies* 28, no. 1 (February 2014): 50–70.

5. Sharrona Pearl, "The Myth of the Jewish Nose. It's Not Really a Thing. So Why Have the Stereotypes Persisted for Centuries, among Jews and Anti-Semites Alike?," *Tablet Magazine*, February 7, 2019.

6. Roland Barthes, *Mythologies* (Paris: Seuil, 1957).

7. Pearl, "The Myth of the Jewish Nose."

8. Blaise Pascal, *Pensées*, no. 413 (162 of the Brunschvicg edition), in *Oeuvres complètes* (Paris: Seuil, 1963), 549.

9. Casey Mock, *Plutarch: Life of Antonius* (2005), 59, Senior Thesis Projects 2003–2006, the University of Tennessee, published online: http://trace.tennessee.edu/utk_interstp2/49. See also Plutarch, *Life of Antony*, edited by C. B. R. Pelling, Greek text, English commentaries (Cambridge: Cambridge University Press, 1988), 190–191.

10. Antoinette des Houlières, "Portrait de Monsieur de Linières. 1658," in *Œuvres de Madame et de Mademoiselle Deshoulières*, vol. 1 (Paris: Chez H. Nicole, 1810), 4.

11. Catullus, Poem XLIII, in *Catullus. Tibullus. Pervigilium Veneris*, translated by F. W. Cornish, J. P. Postgate, and J. W. Mackail, 2nd ed. (Cambridge, MA: Harvard University Press, 1988), 51.

12. Xenophon, *Symposium*, translated by O. J. Todd, in *Xenophon IV, Memorabilia. Oeconomicus. Symposium. Apology* (Cambridge, MA: Harvard University Press, 1992), 573.

13. Ibid.

14. William of Rubruck's report was written in Latin. There is an English translation by William Woodville Rockhill: *The Journey of William of Rubruck to the Eastern Part of the World. 1253–55, as Narrated by Himself, with Two Accounts of the Earlier Journey of John of Plan de Carpine*, translated from the Latin and edited by W. W. Rockhill (London: Hakluyt Society, 1900). A more recent version is *The Mission of Friar William of Rubruck: His Journey to the Court of the Great Khan Möngke. 1253–1255*, translated by Peter Jackson (London: Hakluyt Society, 1990). This version is published online: https://depts.washington.edu/silkroad/texts /rubruck.html. A French version, with excellent scholarly annotations and drawings, is Guillaume de Rubrouck, *Voyage dans l'Empire Mongol*, translation and comment by Claude and René Kappler (Paris: Payot, 1985).

15. René Grousset, *L'Empire des Steppes*, 4th ed. (Paris: Payot, 1965), 341.

CHAPTER 3

1. Paul Shepard, "The Eye," in *Man in the Landscape: A Historic View of the Esthetics of Nature* (Athens: University of Georgia Press, 1991), 20.

2. The battle of Bedriacum took place in the first century AD, when Otho (Roman emperor for three months) tried to suppress the rebellion headed by Vitellus, commander of the Roman legions in Germania Inferior. Otho's forces lost this decisive encounter, following which Otho committed suicide by stabbing himself in the heart on April 16 of the year 69, and Vitellus became emperor.

3. Plutarch, "On those who are said to have the evil eye," Question 7 in *Table Talk*, book V, 680.

4. Plato, *Theaetetus*, 155 d.

5. Aristotle, *Metaphysics*, book I, 982 b12.

6. A. Alvar Nuño, "Ocular Pathologies and the Evil Eye in the Early Roman Principate," *Numen* 59 (2012): 295–321.

7. Pliny, *Natural History*, book VII, ii, 16–17.

8. Ibid.

9. Ovid, *The Art of Love*, book I, 8: 15–16, translated by Rolfe Humphries (Bloomington: Indiana University Press, 1957; 7th printing 1973), 26.

10. S. S. Duke-Elder, *Congenital Deformities*, vol. III-2 of *System of Ophthalmology* (St. Louis: Mosby, 1958), 592–593.

11. Niaz Islam et al., "True Polycoria or Pseudopolycoria?," *Acta Ophthalmologica Scandinavica* 85, no. 7 (November 2007): 805–806; Norman S. Jaffe and Paul Knie, "True Polycoria." *American Journal of Ophthalmology* 35, no. 2 (February 1952): 253–255.

12. The queen of Lydia, wife of Candaules, is left unnamed in Herodotus' narrative; she is given different names in other versions of the story.

13. Quoted by Walton Brooks McDaniel, "The Pupula Duplex and Other Tokens of an 'Evil Eye' in the Light of Ophthalmology," *Classical Philology* 13, no. 4 (October 1918): 335–346.

14. John Lascaratos, "'Eyes' on the Thrones: Imperial Ophthalmologic Nicknames," *Survey of Ophthalmology* 44, no. 1 (July-August 1999): 73–78.

15. McDaniel, "The Pupula Duplex and Other Tokens of an 'Evil Eye.'"

16. Arthur Schopenhauer, "Animalischer Magnetismus und Magie," in *Ueber den Willen in der Natur* (Frankfurt-am-Main: Siegmund Schmerber, 1836). The chapter starts on page 91 of the 1854 edition by Hermann available online: https://reader.digitale-sammlungen.de/de/fs1/object/display/bsb10046947_00119.html.

17. Ernest de Toyot, *Les Romains chez eux : scènes et mœurs de la vie romaine* (Paris: Joseph Albanel, 1868), 120–122.

18. Alexandre Dumas, "Jettatura," chapter XVI in the novel *Le Corricolo*, Gutenberg books online, http://www.gutenberg.org/files/9262/9262-8.txt.

19. Sergio Benvenuto, "Lo jettatore, un'ossessione napoletana," *Lettera Internazionale*, no. 90 (2006): 59–61. See also, from this author, his enjoyable book *Lo jettatore. Capriccio filosofico* (Milan: Mimesis, 2011).

20. John H. Elliott, *Beware the Evil Eye: The Evil Eye in the Bible and the Ancient World*, vol. 1 (Cambridge, UK: James Clark & Co., 2016), 28–29.

21. Andrea de Jorio, *La mimica degli antichi investigata nel gestire napoletano* (Naples: Fibreno, 1832), 96–97.

22. Stendhal, *Rome, Naples et Florence*, 3rd ed., vol. 2 (Paris: Delaunay, 1826), 275–278.

23. Karl August Mayer, *Neapel und die Neapolitaner oder, Briefe aus Neapel in die Heimat* (Oldenburg: Schulze, 1840–1842), vol. 1, 56. This work is available online at https://books.google.com/books/about/Neapel_und_die_Neapolitaner.html?id=I2EvAAAAYAAJ.

24. Francesco Paolo de Ceglia, "'It Is Not True, but I Believe It': Discussions on Jettatura in Naples between the End of the Eighteenth and Beginning of the Nineteenth Centuries," *Journal of the History of Ideas* 72, no. 1 (January 2011): 75–97.

CHAPTER 4

1. Sir Charles Bell, *The Anatomy and Philosophy of Expression, as Connected with the Fine Arts*, 5th ed. (London: Henry G. Bohn, 1865), 15–16.

2. Rosalía Castro de Murguía, *Folias Novas. Versos en Gallego* (Madrid and La Habana, 1880), poem VI, 7, published online at https://archive.org/stream/follasnovasverso00castuoft?ref=ol.

3. David Le Breton, *Sensing the World: An Anthropology of the Senses*, translated by Carmen Ruschiensky (New York: Bloomsbury Academic, 2017), 60.

4. Adolf Erman, *Life in Ancient Egypt*, translated by H. M. Tirard (New York: Dover, 1971), 44–45.

5. Plato, *Republic* VI, 507–509, chapter XXIII of part III in the edition translated by Francis MacDonald Cornford (New York: Oxford University Press, 1941; 25th printing 1964), 219.

6. P. Nucci et al., "Normal Endothelial Cell Density Range in Childhood," *Archives of Ophthalmology* 108 (1990): 247–248.

7. R. W. Yee et al., "Change in the Normal Endothelial Cellular Pattern as a Function of Age," *Current Eye Research* 4 (1985): 671–678.

8. W. M. Bourne, "Biology of the Corneal Endothelium in Health and Disease," *Eye* 17 (2003): 912–918.

9. John P. Whitcher et al., "Corneal Blindness: A Global Perspective," *Bulletin of the World Health Organization* 79 (2001): 214–221.

10. The circumstances in which I first knew the blind men were described in my book *The Five Senses* (New York: Harcourt-Brace-Jovanovich, 1991).

11. Oliver Sacks, "The Mind's Eye: What the Blind See," *New Yorker*, July 28, 2003, 48–59.

12. John Hull's initial book, *Touching the Rock: An Experience of Blindness* (New York: Knopf Doubleday, 1991), was expanded and republished as *On Sight and Insight: A Journey into the World of Blindness* (Oxford, UK: Oneworld Publications, 1997). A film documentary directed by Peter Middleton and James Spinney based on the work of John Hull was released in 2016. It was nominated for Best British Film at the 70th British Academy Film Awards. Professor John Hull died on July 28, 2015.

13. A short note on Vermeij's academic achievements is published at:https://www.amacad.org/person/geerat-j-vermeij.

14. T. Ebert and B. Rockstroh, "Reorganization of Human Cerebral Cortex: The Range of Changes Following Use and Injury," *Neuroscientist* 10 (2004): 129–141.

15. J. J. Tattersall, "Nicholas Saunderson: The Blind Lucasian Professor," *Historia Mathematica* 15, no. 4 (!992): 356–370.

16. Anonymous, "A Blind Sculptor," *Art Journal*, n.s. 5 (1879): 288.

17. A. Pascual-Leone and F. Torres, "Plasticity of the Sensorimotor Cortex Representation of the Reading Finger in Braille Readers," *Brain* 116 (1993): 39–52.

18. Thomas Grimm, "Les yeux de la foi," *Le Petit Journal* (Paris), August 28, 1874, front page.

19. Filippo Baldinucci, *Notizie dei professori del disegno da Cimabue in qua*, vol. 4 (Florence: V. Batelli, 1846), 620–629.

20. Rhys Harrison et al., "Blindness Caused by a Junk Food Diet," *Annals of Internal Medicine* 171, no. 11 (2019): 859–861.

21. The *Dizionario Biografico degli Italiani*, vol. 57 (2001), dates Gonnelli's death to 1656, and attributes it to mushroom poisoning. See https://www.italianartsociety.org/2016/04/baroque-sculptor-giovanni-gonnelli-also-known-as-il-cieco-da-gambassi-was-born-on-4-april-1603-in-gambassi-tuscany/.

22. Baldinucci, *Notizie dei professori del disegno*, 628.

23. Delphine Fitz Darby, "Ribera and the Blind Men," *Art Bulletin* 29, no. 3 (1957): 195–217.

24. Maia Szalavitz, "Do E-Books Make It Harder to Remember What You Just Read?," *Time*, March 14, 2012, published online at https://healthland.time.com/2012/03/14/do-e-books-impair-memory/ (accessed October 23, 2020).

25. Pliny the Elder, *Natural History*, book XXXV, xxxvi, 62–68, translated by H. Rackham (Cambridge, MA: Harvard University Press, 1938–1963; reprinted 1995), vol. 9, 307–311.

26. The information concerning the life story of the craftsman Zhang Mingshan (in Chinese) was obtained through the Baidu Chinese search engine. I acknowledge the invaluable help of my wife, Dr. Wei Hsueh, in translating the Chinese texts. See https://baike.baidu.com/item/%E5%A4%A9%E6%B4%A5%E6%B3%A5%E4%BA%BA%E5%BC%A0/3516025?fromtitle=%E6%B3%A5%E4%BA%BA%E5%BC%A0&fromid=706986&fr=aladdin (accessed October 27, 2020).

CHAPTER 5

1. "Lip," in Samuel Johnson's *Dictionary* online: https://johnsonsdictionaryonline.com/.

2. A reference to Pierre Dionis (1643–1718), famous anatomist and surgeon under King Louis XIV.

3. "Lèvre" in the *Dictionnaire de Trévoux* (Lorraine edition, Nancy, 1739–1742); may be consulted online through the Centre National de Ressources Textuelles et Lexicales (CNRLT) at https://www.cnrtl.fr/dictionnaires/anciens/trevoux/menu1.php.

4. Ibid., 656.

5. Charles Darwin, *The Expression of Emotions in Man and Animals*, 3rd ed. (Oxford: Oxford University Press, 1998), 196.

6. R. N. Emde and R. J. Harmon, "Endogenous and Exogenous Smiling Systems in Early Infancy," *Journal of the American Academy of Child Psychiatry* 11 (1972): 117–200.

7. Elizabeth Anisfeld, "The Onset of Social Smiling in Preterm and Full-Term Infants from Two Ethnic Backgrounds," *Infant Behavior and Development* 5, no. 2–3 (1982): 387–395.

8. Georges Dumas, *Le sourire. Psychologie et physiologie*, 2nd ed. (1906; Paris: Presses Universitaires de France, 1948), 16.

9. Sir Charles Bell, *Anatomy and Philosophy of Expression as Connected with the Fine Arts*, 5th ed. (London: Henry G. Bohn, 1865), 140.

10. P. J. Möbius, "Ueber angeborene doppelseitige Abducens-Facialis-Lehmung," *Muenchener Medizinische Wochenschrifft* 35 (1888): 81–94, 108–111.

11. G. Miller, "Neurological Disorders. The Mystery of the Missing Smile," *Science* 316 (2007): 826–827.

12. For a comprehensive review of Moebius syndrome see the publication by the OMIM (Online Mendelian Inheritance in Man) Center, sponsored by Johns Hopkins University, at https://www.omim.org/entry/157900?search=%22moebius%20syndrome%22&highlight=%22moebius%20%28syndromic%7Csyndrome%29%22.

13. James Parkin, "Experience: I Can't Smile," *The Guardian*, May 18, 2018.

14. Junyan Jung et al., "Bilateral Facial Palsy," *Acta Otolaryngologica* 139, no. 10 (2019): 934–938.

15. Denis-Prudent Roy, *Dissertation médico-chirurgicale sur le rire, considéré comme phénomène séméiologique: presentée et soutenue à la Faculté de Médecine de Paris le 9 avril 1812 par Denis-Prudent Roy* (Paris: Didot Jeune, 1812).

16. For quotations from Virgil, Cicero, and other authors about the sardonic smile, see the anonymous article entitled "La plante qui fait rire" in the magazine *L'Intermédiaire des Chercheurs et Curieux* (Paris), no. 625 (2nd semester 1893), columns 103–104.

17. "Sardonique," in Pierre Larousse, *Grand Dictionnaire Universel du XIX siècle: français, historique, géographique, mythologique, bibliographique...*, vol. 14, S–TESTA (Paris: Administration du Grand Dictionnaire Universel, 1866–1877), 225–226.

18. John Day, *Yahweh and the Gods and Goddesses of Canaan* (Sheffield, UK: Sheffield Academic Press, 2000), 213.

19. Pausanias, *Description of Greece*, book X: Phocis, Ozolian, Locri, translated by W. H. S. Jones, vol. 4 (Cambridge, MA: Harvard University Press, 1979), 465.

20. Jean-Paul d'Ardène, *Traité des Renoncules, dans lequel outre ce qui concerne ces fleurs, on trouvera des observations physiques, et plusieurs remarques utiles, soit pour l'agriculture, soit pour le jardinage* (Paris: Ph. N. Lottin, 1746), 16–17.

21. I used the French translation of the Hippocratic Corpus by Émile Littré. See *Oeuvres complètes d'Hippocrate, traduction nouvelle avec le texte grec en regard*, vol. 5 (Paris: J.-B. Baillière, 1846), 255–257.

22. Gustave Richelot, *Du tétanos: pathogénie, marche, terminaisons* (Paris: J.-B. Baillère, 1875), 8.

23. Jules-Léger-Louis Gimelle, *Du tétanos* (Paris. Hennuyer, 1856), 71–82.

24. Roy, *Dissertation médico-chirurgicale sur le rire*, 93.

25. Hippocrates, *Aphorisms*, section VI, aphorism no. 53, in *Hippocratic Writings*, translated by J. Chadwick and W. N. Mann: I. M. Lonie, E. T. Withington (London: Penguin Books, reprint 1983), 230.

26. Stéphanie Félicité du Crest, comtesse de Genlis, *Mémoires de Mme. de Genlis sur la cour, la ville et les salons de Paris* (Paris: Gustave Barba, 1868), chapter XIX, 64–65. The same anecdote is recounted in Denis Prudent-Roy's *Dissertation sur le rire* (35, footnote 1).

27. "Baise-main," in *Encyclopédie du dix-neuvième siècle: répertoire universel des sciences, des lettres et des arts, avec la biographie de tous les hommes célèbres*, vol. 4 (Paris: ASI-BAU, 1836–1853), 408–409.

28. Pliny, *Natural History*, book XXVIII, v, 24–26, translated by W. H. S. Jones (Cambridge, MA: Harvard University Press, 1963), 19.

29. Willem Frijhoff, "The Kiss Sacred and Profane: Reflections on a Cross-Cultural Confrontation," in Jan Bremmer and Herman Roodenburg, eds., *A Cultural History of Gesture, from Antiquity to the Present Day* (Amsterdam: Polity Press, 1991), 210–236.

30. Jacques Bril, *Petite fantasmagorie du corps. Osiris revisité* (Paris: Payot & Rivages, 1994), 162.

31. Frijhoff, "The Kiss Sacred and Profane," 211.

32. On the Kiss of Lamourette see Pierre Larousse, *Fleurs historiques des dames et des gens du monde: clef des allusions aux faits et aux mots célèbres que l'on rencontre fréquemment dans les ouvrages des écrivains français* (Paris, 1862), 68.

33. Frijhoff, "The Kiss Sacred and Profane."

34. Philippe Moreau, "Osculum, Basium, Savium" *Revue de Philologie, de Littérature et d'Histoire Ancienne* 52 (January 1, 1978): 87–97.

35. The first published edition of *Il Delfino ovvero del bacio* is that prepared by Danilo Arguzzi Barbagli in Francesco Patrizi, *Lettere ed opuscoli inedita* (Florence: Istituto Nazionale sul Rinascimento, 1975), 135–164. It is accessible online at https://mr.codij.site/download .php?file=lettere+ed+opuscoli+inediti+-+patrizi%2C+francesco. A French edition is Francesco Patrizi, *Du baiser* (Paris: Belles Lettres, 2002). The French version is owed to Sylvie Laurens Aubry. I followed this edition primarily, freely translating parts of it and abbreviating others at will.

36. An English translation, with introduction and notes by Sears Jayne, is Marsilio Ficino, *Commentary on Plato's Symposium on Love* (Dallas: Spring Publications, 1985).

37. For a scholarly discussion of the different analyses of love of Ficino and Patrizi, see Sabrina Ebbersmeyer, "Physiologische Analysen der Liebe, von Ficino zu Patrizi," *Verbum, Analecta Neolatina* 1 (1999): 36–47.

38. Ficino, *Commentary on Plato's Symposium on Love*, speech VI, chapter 4, 112.

39. Plutarch, *Life of Marius*, in *Parallel Lives*, vol. 9 (Cambridge, MA: Harvard University Press, 1920), 573–574. Published online at https://penelope.uchicago.edu/Thayer/e/roman/texts /plutarch/lives/marius*.html.

40. This example is mentioned by Suetonius, *Tiberius*, in *Lives of the Twelve Caesars*, but also by Marsilio Ficino in his *Commentary on Plato's Symposium on Love*, speech VII, chap. 4, 160.

41. Patrizi, *Du baiser*, 67.

42. The observation of a mirror stained by a menstruating woman who looks into it is contained in Aristotle's *Parva Naturalia*, 459b. See also Aristotle; *On Dreams*, translated by J. I. Beare, in *The Complete Works of Aristotle*, vol. 1 (Princeton: Princeton University Press, 1984; sixth printing 1995), 731.

43. The reference is to Plato's *Phaedrus*, 255d, where the discussion leads to "love and counter-love." The speaker says that the lover is "like one who has caught a disease of the eye from another." See R. Hackforth, *Plato's Phaedrus* (Cambridge: Cambridge University Press, 1972 reprint), 105.

44. Francesco Petrarca, *Canzoniere*, edited by Giancarlo Contini (Torino: Einaudi, 1964). See sonnet CCXXXIII, 285.

CHAPTER 6

1. Cardan's *Games of Chance* was reprinted in 2015 by Dover Publications, New York, after an edition by Holt, Reinhart and Winston, New York, in 1961. The *Ars magna* was published by the MIT Press in 1968 and reissued as *The Rules of Algebra* by Dover Publications in 2007.

2. Cardan's autobiography, *De propria vita*, has been published in English as *The Book of My Life* (New York: New York Review of Books, 2002), translated by Jean Stoner and with an introduction by Anthony Grafton.

3. Quoted by Louis Figuier in *Vie de savants illustres depuis l'antiquité jusqu'au dix-neuvième siècle, avec l'appréciation sommaire de leurs travaux. Renaissance* (Paris, 1866–1870), 9, note 1.

4. Joseph Addison, *The Tatler*, no. 214 (August 22, 1710).

5. H. E. Barnes, *An Intellectual and Cultural History of the Western World* (New York: Dover, 1965), 569.

6. W. W. R. Ball, *A Short Account of the History of Mathematics*, 4th ed. (New York: Dover, 1960), 224.

7. Quoted from Cardan's autobiography in Pierre Bayle, *Dictionnaire historique et critique par Monsieur Bayle*, vol. 2 (Paris, 1697), 761–762.

8. Hyacinthe Fermin-Didot, in the entry "Cardan" of *Nouvelle biographie universelle: depuis les temps les plus reculés jusqu'à nos jours avec les renseignements bibliographiques et l'indication des sources à consulter* (Paris: Firmin-Didot Frères, 1852–1854), 8:689.

9. Ian Maclean, "Girolamo Cardano: The Last Years of a Polymath," *Renaissance Studies* 21, no. 5 (November 2007): 587–607.

10. See the entry "Cardano, Gerolamo" in the Treccani Encyclopedia online: https://www.treccani.it/enciclopedia/gerolamo-cardano.

11. Anthony Grafton, "Girolamo Cardano and the Tradition of Classical Astrology: The Rothschild Lecture, 1995," *Proceedings of the American Philosophical Society* 142, no. 3 (September 1998): 323–354.

12. Allen McDuffee, "Ronald Reagan Actually Used This San Francisco Astrologist to Make Presidential Decisions," article published May 29, 2017 on TIMELINE online: https://timeline.com/ronald-reagan-astrology-quigley-aa81632662d9.

13. Joan Quigley, the Reagans' astrologer, described her experience as advisor of the presidential couple in her book *What Does Joan Say? My Seven Years as White House Astrologer to Nancy and Ronald Reagan* (New York: Birch Lane Press, 1990).

14. Franz Cumont, *Les religions orientales dans le paganisme romain, conférences faites au Collège de France en 1905* (Paris: Ernest Leroux, 1906), 196.

15. James Crawford Ledlie Carson, *The Fundamental Principles of Phrenology Are the Only Principles Capable of Being Reconciled with the Immateriality and Immortality of the Soul* (London: Houlston & Wright, 1868), 144.

16. Quoted by H. Brabant in *Médecins malades et maladies de la Renaissance* (Brussels: La Renaissance du Livre, 1966), 176–177.

17. Suetonius Tranquillus, *Titus Flavius Vespasianus Augustus*, in *The Lives of the Twelve Caesars*, vol. 11, translated by Alexander Thomson M.D., published online as a Project Gutenberg E-book #6396, released December 14, 2004; see http://www.gutenberg.org/cache/epub/6396/pg6396.html.

18. Jerome Cardan's treatise was first published in Paris as *La métoposcopie de Cardan, comprise en treize livres, et huit cens figures de la face humaine. A laquelle a été adjousté le Traité de signes ou marques naturelles du corps, traduit du grec de Melampus, par Claude-Martin de Lavrendière* (Paris: Thomas Joly, 1658). (The Greek text appeared together; an edition in Latin appeared simultaneously with this one.)

19. According to H. Brabant, *Médecins malades et maladies de la Renaissance*, the first published study of metoposcopy was by Hagecius in 1562; Cardan had announced the existence of his textbook five years before, but it was not published until 1658.

20. Charles Sorel, *La science universelle de Sorel, où il est traité de l'usage et de la perfection de toutes les choses du monde*, vol. 11 (Paris: Toussaint Quinet, 1647), 330–331.

21. W. G. Walters, *Jerome Cardan, a Biographical Study* (London: Lawrence & Bullen, 1898), 137.

22. George Dunea, "The Last Illness of King Edward VI (1537–1553)," *Hektoen International. A Journal of Medical Humanities* 4, no. 3 (Summer 2012), https://hekint.org/2017/01/30/the-last-illness-of-king-edward-vi-1537-1553/#:~:text=He%20was%20troubled%20by%20a,were%20found%20in%20his%20lungs.

23. Grace Holmes et al., "The Death of Young King Edward VI," *New England Journal of Medicine* 345, no. 1 (July 5, 2001): 60–61.

24. Among works that reflect a "revival" of Cardan's work, see E. Kessler, *Girolamo Cardano. Philosoph, Naturforscher, Arzt* (Wiesbaden: Harrassowitz, 1994); and M. Baldi and G. Canziani, eds., *Girolamo Cardano, le opere, le fonti, la vita* (Milan: Angeli, 1999). The two remarkable studies by American authors are: Nancy G. Siraisi, *The Clock and the Mirror: Girolamo Cardano and Renaissance Medicine* (Princeton: Princeton University Press, 1997), and Anthony Grafton, *Cardano's Cosmos: The Worlds and Works of a Renaissance Astrologer* (Cambridge, MA: Harvard University Press, 1999).

25. Grafton, *Cardano's Cosmos*, 17.

26. Nelson P. Trujillo and Thomas A. Warthin, "The Frowning Sign: Multiple Forehead Furrows in Peptic Ulcer," letter to the editor, *Journal of the American Medical Association* 205, no. 6 (1968): 218.

27. Lester S. King, "Metoposcopy and Kindred Arts," *Journal of the American Medical Association* 224, no. 1 (1973): 42–46.

28. Eliphas Levy (pseudonym of Alphonse-Louis Constant), "L'astrologie," in *Dogme de rituel de la haute magie*, vol. 1 (Paris: Charonac Frères, 1930), 310.

29. Alphonse de Lamartine, *Cours familier de littérature: un entretien par mois* (Paris: Chez l'auteur, 1856), 12.

30. Ernst Hans Gombrich, "On Physiognomic Perception," *Daedalus* 89, no. 1 (Winter 1960): 228–241.

31. Michel de Montaigne, *Essais*, book III, chapter 12: "De la physionomie," in *Œuvres complètes* (Paris: Seuil, 1967), 427.

32. Ibid.

33. See, for instance, K. R. Popper, *The Logic of Scientific Discovery* (New York: Basic Books, 1959). Also the excellent dissertation on the origin of scientific ideas by Peter Brian Medawar, *Induction and Intuition in Scientific Thought*, Jayne Lectures for 1968 (Philadelphia: American Scientific Society, 1969).

34. Gombrich, "On Physiognomic Perception."

35. Aulus Gellius, *The Attic Nights*, translated by John C. Rolfe, book I, ix, 2 (Cambridge, MA: Harvard University Press, 1984), 45–47.

36. The fullest account of the Zopyrus anecdote is in Cicero's *De fato* ("On Fate"). See *The Treatises of M. T. Cicero*, edited and translated by C. D. Yonge (London: Henry G. Bohn, 1853), 267–268.

37. This story was originally told in a book titled *Secretum secretorum*, formerly attributed to Aristotle, published by Richard Foerster in his monumental, two-volume *Scriptores physiognomonici græci et latini* (Leipzig: Teubner, 1893). Foerster's treatise became the standard

for all scholarly works on physiognomics; that the German erudite was addressing only scholars in his field is evinced by the fact that his work was written in Latin and remained so for many years. Only recently have sections of his work been translated and commented upon. See, for instance, *Seeing the Face, Seeing the Soul: Polemon's Physiognomy from Classical Antiquity to Medieval Islam*, edited by Simon Swain (Oxford: Oxford University Press, 2007). Another study (in Latin) about the *Secretum secretorum*, with notes and explications (Oxford, 1920), is owed to Roger Bacon. The same anecdote is mentioned in this work (pt. 5: 165).

38. Jerónimo Feijóo y Montenegro, "Fisionomía," in *Obras escogidas del Padre Fray Jerónimo Feijoo y Montenegro* (Madrid: M. Rivadeneyra, 1863), 232.

39. L. A. Zebrowitz et al., "'Wide-Eyed' and 'Crooked-Faced': Determinants of Perceived and Real Honesty across the Life Span," *Personality and Social Psychology Bulletin* 22 (1996): 1258–1269.

40. M. Stirrat and D. I. Perrett, "Valid Facial Cues to Cooperation and Trust: Male Facial Width and Trustworthiness," *Psychological Science* 21, no. 3 (2010): 349–354.

CHAPTER 7

1. Karen Dion et al., "What Is Beautiful Is Good," *Journal of Personality and Social Psychology* 24, no. 3 (1972): 285–290.

2. T. F. Cash and R. N. Kilcullen, "The Eye of the Beholder: Susceptibility to Sexism and Beautyism in the Evaluation of Managerial Applicants," *Journal of Applied Sociology and Psychology* 15 (1985): 591–605.

3. H. Sigall and N. Ostrove, "Beautiful but Dangerous: Effects of Offender Attractiveness and Nature of the Crime on Juridical Judgment," *Journal of Personality and Social Psychology* 31 (1975): 410–414.

4. A. C. Downs and P. M. Lyons, "Natural Observations of the Links Between Attractiveness and Initial Legal Judgment," *Personality and Social Psychology* B17 (1991): 541–547.

5. Quoted in Anne-Marie Daignan, marquis d'Orbessan, "Éloge historique de Paule de Viguier, connue sous le nom de la Belle Paule, lu dans une Séance publique de l'académie Royale des Sciences de Toulouse," in *Mélanges historiques, critiques, de physique, de littérature et de poésie*, vol. 3 (Paris: Merlin Libraire, 1768), 242.

6. Desmond Seward, *Prince of the Renaissance: The Golden Life of Francis I* (New York: Macmillan, 1973).

7. F. S. Feuillet de Conches and Armand Baschet (who signed their book as "Deux Vénitiens"), *Les femmes blondes selon les peintres de l'école de Venise* (Paris: A. Aubry, 1865), 185.

8. The title of the book, excessively long as was customary, may be abbreviated as: *De la Beauté, Discours Divers [. . .] Avec la Paule-graphie ou description des beautez d'une Dame Tholosaine*,

nommee La Belle Paule. Par Gabriel de Minut Chevalier, baron de Castera, Seneschal de Rouergue (Lyon: Barthelemi Honorat, 1587).

9. Marquis d'Orbessan, "Éloge historique de Paule de Viguier," 247.

10. Horace, book I, ode XXXIII.

11. David Hume, "On the Standards of Taste," in *Essays Moral, Political, and Literary*, rev. ed. (Indianapolis: LibertyClassics, 1987), 227.

12. Se the entry "Leblouh" in Wikipedia, https://en.wikipedia.org/wiki/Leblouh.

13. W. Vandereycken, "The Sociocultural Roots of the Fight against Fatness: Implications for Eating Disorders and Obesity," *Eating Disorders: The Journal of Treatment and Prevention* 1 (1993): 7–16.

14. Quoted from the entry "Beau" in Voltaire's *Dictionnaire philosophique*, in *Oeuvres complètes de Voltaire, 17, 1. Nouvelle edition . . . précédée de la Vie de Voltaire par Condorcet et d'autres études biographiques* (Paris: Garnier Frères, 1878), 556–557.

15. Michael R. Cunningham, "Measuring the Physical in Physical Attractiveness: Quasi-Experiments on the Sociobiology of Female Facial Beauty," *Journal of Personality and Social Psychology* 50, no. 5 (1986): 925–935.

16. Victor S. Johnson and Melissa Franklin, "Is Beauty in the Eye of the Beholder?," *Ethology and Sociobiology* 14, no. 3 (1993): 183–199.

17. Johannes Hönekopp, "Once More: Is Beauty in the Eye of the Beholder? Relative Contributions of Private and Shared Taste to Judgments of Facial Attractiveness," *Journal of Experimental Psychology Human Perception and Performance* 32, no. 2 (2006): 199–209.

18. Anthony C. Little et al., "Facial Attractiveness: Evolutionary Based Research," *Philosophical Transactions of the Royal Society B* 366 (2011): 1638–1659.

19. R. Kowner, "Facial Asymmetry and Attractiveness Judgment in Developmental Perspective," *Journal of Experimental Psychology. Human* 22 (1996): 662–675.

20. A. C. Little et al., "Evidence against Perceptual Bias Views for Symmetry Preference in Human Faces," *Proceedings of the Royal Society of London B* 270 (2003): 1759–1763.

21. Harold Osborne, "Symmetry as an Aesthetic Factor," *Computers and Mathematics with Applications* 128, nos. 1–2 (1986): 77–82.

22. Ibid., 77.

23. H. C. Lie, "Genetic Diversity Revealed in Human Faces," *Evolution* 62 (2008): 2473–2486.

24. R. Thornhill and S. W. Gangestand, "Human Facial Beauty: Averageness, Symmetry and Parasite Resistance," *Human Nature* 4 (1993): 237–269.

25. G. Rhodes et al., "Perceived Health Contributes to the Attractiveness of Facial Symmetry, Averageness and Sexual Dimorphism," *Perception* 36 (2007): 1244–1252.

26. Pamela M. Pallett et al., "New 'Golden Ratios' for Facial Beauty," *Vision Research* 50, no. 2 (January 2010): 149; published online November 6, 2009, doi: 10.1016/j.visres.2009.11.003; see final edited form at https://www.ncbi.nlm.nih.gov/pmc/articles/PMC2814183/.

27. Katherine Cooney, "Does This Woman Have the Perfect Face? Meet Florence Colgate, Student and Mathematical Ideal," *Time*, published online April 27, 2012, https://newsfeed.time.com/2012/04/27/does-this-woman-have-the-perfect-face/.

28. Quoted by M. Lepage in his reception speech at the Société Académique de l'Aube, *Bulletin mensuel de la Société académique de l'Aube*, October 1959, pages unnumbered.

29. Robert M. Ricketts, "Divine Proportion in Facial Esthetics," *Clinics in Plastic Surgery* 9, no. 4 (October 1982): 401–422.

30. S. Kanazawa, "Intelligence and Physical Attractiveness," *Intelligence* 39, no. 1 (2011): 7–14.

31. Dio Chrysostom, "On Beauty," in *Dio Chrysostom Discourses*, vol. 2, translated by J. W. Cohoon (Cambridge, MA: Harvard University Press, 1993), 271–289.

32. Heather L. Reid, "Athletic Beauty as Mimesis of Virtue: The Case of the Beautiful Boxer," in *Looking at Beauty to Kalon in Western Greece: Selected Essays from the 2018 Symposium on the Heritage of Western Greece*, edited by H. L. Reid and Tony Leyh (Sioux City, IA: Parnassus Press—Fonte Aretusa, 2019).

33. Michel Tournier, *La goutte d'or* (Paris: Gallimard, 1986), 210.

34. Shadi Bartsch, *The Mirror of the Self: Sexuality, Self-Knowledge, and the Gaze in the Early Roman Empire* (Chicago: University of Chicago Press, 2006), 103.

35. Xenophon, *Symposium*, book I, 8–10, translated by O. J. Todd (Cambridge, MA: Harvard University Press, 1992), 537.

36. Tertullian, *On the Apparel of Women*, book 1, https://www.newadvent.org/fathers/0402.htm.

37. The story of Virginia (c. 465–449 BC) was told by Livy (*History of Rome*, book 3, chapter 44). She was daughter of Verginius and the devoted wife of Lucius Icilius, a former tribune. Appius Claudius lusted after her, had her abducted under the false pretense that she was a slave. The case was brought before a tribunal presided over by Appius Claudius, who declared her a slave. The father asked permission to interrogate her, but instead stabbed her fatally as the only way to preserve her freedom and her virtue. The story has been retold in various literary works, and is the subject of Botticelli's painting *Storie di Virginia*, kept at the Carrara Academy in Bergamo, Italy.

38. For a comprehensive, scholarly review of the historical testimonies about Empress Fausta's death, see David Woods, "On the Death of the Empress Fausta," *Greece and Rome* 45, no. 1 (April 1998): 70–86. This author concludes that Constantine was not to blame for the deaths of Fausta and Crispus. The latter may have committed suicide, and Fausta may have died accidentally in a hot bath in an attempt to provoke an abortion.

39. Henry Howard, Earl of Surrey, "The Lover Comforteth Himself with the Worthiness of His Love," http://www.luminarium.org/renlit/raging.htm.

40. Archibald Bower et al., *An Universal History: From the Earliest Accounts to the Present Time*, vol. 9 (London: C. Bathurst, 1781), 357–358; see digitized version: https://www.google.com /books/edition/An_Universal_History/gsY-AAAAYAAJ?hl=en&gbpv=1&dq=Amurat +and+Susman&pg=PA358&printsec=frontcover.

41. From the *Palatine Anthology* VI, 18; quoted in F. Frontisi-Ducroux and J.-P. Vernant, *Dans l'oeil du miroir* (Paris: Odile Jacob, 1997), 54.

42. See entry "Jean André" in Pierre Bayle's *Dictionnaire historique et critique, nouvelle édition, augmentée de notes extraites de Chaufepié, Joly, La Monnoie, etc.*, 5th ed., vol. 1 (Paris, 1738), note C, 229.

43. Joseph Addison, "Dying for Love," essay no. 108 in *Essays of Joseph Addison*, vol. 2 (London: Macmillan, 1915), 145–148.

44. Rolfe Humphries, in the introduction to his English translation of Ovid's *The Art of Love* (Bloomington: Indiana University Press, 1957; 11th printing 1973), 5.

45. Suzanne Raga, "11 Tips from Ovid for How to Get Over a Breakup," https://www.mental floss.com/article/77983/11-tips-ovid-how-get-over-breakup.

46. Jean Regnault de Segrais, *Oeuvres diverses de M. de Segrais*, vol. 1 (Amsterdam: François Changuion, 1723), 7–8.

47. Ibid., 8–10.

48. Lesel Dawson, *Lovesickness and Gender in Early Modern English Literature* (Oxford: Oxford University Press, 2008).

49. See entry "Leucade" in Pierre Bayle's *Dictionnaire historique et critique, nouvelle édition, augmentée de notes extraites de Chaufepié, Joly, La Monnoie, etc.*, vol. 9 (Paris: Desoer, 1820), 193.

50. Benito Jerónimo Feijóo y Montenegro, "Remedios de el Amor," in *Obras escogidas del Padre Fray Benito Jerónimo Feijoo y Montenegro*, Biblioteca de Autores Españoles (Madrid: Rivadeneyra, 1863), 416–428.

51. See page 6:662; cf. the entry "Fibre" in the digitized version of the *Encyclopédie* made available in the ARTFL project of the University of Chicago, https://encyclopedie.uchicago.edu/.

52. Ibid., 6:665.

53. Gregorio Marañón, *Las ideas biológicas del Padre Feijóo* (Madrid: Espasa-Calpe, 1934). See in particular chapter X, titled "Feijóo psiquiatra."

CHAPTER 8

1. Jerónimo Feijóo y Montenegro, "Fisionomía," in *Obras escogidas del Padre Fray Jerónimo Feijoo y Montenegro* (Madrid: M. Rivadeneyra, Biblioteca de Autores Españoles, 1863), 232.

2. Martial, epigram 54, book XII, in *Martial Epigrams*, vol. 3, translated by D. R. Shackleton Bailey (Cambridge, MA: Harvard University Press, 1993).

3. Johann Christoph Friedrich Schiller, *Essays, Esthetical and Philosophical, Including the Dissertation on the "Connexions between the Animal and the Spiritual in Man* (London: Bell, 1882).

4. Pliny, *Natural History*, book XXXVI, iv, 11, translated by D. E. Eichholz (Cambridge, MA: Harvard University Press, 1971), 11.

5. An actor by the name of Dumirail made his debut in Paris in 1712, left the stage in 1717, reappeared as Mithridates on March 1724, and retired on January 11, 1730. He became a pensionnaire of the Comédie Française in 1752. See Philip H. Highfill, Jr., Kalman A. Burnim, and Edward A. Langhans, *A Biographical Dictionary of Actors, Actresses, Musicians, Dancers, Managers and Other Stage Personnel in London, 1600–1800*, vol. 10 (Carbondale and Edwardsville: Southern Illinois University Press, 1984), 501.

6. Lucian of Samosata, *Dialogues of the Dead*, in *Lucian*, vol. 7, translated by M. D. Macleod (Cambridge, MA: Harvard University Press, last reprint 1988), 171–175.

7. Umberto Eco, *Storia della bruttezza*, 2nd ed. (Milan: Bompiani, 2015), 10.

8. Johann Wolfgang von Goethe, "On German Architecture," in Goethe, *Essays on Art and Literature*, edited by John Gearey (Princeton, NJ: Princeton University Press, 1994), 5.

9. Marcus Aurelius, *The Communings with Himself of Marcus Aurelius Antoninus, Emperor of Rome, Together with His Speeches and Sayings*, book III, section 2, translated by C. R. Haines (Cambridge, MA: Harvard University Press, 1987), 47.

10. Ibid.

11. Gotthold Ephraim Lessing's discussion of ugliness is developed in chapters XXIII to XXV of his *Laocoon*. I used the London edition published by J. M. Dent and Sons, 1949.

12. Moses Mendelssohn, *Philosophical Writings*, translated and edited by Daniel O. Dahlstrom (Cambridge: Cambridge University Press, 1997), 10.

13. Ibid., fourth letter, 19.

14. Lessing, *Laocoon*, 87.

15. See note 1 for *The Spectator* no. 14, March 16, 1711, attributed to Richard Steele. Published online at http://www2.scc.rutgers.edu/spectator/text/march1711/no14.html. See also the entry "John James Heidegger" in Wikipedia.

16. J.-X. Carré de Busserolle (1823–1904), *Notice sur les fêtes des anes et des fous qui se célébraient au Moyen-Age dans un grand nombre d'églises, et notamment à Rouen, à Beauvais, à Autun et à Sens* (Rouen: De Brière, n.d.), National Library of France, identifier: ark:/12148/bpt6k8500542.

17. Frédéric Bernard, *Les fêtes célèbres de l'antiquité, du moyen âge et des temps modernes*, 2nd ed. (Paris: Hachette, 1883), 70.

18. Isaac Disraeli, "Anecdotes of European Manners," in *Curiosities of Literature. With a view of the Life and Writings of the Author*, vol. 2 (New York: W. J. Widdleton, 1875), 190.

19. The French word *écume* literally means "foam," but it was a term popularly used for magnesite (silicate).

20. Note on the *front* page of the Parisian newspaper *La Petite Presse*, July 1, 1872.

21. Charles-Joseph Colnet du Ravel, *L'hermite du faubourg Saint-Germain, ou Observations sur les mœurs et les usages français au commencement du XIX siècle*, vol. 1 (Paris: Chez Pillet Ainé, 1835), 209.

22. Ricky Jay, "Grinners, Gurners, and Grimaciers," in *Jay's Journal of Anomalies* (New York: Quantuck Lane Press, 2001).

23. BBC News online, "Ugly Mugs Gather at Gurning Contest," September 18, 1999, http://news.bbc.co.uk/2/hi/uk_news/451253.stm. See also "Gurners Face Off for Title at Egremont Crab Fair," BBC News for September 2011, https://www.bbc.com/news/uk -england-cumbria-14898808.

24. BBC News online, "Gurners Go for Gold," BBC UK News, September 15, 2001, http:// news.bbc.co.uk/2/hi/uk_news/1545231.stm.

25. David Le Breton, *Des visages. Essai d'anthropologie* (Paris: Éditions Métailié, 2003), 218.

26. A concise definition of the Sadducees by Professor Graetz is that they formed a party "the members of which, without forsaking the religion, yet made the interests of the nation their chief care and object." H. Graetz, *History of the Jews*, vol. 2 (Philadelphia: Jewish Publication Society of America, 1893), 17.

27. Ibid., 21.

28. This is a free translation of a fragment of the novel by Miguel Asturias, *Maladrón, Epopeya de los Andes Verdes*, chapter VIII (Madrid: Alianza Editorial / Losada, 1992), 65.

29. Ibid., 82.

30. Robin Lefere, "Maladrón de Miguel Angel Asturias: de la epopeya a la novela," *Studi Ispanici* 30, no. 1 (2005): 301–305.

CHAPTER 9

1. This chapter appeared previously, in slightly modified form, in the digitized magazine for medical humanities *Hektoen International* 6, no. 3 (Summer 2014).

2. The presence of a crease in the earlobes is known as "Frank's sign." Several studies have found this to be an independent predictor of coronary artery disease with 90 percent sensitivity. See A. Gasga and B. P. Phan, "Familial Frank's Sign: Diagonal Earlobe Creases and Premature Coronary Artery Disease," *Journal of General Internal Medicine* 36 (2021): 1106–1107; K. G. Lee, "Frank's Sign—A Dermatological Link to Coronary Artery Disease?," *Medical Journal of Malaysia* 72, no. 3 (2017): 195–196; Krzysztof Wieckowski et al., "Diagonal Earlobe Crease (Frank's Sign) for Diagnosis of Coronary Artery Disease: A Systematic Review of Diagnostic Test Accuracy Studies," *Journal of Clinical Medicine* 10, no. 13 (June 25, 2021): 2799, https://doi.org/10.3390/jcm10132799.

3. Judson S. Bury, *The Face as an Index of Disease* (London: John Heywood, 1889); Fernand Lagrange, *Considérations sur la physionomie et les altérations qu'elle subit dans les maladies* (Paris:

Lefrançois, 1869); François Cabuchet, *Essai sur l'expression de la face dans l'état de santé et de maladie* (Paris: Brosson, 1802).

4. Audrey J. Henderson et al., "Perception of Health from Facial Cues," *Philosophical Transactions of the Royal Society B* 371 (May 5, 2016), https://doi.org/10.1098/rstb.2015.0380; M. Feingold, "The Face and Syndrome Identification," *Birth Defects Original Article Series* 11, no. 7 (1975): 213–215; Bo Jin et al., "Deep Facial Diagnosis: Deep Transfer Learning from Face Recognition to Facial Diagnosis," IEEE Access, June 29, 2020, doi 10.1109/ACCESS.2020.3005687.

Index